Reports of the Research Committee

of the

Society of Antiquaries of London

No. XXXIX

Zoomorphic Penannular Brooches

By

H. E. Kilbride-Jones, F.S.A.

Published by
The Society of Antiquaries of London

Distributed by
Thames and Hudson Ltd
1980

ISBN 0 500 99030 1

PRINTED IN ENGLAND BY
ADLARD AND SON LTD
BARTHOLOMEW PRESS, DORKING

In Memoriam
Professor Dr Adolf Mahr

CONTENTS

LIST OF FIGURES

PROLOGUE

THIS is the story of a long line of brooches, all differing one from the other, yet made in accordance with the requirements of a single underlying motif, the zoomorphic motif. The component features of this motif are head, snout, eyes and ears, hence its name of zoomorphic. Because the brooches are penannular in form, and their terminals are fashioned in accordance with the above requirements, they are termed *zoomorphic penannular brooches*. These brooches are wholly distinct from any other form, and because of that they deserve consideration on their own merits. They are many in number, and generally they fill the gap between the early little types with bent-back terminals and the exotic productions of the eighth century and later.

Forty years ago an attempt was made at devising an evolutionary sequence for penannular brooches with zoomorphic terminals.[1] The attempt was not entirely successful, and in the ensuing years critical appraisals have been published. Charges of eccentric thinking, even of partisanship, have been made. To this serious worker, the suggestion of partisanship is abhorrent. But unproductive criticism often receives general assent; this may therefore be an opportune moment in which to get the record into perspective once more, in the light of additional experience and a healthy increase in the numbers now known.

Even the term *zoomorphic* has been questioned.[2] Critical appraisal of a term in long use is hardly appropriate. The exercise has added nothing to what was already known about the brooches, which collectively add up to a very distinctive class. That very distinction, their zoomorphic character, marks them out for special consideration. If the term *zoomorphic* is thought not to be entirely satisfactory (as some would have it), it is nevertheless an inherited term, one that is universally understood, and for that reason it should be allowed continued use. Nobody has yet come forward with a better term.

Not that the critics are agreed amongst themselves. Amongst the welter of criticism one or two points emerge as being entirely acceptable. A common criticism is one directed to the inclusion in the 1937 paper of a type of brooch with simple bent-back terminals,[3] crude in its utter simplicity, and produced in numbers in the first century A.D. Forty years ago it looked like being the initial form for which everybody was searching, but now this is seen to have been mistaken thinking. Its value is limited because it shows virtually no development. However, it presages the penannular concept as far as brooches are concerned, and that is all — no more and no less. But no form can remain static for long, though it took roughly a century for it to grow bigger, and by this time it had taken on a new form — the zoomorphic form. This was not the result of steady development, but it was a bigger and a better brooch that now came into being, owing nothing to anything that had gone before except its penannular shape. Large brooches, if they are not to be dull and uninteresting, require some relief, be it decoration on the terminals, or the fashioning of the terminals themselves into some form of representation. In this respect the zoomorphic form stood out as a clever adaptation, however abstract, of some animal style.

However, this is not in itself sufficient acknowledgment of an initial blunder; for Savory[4] goes further. He proposes to divide the brooches into both 'small' and 'large' specimens. His

division into two types, albeit a rough one, is nevertheless workable, and for that reason is accepted here. His is a point well made, for now it is clear (in a general way) that brooches with zoomorphic terminals do indeed divide themselves into two types, the one small, the other large. The small brooches, whose numbers have nearly doubled, group themselves into a very individual series, for clearly they display no developing characteristics, and are possibly the work of the bent-back terminal brooch-makers. Their inclusion in the large brooch series has been the root cause of much confused thinking in the past, particularly with regard to date. In all fairness to them, they deserve to be considered separately.

The zoomorphic motif, as utilized on pins and brooches, is one that remained in fashion for a long time; but the extended chronology, as set down in the 1937 paper, can no longer be substantiated. This chronology has also come in for much criticism.[5] The zoomorphic style lasted for three to four centuries, from the late second century until the destruction of the heroic centres in Ireland in the middle of the fifth century. One series alone soldiered on for a time, but probably production ceased in the early sixth century. The destruction of the heroic centres and the displacement of the Soghain from their midland territories by the Sept Ui Maini in the fifth century may have been simultaneous events, implying destruction of the workshops. For these reasons the new chronology differs from the old. These events are enough to explain why no zoomorphic penannular brooches have ever been found in Dalriada.[6] The distribution of oghams suggests that the absence of brooches from Gwynedd and Dyfed can be explained by the fact that the settlers in these areas of Wales came from regions in Ireland where there was no tradition of brooch-making in this form.

Whilst some criticisms are acceptable, others are not. The rejected criticisms, were they accepted, would not affect the main thesis in any way. However, one's own critical eye must be brought to bear on some other significant matters, one of which is the division of the Irish brooches into four main groups. This division has stood the test of time, but needs emendation in the light of additional information, and because of the considerable increase in the number of brooches now available for close examination. Confusion will be avoided by retaining the former groupings into A, B, C and D brooches, but within each group there are now seen to be variations which would show the brooches to be the work of more than one hand. Because these variations are constant, and are seen to be spread over some brooches only, but not over others, then there must be sub-groups within the main group. Thus Group A is now divided laterally into A_1 and A_2; B into B_1 and B_2; C into C_1, C_2, C_3, C_4 and C_5. Group D, which is representative of brooches made during a period of decline, has no subdivisions. Group C has been found to include by far the largest number, and it is representative of the most productive period in the history of the form.

Form is paramount. All the above groupings have been based on form. Form is most variable, and it is these variations that permit of the above groupings. Anyone who attempts groupings by reference to decoration is in for trouble; for decoration is purely ancillary. Motifs can be anybody's choice; they can be borrowed from anywhere, and from decoration that appears on any class of object. They are less local and more universal. Most of the Irish patterns are bad adaptations of the British. British designs, in their turn, owed a lot to Continental La Tène inspiration. Form is more personal: it is plastic in the craftsman's hands. It is as he wants it. But he adopts a more conservative attitude to decoration and to the

motif that may have travelled across Europe without change. On the other hand, decoration is valuable for dating purposes, and must be given full consideration. Form and decoration — the merits of both are worthy of full consideration.

When premises come under attack, it is as well to set down briefly what the critics are about. Raftery,[7] when searching for the genesis of the zoomorphic form, thought it axiomatic that the centre of greatest distribution must also have been the homeland of initial development. By this he means Ireland. Development was supposed to have been from 'a Roman prototype', which, however, remains undiscovered. Savory[8] rejected Raftery's thoughts on the matter, and he also rejected the present author's 'eccentric chronology', even though, on the whole, Mlle Henry agreed with it.[9] Some of Savory's arguments have led to further confusion; for instance, he proposes a mid-fourth to mid-fifth-century date for the fully developed form, even though he had dated 'less well developed specimens' to the third or fourth centuries, views to which George Boon subscribes.[10] Some conclusions are arrived at by discrediting some active associations which are not very well documented.[11] But even worse is to come: Mrs Fowler, whilst subscribing to the validity of Savory's arguments on the one hand,[12] on the other is of the opinion that the squared terminal brooches (her name for zoomorphic penannular brooches) could have come into fashion, as a type, in the second century.[13] Out goes Savory's dating of brooches by their late associations; but Mrs Fowler is on even ground when she charges the present author with 'stretching out' his chronology. Stevenson now looks upon small Romano-British clench end penannulars as being ancestral to the fifth-century corrugated or plain hoops.[14] Anyone reading the above résumé must realize that the story is badly in need of being brought back into perspective.

However, Savory's fifth-century dating for the early developed types is one that has received general acceptance. It is subscribed to by Leslie Alcock,[15] whose belief it is that the manufacture of zoomorphic penannular brooches was confined to a single century, from the fourth to the fifth, with minor developments, which he thinks mean more to a modern typologist than ever they did to a fifth-century Briton. According to Alcock, zoomorphism as applied to brooches reached Ireland and Pictland in the minds of Celtic craftsmen who had been carried off as slaves.

Imagination, unsupported by facts, has played too strong a hand. Some of Mrs Fowler's postulates[16] are in the same category. In her tract 'Celtic metalwork of the fifth and sixth centuries', all penannular brooches are seen as being part and parcel of a single family, like branches springing from a tree trunk. This Darwinian conception of the origin of the species must, in part, be discredited. Letters of the alphabet are used to distinguish the various forms. Thus, the letter F is reserved for the brooches which are the subject matter of the present study. F, it seems, was evolved out of E. Each has its sub-species. Thus F (plain) becomes F_1 when elaboration with plain enamel takes place, and F_2 when there is further elaboration with 'ultimate La Tène' decoration.

Such divisions are purely arbitrary. Each species is divided up solely on grounds of decoration, a method now condemned as being wholly unreliable. As an example, Fowler lumps together brooches from as far apart as Traprain Law, Abingdon and Co. Westmeath, in order to illustrate her ideas concerning the application of enamel to make up her F_1 sub-scries. Such brooches as those referred to are uneasy bedfellows at the best of times. There is a discrepancy of date, and in any case, the Co. Westmeath brooch may once have

been decorated with millefiori enamel. The whole exercise creates a dangerous precedent, in that type F was not evolved out of type E at all, but was evolved in the manner set out below. Admittedly, imaginative renderings can sometimes be excused, for in a case like this facts are few and hard to come by, but such as they are they in no way support the kind of arbitrary divisions which Mrs Fowler has postulated. Agreed, all penannular brooches are safety devices for securing clothes, but this does not make each and all part of a unitary movement. By using the argument put forward, it would be possible to couple a modern safety pin with a La Tène brooch.

To get the story into perspective, it is about a class of brooch which, quite suddenly, came into being in the second half of the second century A.D., based on the penannular form, but otherwise having no relationship with any others of a similar penannular make-up. The model for it was a second-century north British penannular bangle. The new brooches are bangle size, and they stand out above all their rivals as a unique form. Manufacture continued for a long time, and although variations were many and sometimes ingenious, the underlying zoomorphic motif was faithfully adhered to for most of the history of the type.

ORIGIN OF THE ZOOMORPHIC FORM

INGENIOUS ideas have been put forward to explain the origin of the zoomorphic form. Some frankly agree it is a puzzle.[17] The suggestion has been made that the Caledonian snake-armlets had something to do with it.[18] More recent evidence suggests that the zoomorphic form came into being as the result of a combined effort on the part of the Brigantes and of their friends, the Votadini. The basic idea came from a Brigantian bangle.

It is not clear how the Brigantes developed the form of their bangle, and to us it does not matter very much; but this bangle was the means of stimulating the Votadini into reconsidering the form of their proto-zoomorphic pins, and as a result of these deliberations there was created a synthetic representation not previously seen in Celtic Britain. The new motif was unlike any other animal representation. The reason why it was different is because it is abstract. Earlier and generally Continental forms depicting animal heads were more naturalistic. But there is yet another difference. Whereas these naturalistic productions[19] depict the animal head with its face to the *outside*, in the case of the new highly stylized form, the animal faces *inwards*, the snout engaged in a 'hoop-swallowing' act, as Stevenson has picturesquely put it. A further distinction is that the back of the head is always squared.

The whole movement towards this new development could have been initiated because of a feeling of boredom with the proto-zoomorphic form, which the Votadini had designed themselves. This form is made up of a *rounded* head and a snout, but there are neither ears nor eyes. No brooches have been found with this form of terminal, so that the proto-zoomorphic form was confined to pin-heads. The snout is slightly upturned at the tip, which probably was because the earlier pins had bent-back, or simulated bent-back heads, one such pin having been found at Traprain Law. The design is not a very striking one, and in some a spot of enamel has been added to the centre of the heads to make them a little more interesting. (A number of these pins is shown in fig. i.) The Votadini were not famed for quality of workmanship, though they were competent metalworkers. Distribution of these pins is confined to Traprain Law, Newstead (one) and Covesea Cave (one): at the oppidum they were found in three separate levels, the lowest, the third and the second. The lowest level is normally regarded as belonging to the late first century, or definitely not later than the beginning of the second century A.D., though the excavators' division of the occupation of this oppidum at Traprain Law into four levels has been questioned.[20] It is now suggested that the finds fall more reasonably into two groups, the two lowest levels (four and three) showing a balance of Roman, native Iron Age and Romano-British, whereas the two upper levels (two and one) appear to be later, and are more native in character. If this modified division into two chronological levels is accepted, then the proto-zoomorphic pins in this part of north Britain must belong mainly to the Roman and Romano-British period, whereas the square-headed pins, and with them the zoomorphic penannular brooches, would then belong to the 'native' period. In terms of years, this would separate the two classes of pins by at least a century.

This dating of the proto-zoomorphic pins would appear to be supported by the Newstead evidence. The Newstead pin, which has a large sinking on the head for enamel, came from

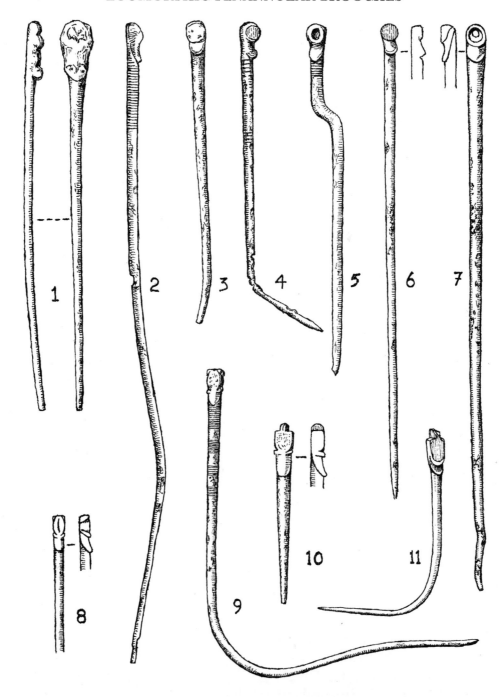

Fig. 1. Traprain Law, East Lothian: 1–7, proto-zoomorphic pins; 8–11, zoomorphic pins. (1/1)

Fig. 2. Irish proto-zoomorphic pins. 1, Crumlin, Co. Dublin; 2–5, Ireland; 6, *Cilurnum* (Chesters), Northumberland (1/1). Lengths: 1, 23 cm. (point missing); 2, 36 cm.; 3, 19 cm.; 4, 29 cm. (point missing); 5, 32 cm. (point missing); 6, 34.5 cm.

a level corresponding with that of the early building near Block XVII, within the fort,[21] and therefore a Flavian or at the latest a Trajanic date is suggested for it. The earliest pin is no doubt that with the bent-back or simulated bent-back head, which was found at Traprain Law. Fine ribbing extends downwards from the head for a distance of 2 cm. It is also the longest of the Scottish pins, being almost 18 cm. in length, though none of the north British pins is either as long or as stoutly made as their Irish counterparts, some of which are 35 cm. long, with a diameter of 1.2 cm. at the top end. But, whereas signs of development are lacking in Ireland, at Traprain Law the bent-back form was succeeded by another, also from the fourth level, on which at the front there is a circular plane. This is the ultimate form, which was adopted by the Irish. The only advance on this form was at Traprain Law, where a sunken hole was put into the middle of the circular plane for the reception of enamel.

All the Irish pins but one are unprovenanced (fig. 2). After the occupation of Britain, ideas took rather longer to reach the Irish metalworkers.[22] This could be the explanation for the decoration of pin fig. 2:4, the decoration of which matches that of brooch No. 108. There are several Irish pins with British locations: Boon[23] has reported on the discovery of two pins on Margam Beach, west Glamorgan, and on one from the Prysg Field, Caerleon, and on yet another from Silchester, Hampshire. Amongst the Roman and Romano-British material from *Cilurnum* (Chesters), on Hadrian's Wall, there is another.[24] The *Cilurnum* pin is unstratified. This fort had a long history, and all that can be said is that the pin must have been lost at some period prior to the fourth century. The Caerleon pin is enamelled, and Boon considers it to be of Antonine date.

It is thus clear that the Irish were making proto-zoomorphic pins in the second century,[25] and that the design itself, which is Votadinian, was nascent in the late first, or early second century. It probably had a longer life in Ireland than was the case in Britain. Irish memories tend to be long, and Irish products are often less progressive for the same reason, though this was not always the case, for in former times Irish influence on British art was considerable.[26] After the occupation, however, Ireland received little stimulation from outside, beyond the little proto-zoomorphic brooches from Knowth[27] and New Grange.[28]

It is perhaps curious that the Votadini had not as yet, in the second century, got round to making penannular brooches. They were familiar with the penannular form, since little

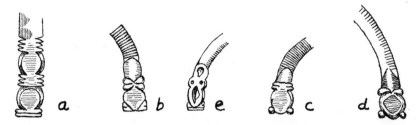

Fig. 3. Terminals showing development of zoomorphic form: a, bangle, *Isurium Brigantum* (Aldborough), Yorkshire; b, brooch no. 1, Traprain Law, East Lothian; c, brooch No. 2, Longfaugh, Midlothian; d, brooch no. 3, Ford of Toome, Lough Neagh; e, pseudo-zoomorphic brooch, Barnton, Edinburgh. (1/1)

bent-back specimens, including one turned into a finger ring, were known at Traprain Law. But now the stage is set for a change. To recapitulate: the metalworkers were familiar with the penannular form; they had developed a proto-zoomorphic head; they had applied ribbing to their pins. One wonders what prevented them from bending the pin into a circle and adding a second head, to make two terminals. An important point to note is, had they done this, the back of the head would have been to the *outside*. But the heads were still rounded, and heavy, and ugly. Then a Brigantian bangle fell into their hands.

This Brigantian bangle (fig. 3:a) was remarkably different. It was lightweight, it was penannular, with a terminal design that gave the Votadini all the ideas they wanted. The ends of the terminals were squared.[29] The circular, surface rounded sections, each separated by triple mouldings, reminded them of their own round heads. All this was achieved on comparatively thin metal, to save weight. A coalescence of ideas could not have been long delayed, and the result was a new design of brooch, roughly bangle size, and with a terminal form not seen before.

Not all the steps taken in this evolution of a new form are known, but sufficient evidence remains to indicate how the transition was made. Selected brooch terminals are shown in fig. 3, and in these some of the essential features of the Brigantian bracelet may be picked out.

The first terminal (fig. 3:b) shows how the ears were first formed. The end moulding here is double, but it was cut through at its centre by a file (not intentionally) when the metal-worker adopted the lazy man's method of shaping the head. This should have been filed from the sides, and not from the end. This may have been due to inexperience. The file marks caused a division of this outside moulding at its centre, and because of this the development of the ears was already under way. Fig. 3:c shows that the inner moulding is still undisturbed, so that, strictly speaking, its division to form the 'eyes' may have been delayed, or here the metalworker may have reverted to an earlier form, since this brooch is a more sophisticated specimen than is the first. It may be concluded, therefore, that at first mouldings on both sides of a still rounded head were continuous, and not divided at their centres. It is, of course, the outer moulding which gives to the terminal its squared end. Throughout, heads remain rounded, just as they did in the old proto-zoomorphic days, but the rounded shape is now more of an illusion, because they are seen to be rounded only when viewed from above.

Something must be said about the dating of the object which heralded these events. A mid-second-century date is claimed for the *Isurium Brigantum* (Aldborough), bangle,[30] on the grounds that it was found in active association with flange fragments of mortaria in cream-coloured fabric, one bearing the fragmentary stamp of VITALIS IV. Evidence from his kilns at Hartshill, Warwickshire, points to activity *c.* A.D. 120–45. On another associated mortarium there is a fragmentary retrograde stamp of ICOTASGUS, who was a potter working at Mancetter, Warwickshire, *c.* A.D. 135–70. This evidence supports the mid-second-century date for the bangle, though being of metal it could have survived from an earlier period.

The brooches referred to above cannot be so accurately dated. Their find-spots are within a restricted area, on the southern shores of the Firth of Forth, suggesting they were made locally. There were well-equipped workshops at the oppidum of Traprain Law, and undoubt-edly they were made here. The Longfaugh, Midlothian, brooch (fig. 3:c) had an interesting association which everybody wants to ignore.[31] It was found alongside, or near to, a bronze

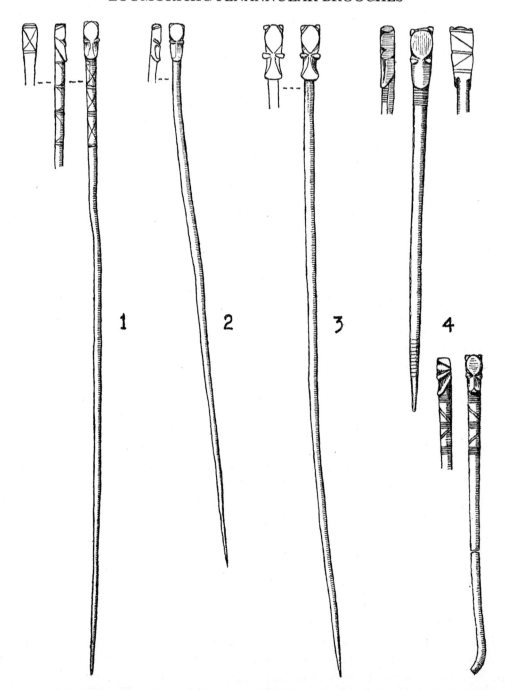

Fig. 4. Zoomorphic pins: 1–3, *Cilurnum* (Chesters), Northumberland; 4, Ireland.
Below (right), *Onnum* (Halton Chesters), Northumberland. (1/1)

patera and a bronze buckle, plainly a small hoard. The patera is of a type the evolution of which can be traced from small beginnings in the second century to full maturity a century later. On balance, the patera is said to belong to the second half of the second century.[32] The buckle has a close parallel at Newstead,[33] where a specimen was found in the upper levels of Pit II, and dated here to the Antonine period. The Traprain Law brooch (fig. 3:b) came from the upper 'native' levels. This is a clear case of survival from earlier times, since more developed forms of the zoomorphic head have come from lower levels. For instance, brooch No. 5 came from the third, or Romano-British level. In any case, it must not be forgotten that the disturbed conditions of A.D. 196, after the Antonine Wall had been abandoned, resulted in the destruction of the workshops, not only here at Traprain Law, but as far south as Brigantia. The metalworking industry never recovered from the effects of this catastrophe.

The most likely date for the manufacture of these early zoomorphic brooches is the late second century A.D., an opinion which is based on all the above evidence. The disaster of A.D. 196 accounts for their small numbers. It might also account for the appearance in Ireland at about this time of the earliest brooches of the Initial Form. Some metalworkers may have fled across the narrow seas to the Antrim or Down coasts, to seek sanctuary from the enraged northern tribes. Perhaps they took their patterns with them. Anyway, it is pertinent to this line of thought that none but the Initial Form has ever been found in Britain, and that further development took place only in Ireland.

Pins also assumed zoomorphic heads. These are few in number. There are four from Traprain Law (fig. 1:8–11) and only one, without locality, from Ireland (fig. 4:4). But three Irish zoomorphic pins were found at *Cilurnum* (Chesters),[34] but they are unstratified. One of these (fig. 4:3) is quite unique: the head is squared, and all of the four faces have identical features. The decoration on fig. 4:1 can be matched by that on one of the proto-zoomorphic pins, that found at Crumlin, Co. Dublin (fig. 2:1). None of the zoomorphic pins displays any development characteristics, so it must be assumed that all the development work was done on the brooches. The *Cilurnum* pins are delicate, imaginative; the sole specimen from Ireland is very mature. The pin point is wormed, an idiosyncrasy noted on some of the earlier Irish-made brooches.

The involvement of both the British and the Irish in the early development of the zoomorphic brooch means that it is impossible to be partisan in one's treatment of the subject. The involvement of one country in the other's affairs also renders this impossible. Apart from that, some Irish-made brooches and pins found their way to Britain. Cohesiveness is assured by the fact that no matter where the brooch may have been made, the underlying motif was the same, the zoomorphic motif which everybody copied faithfully.

CASTING AND FINISHING

IN a study of this magnitude one tends to pass over or lightly to touch upon various aspects of manufacture, like the casting of brooch forms, and the finishing of those products. Every trade has its specialized processes, and metalworking has more than most. Since the metal involved in this study is bronze, it makes for a better understanding all round if something is understood about the processes involved in bronze founding and finishing. They are in no way mysterious; in fact, anyone with some experience of metalworking can found metal, so long as it is non-ferrous. Even the making of moulds is not a difficult undertaking. Finishing requires a steady hand, and not a little patience, and in the long run it is experience that counts. What follows is intended mainly for those who know little or nothing of the processes involved.

At the centre of the workshop there must be a good furnace. This can be constructed by digging a square pit in the ground. This pit should be lined with clay. On one side an air passage is made, and near it a tuyere (for the bellows) must be cemented in, though good hard clay will suffice; on all accounts it must be held firmly in position, with its nozzle directed upwards. A full goat-skin makes an excellent bellows, and it will provide sufficient air for a full blast. The pit can now be filled with lighted charcoal, and rapid work with the bellows will ensure that soon temperatures in excess of 1100°C will be reached. Copper melts at 1083°C, and with the addition of tin (to form bronze) the melting point is lowered.

For melting the metal, crucibles will be required. These must be handled with the aid of long tongs. Iron tongs were found at Garranes, and at Traprain Law, and a good example came from a grain silo dated to 180 B.C. at Garton Slack.[35] The crucibles at Garranes, West Cork,[36] and at Traprain Law were pyramidal in shape. This shape helped to minimize the spillage of metal when pouring. Enough copper 'cake' for the job on hand would then be put into the crucible, and heated. In Celtic Britain, copper cakes were sometimes round; one such cake found at Newstead was found to be of 99% pure copper.[37] Once the metal in the crucible has melted, it must be given a final stir with a green branch. The methane and other gases so given off help in the refinement of the copper. After the addition of tin, the molten bronze is then poured into a suitable mould, and allowed to cool, naturally.

Moulds of this period were normally of baked clay, though open stone moulds were still in use at the Mote of Mark.[38] Stone moulds are always open moulds, whereas clay moulds are normally made in two halves, which are keyed together. The mould itself is made from a pattern, which can be of wood or of lead. The quality of the casting is wholly dependent on the excellence of the pattern. Great skills are called for in pattern-making, because an inferior pattern will produce a bad casting. Wood, for pattern-making, was used in the engineering industry up to the first half of the present century. But at the brooch factory at Clogher, Co. Tyrone, lead was used, as is attested by the discovery there of a lead pin (No. 150). After the mould is baked, the imprint of the pattern will remain on the interior. When molten metal is poured into the funnel-like opening on the top of the mould, it will assume the shape left by the pattern, when cold. One half of a baked clay mould for casting a penannular brooch was found at Dooey, Co. Donegal.[39] Clay moulds were numerous at

Traprain Law, though amongst them was none for casting penannular brooches, but there is a complete one for casting a dress-fastener.[40] This shows clearly how the two halves were keyed together, with the funnel-like opening at the top.

After cooling, the two halves of the mould are separated, and the casting extracted. This is likely to have 'rags' round the edges. This is typical even of modern castings. A raw casting of a penannular brooch terminal (No. 131) was found in the factory at Clogher.[41] Bronze is very suitable for casting: it is harder and stronger than is pure copper, and it takes on a very good finish. Work-hardened bronze can reach the hardness of a medium-quality steel.[42]

The casting is now ready for the finishing processes, and for these a further set of tools will be required, essentially those given below:

1. Small anvil
2. Hammer, preferably with one end rounded
3. Files
4. Chisels
5. Punches
6. Chasers
7. Compass
8. Drills

Firstly, the rags must be removed from the casting, this being done by the files. Next, if there is any hammering to be done, this will be done on the anvil. A small block anvil was found at Garranes.[43] Some anvils have pointed bases, for driving into the ground.[44] Benches were not used at this time, nor are they used by the itinerant smiths today. Hammers are not uncommon on early sites: one was found at Traprain Law,[45] and another with rounded butt and an oblong shaft-hole at Silchester.[46] The rounded butt end was a necessary feature to ensure that hammer marks were not readily seen. This form is of Continental origin. Déchelette reports on one which came from the tumulus of Celles près Neussargues, in central France.[47]

Files were also found in the same tumulus.[48] In fact, files are quite common. Files, tanged and shouldered for wooden handles, and very similar to the French specimens, were found at Traprain Law.[49] These have teeth on one side only. The teeth are widely spaced, there being roughly 12 rows to the inch. This type of file would be useful only for rough trimming, such as getting rid of rags. It is clear from the work done that finer files were available, but none seems to have survived.

Chisels are used for deep channelling, or for parting metal. Another tool, often mistaken for a chisel, is the chaser. The essential difference between the two is that the chaser has the sharp angles rounded off, whereas the chisel retains these sharp angles. The rounding off of the corners prevents the chaser from doing damage to the surface of the metal. In use, repeated blows from a hammer cause the chaser to make a light channel in the metal surface, each blow carrying the tool forward a little, so that it does not have to be lifted off the work until the line has been completed. When examined closely, a line so made appears to have been incised. The line can be made straight or curved at the will of the craftsman.

It will be appreciated that chasers, punches, drills and compasses are required only when the object is to be decorated. In the case of plain brooches, all that is required is a chisel and some files. But since most of these objects have a very smooth finish, they must have been buffed. However, file marks are visible on some of the less well finished brooches and pins. When terminals were enamelled, the metal surface had to be undercut for this purpose, and this work was done with a chisel. Preparation for this process may be seen in the case of brooch No. 32. Chisel marks are very common at the base of the hollows prepared for the reception of enamel; these were purposely left in order to give the enamel a better grip. Where terminals bear decoration against this enamel background, the pattern is left standing by the simple process of chiselling around it. This pattern would have been copied from another on a 'trial piece', which is normally of bone or of antler. One such trial piece was found at Dooey (fig. 5:2, p.20).[50]

Close examination of chisel marks and chased lines will reveal from what angle the metal-worker approached the work. Also highlighted are his errors of judgment. A skating chisel, or a chaser that jumped the line, will both leave ample evidence of the occurrence. Strangely, all marking out appears to have been done with the chaser, rather than with a scriber. Some metalworkers must have been very short-sighted, since some chased lines can be followed successfully only with the help of a lens. Drills were flat, and V-pointed. A heavy burr is usually left around the drilled hole, indicating that the drills were not very sharp, or alternatively the drills may not have been hard enough. Some holes are very small, indicating that fine drills were available. In the absence of hardening techniques, all drills must have had a very short life.

It will now be appreciated that the operations involved in producing a zoomorphic penannular brooch are in no way involved, and can be carried out without difficulty by anyone with a reasonable amount of experience. Decoration alone remains tricky: there is no other word for it, and the number of poor attempts at it by craftsmen of the past are recorded on the brooches themselves.

Enamelling is a simple process, for which no further equipment is necessary, except for a pestle and mortar. Enamel is nothing more than a vitreous coating fused on to a metallic base: it is closely related to glass, but it is somewhat softer, and it requires the application of less heat than does glass. In Ireland, red was the invariable colour, though other colours were used in Britain. The familiar red enamel was composed of sand, red lead and potash. Firstly, it is made up into small cakes, but when required for use, the cakes are broken up and ground down to a fine powder. For this purpose a pestle and mortar are required. A stone mortar was found at Garranes,[51] along with numerous fragments of glass intended for use as enamel. Some fragments were found still fused to clay crucibles,[52] which were similar to those used for metal.

So far as the brooches are concerned, the most common technique used is that known as *champlevé*. A level topped layer of enamel is placed in all the cells sunk into the terminal, around the decoration, and after firing this enamel will adhere to the metal underneath. Actually, enamel does not adhere too well to bronze because of its tin content, and this is the reason why the enamel has fallen out of so many terminals. Enamel adheres better to gold, silver or copper.

Enamel was late in reaching Ireland. Mlle Henry[53] thinks its first appearance was in

the first century A.D., basing her assumption on the occurrence of enamel on some Irish horse-bits of that period. The wide range of colours used in Britain on (for instance) dragon-esque brooches was never used or perhaps even known in Ireland.

Another form of enamel is that known as millefiori. Millefiori is made up of a number of glass fibres, often of different colours, to make a pattern, and these were bunched together to form a round or square stick, from which pieces were broken off to be sunk into a red enamel background. Afterwards the surface was ground down to dispose of any uneveness. It was a cheap and nasty way of getting round the problem of how to decorate a terminal, and inevitably it succeeded in killing the skills necessary when decoration was of greater importance than enamel. Millefiori implies that the chaser had have discarded for good.

TRADE AND BOOTY

EVERY product quickly finds its own level amongst the productions of its time. The governing factors are appearance, desirability, availability, and purchasing power. In the second century A.D. the most successful traders and manufacturers of personal items were perhaps the brooch-makers of Nor'nour, and the dress-fastener and bangle-makers of Traprain Law. These products are well known; and, although the factories responsible for them were situated on the fringe of the Roman world, full advantage was taken not only of the road system as a means of communication but also of the stable conditions that made that possible. The people of Nor'nour and the Brigantes had their eyes turned towards the markets in the civil province, but less so the Votadini, who had between them and the civil province the military areas of the north. The quantities of Warwickshire pottery in the north is an indication of the free movement of merchandise, but this freedom of movement appears to have been extended rather less to the Votadini, whose bangles were traded mainly as far as the Wall area, with a trickle beyond, whilst dress-fasteners had a westerly distribution as far as south Wales. So that, whilst the Roman presence was good for trade, and Collingwood maintained[54] that the stimulus of new ideas was a direct result of the Roman conquest, making much of the work produced by these factories art rather than mere craft, the Votadini appear to have been less influenced than most. The answer may be found in the lack of direct contact with the markets that others desired most.

There are other aspects of the situation. One is the seeming independence of the Votadini, whose oppidum the Romans appear to have bypassed. Normally, they are regarded as having been the friends of Rome. But were they? If the distribution of their products gives the impression of aloofness from the civil province, they were for sale to those who lived in the fringe areas, even to the Welsh tribes. Note must be taken also of the fact that developments taking place at Traprain Law were quickly understood in the north of Ireland. This is one of the aspects of the situation, in the early centuries of the occupation, that has never really been examined in any detail. Inevitably this raises the matter of the Roman attitude towards the Irish. We have it on record[55] that the Irish Sea was an Irishman's highway, and that the Irish continued to paddle their canoes up and down the west coasts of Britain, causing trouble by sporadic raids in their search for booty. In addition, the old Group IX axe route from Antrim via Kintyre, Ardlui and Glen Dochart to the lands of the Caledonians was never at any time breached by the Romans, and its continued use is suggested by the discovery at Newry of a massive armlet, and the Deskford boar's head is evidence of a two-way trade. If, in Agricola's estimation, it would have taken no more than a single legion to add Ireland to the Empire, why did the Romans tolerate these conditions, which by A.D. 275 had led to the establishment in Pembroke of an Irish aristocracy? Leinstermen also occupied large tracts of what is now Caernarvon. Obviously, the Irish were a nuisance. But if the Irish did have nuisance value, to whom was the advantage? Possibly, the advantage was to the Romans; for the Irish may have proved to be a greater nuisance to the Welsh than ever they were to the Romans. Had they wished it, the Romans could have swept the seas of Irish coracles. By occupying the attention of the Welsh, the Irish may unwittingly have helped the Romans by relieving pressure on the western frontier.

There is little if any reciprocal evidence from Ireland. The coin evidence suggests that raids were most successful in their outcome in the second and fourth centuries: the second-century Roman finds in Ireland can be equated with the disaster of A.D. 196, when Britain was left defenceless as a result of Clodius Albinus' expedition to Gaul; whilst the fourth-century booty must have been acquired as a result of the *barbarica conspiratio*, and later, in 388, when the Irish began to pour into Wales. The brooches throw some light on the subject. Whilst they indicate that movement between Scotland and the north of Ireland was still possible in the late second century, Irish-made zoomorphic penannular brooches and proto-zoomorphic and zoomorphic pins found their way to the Wall area, and again to the territory of the Silures in south Wales, penetrating even as far as Silchester.

All activity was one way, and this is what is meant by the lack of reciprocal evidence. It is plain to see why the Irish were attracted to Britain at this time. Irish society was an heroic one, but poor. Their economy was agricultural, with a strong emphasis on pastoralism.[56] The normal settlement was a family enclosure, usually ring works of bank and ditch, and containing a dwelling house with or without farm buildings. There were no towns or cities as such, but there were the four great heroic centres (pre-dating the forts) of Tara, Cruacha (Rathcroghan), Ailenn (Dun Ailenne, Knockawlin) and Emain Macha, near Armagh. Power lay in the hands of numerous petty kings, whose main occupation was fighting and feasting. Patronage of the arts was minimal. This is reflected in the kind of decoration that was applied to the brooches, though they were in other respects technically competent productions. But this applied decoration is at once multiplex, in the sense that it is made up of bits and pieces of designs and patterns, which do not appear to have much meaning, and were not clearly understood. The riches and the exotic products available in Britain must have acted like a magnet.

This paucity of art motifs and designs was the result of the severance of communications after the disaster of A.D. 196. Traprain Law remained unoccupied for perhaps 30 or 40 years. The ensuing hiatus is frightening, in that Celtic art appears to have gone underground. Roman productions were everywhere, but they were anaemic, artistically speaking, and somewhat vulgar. The position was that Ireland should have been the last repository of Celtic art at this time, yet here too there was little enough of it about, nothing more than a few spirals and a triskele or two, an art impoverished of fresh ideas.

There must have been refugees from Roman Britain. The settlement on Lambay quite clearly belonged to refugees. Their leader must have been a man of substance, with his beaded torc, his sword and scabbard, and his brooches, and he was probably on the wanted list. Other refugees there must have been, and some material, thought to be booty, may have been amongst their possessions. Refugees sometimes return as fifth-columnists, to infiltrate the population. It is just a thought, but some of the Irish pins and brooches may have got to Britain by this means. But this still does not explain how two Irish brooches found their way to a Frisian *terp*, the only foreign finds of this class.

The Roman withdrawal brought severe repercussions upon the Irish. Once the source of plunder was exhausted, the parasites who lived off it were doomed. Disintegration of Irish society followed: Emain Macha was destroyed, though exactly when this disaster occurred is not clear. Medieval Irish historians have fixed the date at A.D. 327, but this is too early. However, an alternative tradition places this event as late as 450.[57] The other heroic centres

went the same way at about the same time. Also in the fifth century the Soghain were dispossessed of their midland territories by the Sept Ui Maini. As a result of the general collapse of its heroic society, Ireland then moved towards a dynastic polity, under which kings took over from the warrior caste.

Consequent upon the Roman withdrawal and with better government in Ireland, the two countries bordering the Irish Sea might be expected to have resumed more normal relations. Yet no later brooches have been found in Britain. The reason is clear: manufacture had ceased by this time, or it was rapidly drawing to a close. There were none even in the Goedelic colonies in Argyll, and in Wales and Cornwall, noted by Marcellinus[58] as early as A.D. 360.

The arrival in Ireland of Christianity (Nendrum was founded around A.D. 445) failed to give any new stimulus to Irish art. Instead, the calmer conditions prevailing made it possible for eastern Mediterranean amphorae to be imported; oghams had swept, or were sweeping, across Pembroke and were proceeding eastwards, and only the arrival in north Wales of the Gododdin had managed to rock the boat a little.

SOME USEFUL DATES

A.D. 196 Northern tribes break into a defenceless province. Metalworking in the territories of the Brigantes and the Votadini brought to an abrupt end.

208 Hadrian's Wall rebuilt.

209 Caledonians reduced to unconditional surrender.

275 Irish raids on S.-W. coasts of Wales stepped up. An Irish aristocracy settled in Pembroke, and Leinstermen occupy western Caernarvonshire.

296 Fresh trouble along Hadrian's Wall.

343 General alarm, accounted for by another Irish raid.

367 *Barbarica conspiratio*, with concerted Irish raids on the West.

388 Irish begin to pour into Wales.

405 Harrying of south coasts of Britain by Niall of the Nine Hostages.

410 Separation of Britain from Rome.

440 The Gododdin drive Irish out of North Wales.

445 Nendrum founded.

450 (?) Destruction of Emain Macha.

THE TIME LAG IN IRISH ART

BRITISH archaeologists are fortunate in having a well-documented history of the Roman occupation of Britain at their elbows. Their Irish counterparts are less fortunate, for there is no written history of the same period in Ireland. Irish historical records begin late; even for the fifth century there are virtually no documentary sources, and the position had only slightly improved by the sixth century. There was a great monastic flowering in the mid-sixth, and with the seventh century the country emerges into the full light of history.

The whole period covered by the brooches is, as it were, an historical vacuum, in which firm datings are unknown. So comparisons are impossible. However, before the occupation of Britain it was possible to make comparisons between the art in Ireland and the art in Britain, and to know that changes in style were of a contemporary nature. Even up to the time of Agricola's attempted penetration of the Highlands of Scotland this happy relationship does not appear to have been disturbed very much, but subsequently contact appears to have been via the back door, so to speak. Even so, some measure of contact always appears to have been maintained, as can be demonstrated by the little similarities of decoration that are common to both countries. But these similarities were becoming slower to trickle through, so now a new factor has to be taken into consideration — a time lag. This time lag first made its existence felt when some patterns that ought to have been of first-century date were seen on articles that were plainly later, in Ireland. This created problems in relation to date. There have been hit-and-miss attempts at overcoming these problems, but something more positive is required. The alternative is to accept the existence of this time lag, and to live with it. But this in turn creates another problem: how long was this time lag? Even worse: was it variable?

Fortunately, now there are one or two sources of information that throw some light on the problem. One source is a little 'pattern book' or, more precisely, an antler trial piece with four facets, each facet bearing a pattern of some sort, which was found in what has been claimed to be a metalworker's transit camp at Dooey, in north-west Co. Donegal.[59] Amongst the designs recorded here are the multiple lozenge pattern, the chevron pattern, spirals both single and double, and an emasculated version of the sixfoil motif, a version most favoured by the Romans. All these patterns were common in Britain during the early Romano-British period.

The more important facets are illustrated in fig. 5:2 and fig. 6:top. Here are patterns and motifs which are represented on some of the zoomorphic penannular brooches, and for this reason they must be closely examined. One man's understanding of early Romano-British art patterns is faithfully recorded on this little trial piece, but we have to try to discover when that recording was made. Of importance is not so much how he came by these patterns, but when.

So far, this Dooey trial piece is the sole repository in Ireland of so many patterns popular in Britain during the first and second centuries A.D. If we take spirals first, double spirals similar to these can be seen on studs which were found at Corstopitum,[60] where they are recorded as being of second-century date. But this form of spiral was also known in the first

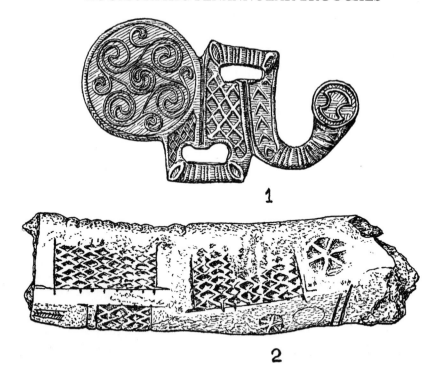

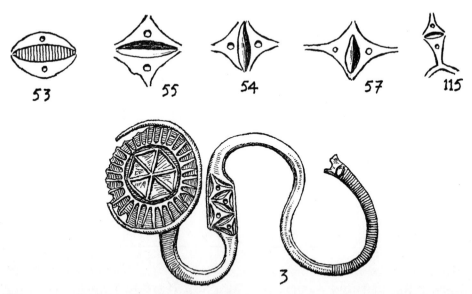

Fig. 5. 1, latchet, Dowris, Co. Offaly; 2, antler trial piece, Dooey, Co. Donegal; 3, latchet, Newry, Co. Down; 53, 55, 54, 57, 115, details taken from brooches bearing these numbers. (1 and 3 full size)

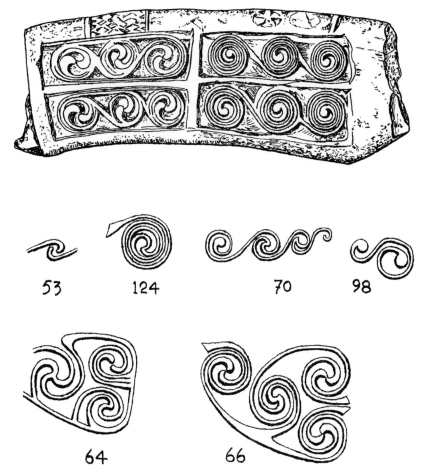

Fig. 6. Top, antler trial piece, Dooey, Co. Donegal. 53, 124, 70, 98,
64, 66, details taken from brooches bearing these numbers

century (compare the quadrilobe mount from Santon,[61] which is of mid-first-century date).
Next, the chevron pattern must also be of mid-first-century date (compare its occurrence on
the bronze bowl from Snailwell, Cambridgeshire,[62] which had been buried with the body
of an Iron Age warrior who had been killed a year or two after the Claudian invasion of
A.D. 43). The multiple lozenge pattern, much favoured by the Celts of Britain, and adapted
by them from imported art forms in early Roman times, is seen on many of the dragonesque
fibulae which were manufactured in north Britain in the second century A.D. One of the
earliest native-made objects bearing lozenges is the first-century A.D. horse-bit found in the
Thames at London.[63] A very definite link with Roman Britain is to be seen in the emasculate
style of the sixfoil motif, as it is represented on the Dooey piece. The petals are not petal-
shaped at all, but are straight-cut. This crude form of symbolism was much favoured by the
Romans: it is to be seen on Roman altars and tombstones erected by personnel of the Roman
army. For instance, it can be seen on an altar dedicated to the god VITIRIS by Tertulus at

Cilurnum (Chesters),[64] and again on a tombstone of Gaius Saufeius, a soldier of the Ninth Legion.[65] The Ninth Legion was at Lincoln some time after A.D. 47, where it established its base; but it is not mentioned in the Army List after A.D. 117. By the motif's appearance on these altars and tombstones one can sense some religious connotation, a sort of hallowed motif, and this feeling is strengthened by its appearance on antefixes, where representation is in the same style. There is a good example of an antefix, of Prysg No. 2 type, and bearing this motif, from Period 5 (A.D. 268–90) at Caerleon.[66] One of the Irish proto-zoomorphic pins was also found at Caerleon.

On balance it could be maintained that decorative styles, like those on the Dooey trial piece, are of second-century date in Britain. Yet, according to the record, the earliest appearance of the multiple lozenge pattern on an Irish penannular brooch is No. 93, which perhaps belongs to the third century. Spirals, single and not double, make an early appearance, but the chevron pattern had to wait for perhaps two centuries before its appearance is recorded. The sixfoil motif, in the form discussed, does not make any appearances on Irish brooches, but it is very evident on the Newry latchets, one of which is illustrated in fig. 5:3. Here this motif is superimposed on the 'sunburst' pattern. The sunburst pattern was popular as decoration on second-century disc-brooches, mostly in stylized form. A very good natural representation appears on a dress-fastener belonging to the second half of the first century.[67] Perhaps the earliest record of its appearance in Britain is on an imported provincial Roman bowl found at Snailwell.[68] It probably came from Gaul.

In an attempt to arrive at a suitable date for the Dooey trial piece, account must be taken of the fact that zoomorphic penannular brooches were unknown in Ireland before the late second century. Even so, none of the Dooey patterns is seen on any of the early brooches. They first appear on well-developed forms, which belong to a period of maximum productive capacity, and all belong to Group C. The suggested period is the third to fourth century. The trial piece itself came from Phase I at Dooey, represented by a sealed and stratified occupation layer, thought by the excavators to belong to 'the early centuries A.D.'.[69] The same occupation level yielded two toilet articles, probably Romano-British in origin.[70] Dooey was a workshop site, and crucibles and clay moulds, one for casting a different type of penannular brooch, with baluster-like terminals, were also found. It must be assumed that occupation of the site lasted for some considerable time, though Dooey has been described as a transit camp. There is no evidence here that will help with the dating of the trial piece; but the association with one another of all the motifs and patterns on this piece, and their comparison with others of a similar nature in Britain points to a third-century date. But some patterns are of first- and second-century date in Britain, so that it would seem that the time lag involved is of the order of a century to a century and a half.

Further light has been shed on the time lag problem in Ireland by the discovery of a silver proto-handpin of Irish manufacture in the territory of the Silures at Oldcroft, near Lydney, Gloucestershire.[71] This pin was found amongst a hoard of 3330 bronze coins, 11 of which dated before A.D. 330, and the latest was one of Julian (A.D. 354–9). There was also a siliqua of Constantius II (342–3) and another of Constans (348–50). The coins provide a secure *terminus ante quem* dating of A.D. 354–9 for the pin. Yet the decoration on the pin consists of a central much-stylized version of the palmette (fig. 7:d) with a lobe to each side, each lobe having a dot at the centre to give it an ornithomorphic character. This

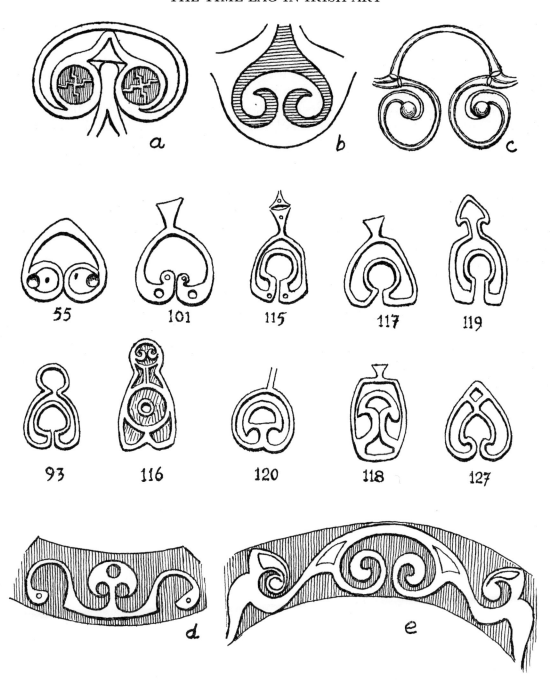

Fig. 7. Details from various objects: a, Battersea shield, London; b, horn-cap, the Thames at Brentford; c, the Cork horns; d, proto-handpin, Oldcroft, near Lydney, Glos.; e, terret, Westhall. 55, 101, 115, 117, 119, 93, 116, 120, 118, 127, some variations on a basic motif, suggested by b. (The numbers correspond with the numbers of the brooches concerned)

style of decoration is important in that it possesses a direct affinity with that on some of the terrets of the surviving early Iron Age in early occupation times in Britain, notably on those found at Westhall (fig. 7:e).[72] These Westhall terrets must have been buried at the time of the Boudiccan insurrection, in which case a time lag of 300 years is suggested. Obviously, this is unacceptable. A long survival period for the pin is indicated, seeing that it is of silver, and clearly valuable to its owner, which is the reason why he buried it with his savings. Possibly it was an heirloom. Allowance must also be made for its sentimental value.[73] One could allow for at least 100 years, or perhaps more, and the time lag might therefore be of the same order as that for the decoration on the Dooey trial piece, namely 150 years.

Since it is impossible to be more specific than this about the extent of the time lag, this period of 150 years may be taken as a working hypothesis. It must be apparent to all that this matter of dating Irish-made products, due to the absence of an historical background, is no easy one, and is fraught with difficulties, particularly when long survival rates also have to be taken into consideration. Some brooches are heavily worn, indicating long service. By the standards of those days, they must have been expensive items, and, if they belonged to chiefs or to people in high positions, would most likely have been passed on from one generation to the next. Another unhelpful factor is the lack of progression in Irish art. However, all in all, the style is Irish, and for that reason is easily picked out. It is perhaps a little odd that these styles took 150 years before they appeared in true Irish fashion, after being borrowed from the British, but this is the position, and it is something for which due allowance must be made.

ANALYSIS OF DECORATION

DECORATION is always ancillary. The attitude of craftsmen to decoration is well expressed by the discovery at Rathvilly, Co. Carlow, of twin brooches, found together, and alike in all respects (perhaps even out of the same mould); yet the applied decoration is totally dissimilar. Decoration supplements appeal; its application is an eye-catching exercise. But this does not mean that decoration is of no value: its value is judged chiefly on our ability to date it, apart from any aesthetic qualities which it might possess. Our ability to date decoration often puts it ahead of form, because whereas form might be of purely local character, decoration is more catholic. It is most likely to have inherited traits which are of extreme value to the research worker. The quality of the decoration is a very sure guide to the amount of imaginative effort put into a job by a metalworker, and it becomes a useful guide to the complexity and the direction of his outside contacts.

In Ireland, the scope for artistic expression was nothing like as great as it was in Britain. There were no horse trappings but bits, and these bore little decoration. There is a paucity of shield-bosses and horn-caps. In an heroic society like that in Ireland this curious state of affairs must be remarked upon. Yet there was no falling off of manufacturing competence, which makes the absence of real artistic effort all the more surprising. The scope of the Irish metalworker was therefore rather restricted, and his most profitable outlet must have been in pins and brooches.

As to motifs and patterns, their individual importance is reckoned by the rate of their duplication. First place goes to the stylized palmette, followed by the spherical triangle and the spiral. Chevron and multiple lozenge patterns are of rarer occurrence. They have been dealt with above, which leaves the stylized palmette, the spherical triangle and the spiral for further consideration.

THE STYLIZED PALMETTE

The reader has become familiar with this motif, by its occurrence on the Oldcroft proto-handpin. This representation on the Oldcroft pin is one of the smallest ever achieved; other representations are normally larger. Size, naturally, is governed by the physical dimensions of the object to be decorated. On brooch terminals there is a limitation of space, and sometimes this is rather extreme.

The naissance of this stylized motif is interesting. The development is set out in the drawings of fig. 7. Figure. 7:a is a detail taken from the Battersea shield; fig. 7:b is a detail taken from the horn-cap found in the Thames at Brentford. The latter varies markedly from the first. The horn-cap palmette represents the ultimate in stylization in Britain. Originally, the motif had been borrowed from classical sources, and this form of stylization as seen on the horn-cap is chiefly British; it is a form that even survived the occupation, for later it appears in openwork fashion on some of the hanging-bowl escutcheons, notably those from Castle Tioram in Moidart,[74] and there is even a mould for casting a similar escutcheon, which was found at Craig Phadrig, Inverness.[75] Another escutcheon having this same design in openwork is that from Baginton, Warwickshire.[76] This style had affected the decoration on the Westhall

terret (fig. 7:e) which in turn served as a pattern for an even more simplified version, that seen on the Oldcroft pin (fig. 7:d).

An early Irish style is that represented on the Cork horns (fig. 7:c),[77] a style that comes nearest to that represented on the Battersea shield. Similarities of style between the decoration on the Cork horns and on the Stichill collar[78] had already been noted. The Stichill collar is of first-century A.D. manufacture, and is one of a number of objects found in Britain displaying Irish influence. Incorporated with the design on the Cork horns is the Irish elongated trumpet, shown in C scroll fashion. The inturned ends of the palmette were fashioned into roundels with bosses at their centres. The decoration is cast on, just as it was in the case of the Bann disc. This is a highly specialized and difficult process, and one that was never mastered in Britain. Technically, the Irish metalworkers were far ahead of their British counterparts, experts in achieving fine detail by this difficult process, and which by any other means would have been impossible. Unfortunately, these skills did not outlive the first century, and appear to have been lost for ever.

These Cork and Stichill patterns are truly Celtic in character, yet they differ from the British style. A parting of the ways appears to have occurred at about the time the Battersea shield was made. Had this Irish development continued, it must have superseded all others for technical excellence. So why were these skills allowed to peter out in Ireland? There is no ready answer to that question; instead the general standard was lowered, and little was carried forward from a vigorous art movement. A few reminiscences of the old style can be seen on some of the earlier brooches, but, for the rest, the work is rather mediocre. The stylized palmette is about as simple a motif as it would be possible to devise — the ultimate in degeneration. It was permitted degradation, too; for finally it was allowed to break up into uneven circles and other meaningless meanders, having completely lost all significance for those practising a most degenerate art style (fig. 7:55–127).

THE SPHERICAL TRIANGLE

So named because in shape it resembles the central gap left by three touching spheres, the spherical triangle is of ancient Continental lineage. As a motif it tends always to remain aloof, never being mixed in with other forms of decoration, but occupying a position on its own, either centrally (as on the Witham shield boss) or within a circular panel, as on the hand mirrors. Also it appears prominently on sword scabbards of the early Iron Age, and on such objects as bridle-bits, notably those in the Polden Hill hoard. Its appearance in Ireland was comparatively late. Irish spherical triangles are easy to pick out, since most of them have a dot at the centre: more than that, they are normally paired. That these differences came about was due to confused thinking on the part of the Irish metalworkers: thinking it to be a spherical triangle, they misunderstood a pattern similar to one which decorates the handle of a mirror found at Nijmegen, Holland,[79] one of the latest in a series of British mirrors. This pattern appears in much reduced form on the terminal of a small and delicately made brooch which was found by George Eogan during the Knowth excavations,[80] where it is represented complete with dots (brooch No. 53 and fig. 5). The Nijmegen mirror belongs to the late first or early second century A.D.[81]

The sudden eruption of spherical triangles appears to have occurred soon after the intro-

duction of this British pattern. Imitating this pattern, they are represented in paired form, and the dots noted in the case of the design on the Knowth brooch were carried forward to the paired triangles. These paired spherical triangles are equally common on the latchets: that shown in fig. 5:3 is one of several found at Newry, Co. Down, where formerly a workshop must have existed. The people of Newry were in contact with the Caledonians via the old Group IX stone axe route, as suggested by the discovery at Newry of a Caledonian massive armlet. Massive armlets are considered to be of second-century manufacture, and probably late in that century. Further evidence of contact with Britain is to be seen in the two patterns on the latchet's disc, the Roman version of the sixfoil motif superimposed on the sunburst pattern. Both these designs are featured on northern metalwork and altars and tombstones of the first and second centuries A.D., though never in intimate association. On the latchets, paired spherical triangles are featured on a panel placed between the first and second loops. The latchet illustrated in fig. 5:3 also bears fine ribbing on the final loop. Ribbing such as this is to be seen on many of the early brooches. These similarities can assist in the dating of some of the Irish zoomorphic penannular brooches: allowing for the time lag involved, perhaps a date somewhere in the middle of the third century would be appropriate for all brooches bearing paired spherical triangles.

There is thus a feeling of persistent contact with Britain during the first half of the occupation. Naturally, these patterns, together with the massive armlet, could have been brought to Ireland by refugees, fleeing before the northern tribes at the time of the A.D. 196 disaster. This is a possibility, and if some of the refugees were also metalworkers, they could be expected to set up shop in Ireland.

The spherical triangle could have been a talisman. There is little else that can be said about it, and its subsequent history is somewhat clouded.

SPIRALS

Spirals do not figure largely in Continental La Tène art, neither are they of common occurrence in pre-Conquest Britain. Yet spirals have a respectable ancestry, for they appear at odd moments and in odd places. Nearer home, they can be seen on the fourth-century B.C. gold-covered disc from Auvers, seine-et-Oise,[82] and upon such objects as the bronze torcs from Prosnes, Marne.[83] Single spirals are easy to fashion, for they are nothing more than a diminishing circle. In Ireland, local variations occur: for in many instances the finials are swollen.[84] There was a liking for these swollen finials amongst the Irish metalworkers: almost every finial on the Turoe Stone has been treated in this manner.[85] The same can be said of the patterns on the Loughcrew trial pieces.[86] However, it is not so much that the finials are swollen, as what was subsequently done to them by the Irish; quite often they were hollowed out. At a quick glance, the hollowed out finial can be mistaken for a double spiral.

There are instances of these happenings on one or two of the zoomorphic penannular brooches, and similar hollowed-out finials can be seen on the disc of the latchet from Dowris, Co. Offaly (fig. 5:1). Double spirals also exist: some are represented on the Dooey trial piece. Also, there are double spirals on two brooches from the Athlone area (Nos. 66 and 67), and the Lough Neagh brooch (No. 70) has decoration consisting of a combination of both single and double spirals. In the majority of cases the technique of execution is not

expert: for instance, there are no spirals in Ireland which can compare with the spirals on many of the hanging-bowl escutcheons in Britain, either in execution or in layout. Possibly the cramped space available on the brooch terminals had an inhibiting effect on the craftsman, and this in turn affected the quality of workmanship. But the matter probably goes deeper than that; for technical ability is variable, from one workshop to another, with the best work coming from the Athlone area. On the Athlone brooches, triple spirals also make an appearance, and here the style is more in keeping with the British.

Irish spirals are difficult to date. It is tempting to make comparison with those on the hanging-bowl escutcheons, but this would imply contemporaneity, which is not the case. Most likely, the Irish spirals are earlier. The evidence is meagre in the extreme and, as is usual, one has to fall back on speculation. In addition, Athlone is far removed from the Saxon shore, and spirals similar to those in the Athlone area have not been seen in other regions of Ireland, either to the north or to the east. Contact with Britain at this period is therefore most unlikely.

ANALYSIS OF FORM

BECAUSE form is the visible aspect of an object, its tangibility leads primarily and automatically to its analysis. By this is implied shape, arrangement of parts or constituent pieces of a static form. But form is also transmutable. It is transmutable because no one is ever really satisfied with his handiwork, and dissatisfaction leads to modification. Many forms are the progenitors of others. Originality is rare; but sometimes intense development will lead to the production of an entirely new shape, which thereafter is copied extensively. This new shape must perforce be an Initial Form.

The zoomorphic form was one of these new shapes. It grew out of two ideas. The first productions were tentative, with no signs of maturity, and these are here labelled the 'Initial Form'. Once devised, the metalworkers set out to perfect it. The result is a series of brooches showing an amount of gentle experimenting with the shape of head, ears, eyes and snout, until a suitable standard, for purposes of production, was arrived at. However, none of these slight changes takes away from the fact that here was an Initial Form, representative of something that was new. Only when brooches begin to enlarge, or have something added to them by way of decoration, can it be said that the Initial Form has been left behind, outdated, and new groups begin to emerge. It is the old case of the senses tiring of one static form, and wishing to devise a few variations on the original theme. When each variation becomes constant, and is seen to be spread over several brooches, then these brooches form themselves into a separate group. Some of these variations express the likes and dislikes of individual metalworkers: one likes rounded eyes, another prefers them to be pyramidal. Sometimes these preferences have a regional flavour.

For all these reasons the most important single criterion is form. Form alone is basic to the requirements of typological sequences. And with form goes technique, sometimes equally important in its own way. Both vary, or are varied, according to personal whims, or to suit the demands of customers. Form is as clay in the craftsman's hands, subject to his skill as a tradesman, to the steadiness of his hand, and even to the condition of his eyesight. Deficiencies of eyesight must have played a big part in productive ability. This is evident in the case of brooches made in the Clogher, Co. Tyrone, factory. The brooches themselves may not be models of their kind, yet sometimes the decoration is so finely executed that none but a man suffering from excessive short-sightedness could have undertaken the work. Because of his disability, the craftsman's work can be picked out with little trouble. Modes of expression play their part. Grouping brooches together by these means constitutes a more satisfactory method than that adopted for the 1937 paper, in which decoration also played its part.

Geographical frontiers, apart from those of Roman Britain, are not clear, and are touched on only lightly in the course of the present study. There appears to have been a measure of unity in the Celtic world of the period under discussion, which was probably occasioned by the Roman presence. Only the Romans succeeded in putting up barriers, and even these may not have been as formidable as some would have it. The routes of contact are impossible to define, though the pre-Conquest contacts with Galloway may have been maintained to some extent. Points of egress or ingress are less important than the knowledge that the seas between

Ireland and Britain were crossed by coracles, and geographical bounds assume minor importance.

On the matter of productive skills, the Irish do not emerge as innovators. The technical advances made at the time when the Cork horns and the Bann disc were made had already been forgotten, though the reason why is not clear. But they were clever adapters and improvers: they took the Initial Form (from Britain) and they altered its form and appearance to suit local tastes. They added decoration. All the time they were most careful to maintain the zoomorphic form, and they nurtured it through several centuries of repetitive work. This long understanding is rather extraordinary.

The groupings which follow have been possible only because of the large number of Irish brooches which are known to exist. There are none for Britain, because the British brooches are few, and all belong to the Initial Form. But they do tend to show that there were only two areas of contact with the people, the first in the Lothians and the second in Wales and the southern Midlands. Many brooches, also of the Initial Form, which have been found in Britain are not British but of Irish manufacture. Today it is not enough to say that one brooch resembles another: minor details count for a good deal, and it is these which have influenced the groupings in the present study. It is realized that some craftsmen effected changes as an eye-catching exercise, to improve business. Sometimes the results are found to be less satisfying than in the case of the originals, and sometimes there is an urge to return to the original conception, or the form may be scrapped altogether. Every trader has to test public reaction, and sometimes this is found to be unfavourable. Craftsmen were therefore sometimes slow in making a move.

Most of the early zoomorphic penannular brooches are of slight construction; but, with the passing of time, they become heavier and therefore more robust. These changes may have been influenced by changes of habit. The size and weight of the pins suggests that the material they held together must have been homespun.

Geographical code names have been avoided since the centre of manufacture of each group is not always easy to determine. There appears to have been some opposition to the exchanges of ideas in Ireland, particularly with regard to decoration; though, in the case of form, some borrowings are evident. Some of these borrowings are of a local nature.

Finally, a word must be said about the retention of the term 'Initial Form'. In the 1937 paper it was used to represent a small bent-back terminal penannular brooch, then thought to be the ancestor of the zoomorphic form; now this term embraces all those brooches having terminals fashioned in a genuine zoomorphic form, from the time of its introduction up to the point where cast features, as opposed to hand-formed features, were first introduced. With this matter made clear, the usage of the term here cancels out any other implication which may be attached to it.

THE INITIAL FORM

The manner in which the Initial Form came into being has already been detailed above. This initial attempt was tentative at first, but gained in assurance with experience and the passing of the years, as is the case with most new designs.

Although there are both pins and brooches with zoomorphic heads or terminals, the

brooches alone show the early development of this new zoomorphic form. Pins belonged to an older tradition, which was proto-zoomorphic, and may therefore have been slower to alter. Now pins changed one type of head for another. It is interesting to note that only one known factory produced both pins and brooches, and this was situated in the oppidum of the Votadini at Traprain Law. In one way this is significant. The significance is in the fact that clearly brooches superseded pins. Pins are few and brooches are many. The whole new penannular brooch concept became popular, particularly with the Irish, and it retained its popularity for roughly four centuries. This is a long time, by most counts.

A brooch that assists in illustrating the transition to the full zoomorphic form is No. 1, which was found in the 'native' levels at Traprain Law.[87] Note the squared end to the terminal. Here, somewhat altered, are the essential features of the Isurium Brigantum bangle — the rounded flat head and its accompanying mouldings. On the Traprain brooch the end moulding has become divided at the middle. This division took place because the metalworker, to round off the head, had filed inwards from the end, instead of from the sides. But for this, the moulding would have been continuous. The snout is plain, and shaped like those on the proto-zoomorphic pins. It is possible that the hoop may have been ribbed all over, but this fact cannot be determined since its condition is poor. A more workmanlike job is brooch No. 2, from Longfaugh, Midlothian,[88] though the shape of pin-head here is less satisfactory than it was in the case of No. 1. But brooch No. 2 is a neater job, a more competent production, displaying a certain delicacy of feeling, particularly with regard to the shaping of the head. Here the double moulding representing eyes remains untouched. But the division at the centre of the outer moulding of No. 1 must have given the impression of ears; and the process is carried forward in No. 2 by rounding off the ears altogether. The new ear shape was less appreciated than was the original, because the filing of the head shape, by holding the file at an angle of 45° to the vertical, left a triangle of metal at the corners, and this eventually became the most popular form of representation for the ears. The snout is here foreshortened. Fine ribbing, divided into four bands by wide gaps, decorates the hoop. This form of divided representation became the norm for ribbing, though the pattern was not always strictly adhered to.

Initially, the head shape was round, in accordance with past practice. In the case of the earliest brooch from Ireland (No. 3), the specimen from the Ford of Toome, Lough Neagh,[89] the head is of this shape; but otherwise it shows a significant change of style — the eyes are now rounded, like the ears in No. 2. Perhaps this was intended to introduce a bit of symmetry into the design, but it barely succeeded because the snout upset the balance of the design. Snouts were kept short and level with the hoop until such time as somebody realized their possibilities as a pin stop. Then the snout tip was raised, and the pin-head became really captive. But this advance is still a long way off. The Ford of Toome pin-head is like that of No. 1, and there are few essential differences between the two brooches, except for ear and eye shape; so it must be assumed that the Irish were made aware of the new development in penannular brooches not long after the Initial Form came into being. This again brings up the matter of Votadinian relations with the Irish, which somebody should examine in detail.

Of the above three brooches, the Longfaugh brooch (No. 2) alone is datable. It was found near or in association with a Roman patera and a buckle. Savory discounts the association, and others have followed him. With the other two objects this was the type of small hoard

which was not uncommon in the south of Scotland — the Lamberton Moor, Berwickshire, hoard is another. These hoards must have been buried around A.D. 196 during the headlong retreat before the marauding northern tribes bent on revenge and destruction after the abandonment of the Antonine Wall. Even Traprain Law did not escape destruction, and the oppidum was abandoned for upwards of 30 or 40 years.

The nationality of these marauders has never been properly questioned: were they broch people? There are some significant acquisitions by them about this time, notably brooch No. 18, an early form, which comes from Aikerness broch, Evie, Orkney, and a small brooch, fig. 51:8, which was found in Okstrow broch, Orkney. This latter broch yielded fragments of a coarse Sigillata bowl of Form D.45, probably dating from the late second or early third centuries.[90] Similar pottery was found in the Midhowe broch,[91] from whence came a portion of a bronze ladle. Samian was found in the east broch on the island of Burray.[92] These finds, together with a trumpet brooch from Kirkwall, and bits and pieces of Roman beakers, bronze handles and the like, are significant, in that they point to a drift of Roman material to the Orkneys during a single period only, not to be repeated. The Aikerness brooch is very similar to No. 15, from Scotland, and it was undoubtedly made there. The presence of brochs south of the Antonine Wall at an earlier period[93] suggests that there must have been some amongst these people from the far north who were familiar with this territory; though not everybody will accept the idea of triumphant broch people returning north with the spoils of their incursions into the south. However, some explanation must be found for this one-period drift of Roman material to the Orkneys, and it is unlikely to have been in the course of trade.

No other event but the disaster of A.D. 196 could have had such repercussions throughout the northern province. The workshops were destroyed. This means that the most advanced form of brooch ever produced at Traprain is represented by the Aikerness brooch, and by another, slightly more advanced, from Pinhoulland, Walls, Shetland (No. 20). These represented the ultimate in brooch-making in Britain at the time the workshops were destroyed. This implied that forms not as advanced as these must be earlier, and none can be later than the end of the second century. These Aikerness and Pinhoulland brooches are representative of a stabilized form, though that form had not been stabilized much before the second level brooch from Traprain Law (No. 4) was made. Now the ears and eyes are like oblong or rounded mouldings at the four corners of the head, perhaps to balance out one another. The head only appears to be round; this effect was achieved by undercutting the metal to leave ears and eyes outstanding. In a sense this is an optical illusion, for the head appears round only when seen from above. The snout tip is slightly up-turned, a new development. At last the pin-head has assumed its true barrel shape, another indication of finality of development.

However, the finding of this brooch in the second 'native' level is not going to upset brooch chronology very much, neither will it take away from the importance of the second-century horizons, because dramatic changes had already taken place in the third, or Romano-British, level at Traprain Law. Brooch No. 5, from this level,[94] is matched exactly by a pin (fig. 1:8). This is a dramatic change in personality, for these are so utterly different, in that they are long-headed, rather than having the customary round heads, a new variation played on an original mature theme. Down the long axis of the head there is a medial line. Ears and

eyes are marked off at the corners, and the snout tip is slightly up-turned. The hoop is plain. The only parallels to this new form are to be found in the south Wales and Warwickshire areas, and in Ireland. There is an impressive likeness between No. 5 and a brooch from Minchin Hole, Penard, Glamorgan (No. 6)[95] and another from Stratford-on-Avon, Warwickshire (No. 7).[96] No. 6 has ribbing on the hoop, and so has No. 7, except that, in the latter case, that ribbing is divided into four bands. The pin-head of No. 7 is a bit primitive.

The discovery, in this area of south Britain, of forms that could have originated nowhere but at Traprain Law, has produced some odd reactions. Savory insists on a southern origin, and not before the fourth century. The reason for this idea is that the Minchin Hole brooch was associated with fourth-century finds. Yet its Traprain Law equivalent came from a Romano-British level that preceded the disaster of A.D. 196. Another northern import is brooch No. 8, from *Segontium*, (Caernarvon),[97] and of much the same period. *Segontium* has yielded some worthwhile brooches; in addition to the one quoted, there are 'small' brooches, one with terminals reminiscent of those of No. 8, with suggested associations that could put it prior to A.D. 200.[98] 'Small' brooches do not belong to the northern brooch movement, but are a British phenomenon confined mainly to Brigantia and that area near the mouth of the Severn. For what it is worth, the Porth Dafarch evidence, as read by Wheeler in his *Segontium* report, would confirm this early date, since the brooch (No.14) was found close to an occupation floor which yielded Roman pottery, including a piece of second-century Samian. But the Porth Dafarch brooch is Irish-made.

Leaving aside the 'small' brooches, considered below on their own merits, everything still points to a late second-century date for the beginning of this influx into north Wales and the Severn area of early brooches of north British and Irish origin; but so far as the northern brooches are concerned, the movement could not have lasted long, owing to the destruction of the northern workshops, in A.D. 196. This trickle to south Wales of Votadinian brooches is interesting, because it follows the same pattern as the trickle of northern dress-fasteners. There might have been a sympathetic link-up between the Votadini and the tribes in Wales. It will have been noted that both brooches and dress-fasteners carefully avoid the civil province, and the latter are found mainly in fringe areas. Of course, dress-fasteners pre-dated brooches by more than a century, and so many circular dress-fasteners have been found under conditions that date them by association to Flavian times.[99] It may be wondered if their presence in Wales indicated northern help for Caratacus, round about A.D. 51, when he tried to teach the Romans a lesson from his impregnable position in Wales, and if this association with the Welsh tribes lasted into the second century. Like the Votadini, some of the Welsh tribes remained unmolested by the Romans. But, apart from that, there is a suggestion of trouble in Wales in A.D. 169, by the burning of the Wroxeter forum, and by the debris of a conflagration found at Worcester. This built up to fresh trouble at the end of the century when Clodius Albinus crossed to Gaul. In such volatile situations help was likely to come from afar against the common enemy.

This is not so much a fanciful picture as one that has as background the events and incidents of the times. Trouble for Rome meant freer movement for the rebellious tribes, and the period towards the end of the second century, a period of weak defences, was the happiest of all for the natives. Even Irish foraging expeditions were stepped up at this time, as the coin evidence from Ireland suggests. But the outcome in the north was probably unexpected:

neither the Votadini nor the Brigantes could have foreseen the destruction by the northern tribes of their workshops and settlements.

Another outcome was that the liaison with the Irish workshops stopped, as from this moment. Henceforth, the Irish were on their own. The Roosky, Co. Roscommon, brooch (No. 9) must have been among the first of the Irish-inspired examples. It is a very fine brooch, of superior workmanship, and better than anything so far seen. But, whilst slightly heavier, nevertheless it owes everything, in the matter of design, to Votadinian inspiration. There is fine ribbing, divided into four bands, on the hoop, and the terminal details are in most respects similar to those of the Traprain Law brooches. But the terminals are wider, the ears are marked off diagonally at the corners, and both ears and eyes have dots at their centres. There is a medial line on the head, with dots on both sides. Dots are an Irish idea. In profile, the ears are cross-hatched. The snout is foreshortened, with up-turned tip, which also carries an inscribed line. The pin-head is well moulded, and the outer mouldings carry nicks. The pin-point is decorated, and there are hatched lines high up just below the pin-head.

This Roosky brooch introduces us to something different, the world of the Irish brooch-maker: different because it was untrammelled, the horizons wider, and, in an heroic society, it was a world of opportunism. The difference is reflected in the brooches, with additions of dots and other little bits of decoration, and these additions become more diffuse and eye-catching with the passage of time. The Irish were less sober than the British, but quick to take over an already developed form once the northern British workshops had been destroyed. From the third century, all brooches are of Irish manufacture; perhaps some were even made in the last years of the second century.

Already, the new pattern of snout, exemplified in the Roosky brooch, is a set form — the tip up-turned, a quick change from the traditional British form. Notable examples are the brooches from the Roman villa at Witcombe, Gloucestershire,[100] the brooch from Caerwent, Monmouthshire,[101] the brooch, used as a bangle, from Bifrons, Canterbury, Kent,[102] and the brooch from Porth Dafarch, Anglesey.[103] Irish brooches all and every one. Note the worming on the tip of the pin of the Witcombe brooch (No. 10), which is similar to worming on the tip of the pin of the Caerwent brooch (No. 11), which can be paralleled by the worming on the pins of the brooches from Knowth (No. 53) and from Limerick (No. 17). This worming also appears on the pin of a brooch with enamelled terminals found at Abingdon, Oxfordshire (No. 25), which can be paralleled by a slightly larger brooch from Armagh (No. 26), also with enamelled terminals; and the pin-head of the Armagh brooch (No. 26) exactly resembles the pin-head of the Witcombe brooch (No. 10). The transverse parallel lines on the Witcombe brooch pin are similar to those on the Armagh brooch pin. Parallels of this nature are sufficient indication of the origin of those brooches found on British soil.

The up-turned form of snout seen on the Roosky brooch is another distinguishing feature of Irish-made brooches, some found in remote areas, like the badly-preserved specimen from Maghera, Co. Donegal[104] (No. 12) to those found on British soil, like the Caerwent and Porth Dafarch brooches. These are not the sole Irish objects found in Britain, so that resistance to this claim can be lessened by the thought that Irish horse-bits were included with the Llyn Cerrig Bach hoard,[105] and others are known from Worcester and Devon.[106] However, it is unlikely that there is any link between horse-bits and brooches: in Ireland the two

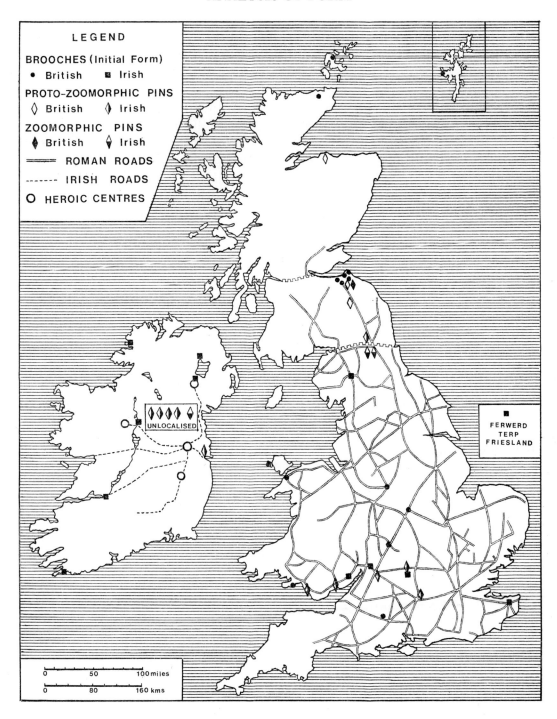

Fig. 8. Map showing distribution of brooches of the Initial Form, and also zoomorphic
and proto-zoomorphic pins

distributions are dissimilar. On the other hand, plain brooches of the Initial Form are in general distribution over most of Ireland (map, fig. 8). This is an interesting situation, because it indicates freedom of movement over most of the country, and an ability to penetrate into Britain; two brooches even got as far as Holland. This freedom of movement was achieved by no other group.

A curious feature of these finds is that many come from Roman sites, including forts. Irish products had found two areas of ingress, one near the Wall, the other through the territory of the Silures in south Wales. The known areas of Irish settlement, in Pembroke and the Lleyn Peninsula, have not yielded a single zoomorphic penannular brooch, or even a pin, but these may have come too late, for it is known that the Pembroke settlement was not enlarged until A.D. 275. Since these settlements in Wales had a long history, it must be assumed that both the pins and the brooches got to south Wales before the Irish had got a firm foothold in Pembroke. And since everything points to a period of unrest as being the most likely time, it must be assumed that there was probably a minor *barbarica conspiratio* at the moment when the defences were at their weakest at the end of the second century, and that the Irish were aiding the Silures. There were Cruithin in Galloway, with close relations in Down and Antrim, so that there were friends here, just as there were in Wales.[107]

As to the brooches themselves, it is now noted that a certain standardization of form has crept in; in particular, the terminals of the Caerwent and Bifrons brooches are identical, and so would Porth Dafarch have been had it not been badly finished. The Bifrons brooch had seen service as a bangle, and it was found in a Saxon grave of *c.* A.D. 500. However, that bit of history is ancillary, and has no bearing on the present argument.

An identity of pin-heads is noted in the cases of brooches Nos. 16 (no locality) and 26 (from the neighbourhood of Armagh). The style seen reflected in the Witcombe pin-head is repeated in these two specimens. Brooch No. 16 is of masterly appearance, great care having been taken with the finishing processes, particularly with the delicate mouldings of the pin-head. The style of ears and eyes is reminiscent of No. 3. Head shapes are becoming elliptical, and in this respect there are four brooches (Nos. 11, 13, 14 and 16) with a common head shape. Details such as these are important, in that they indicate contemporaneity of thinking.

Most of the variations noted have been the result of Irish initiative. The current trend should be compared with the final thinking in Britain. No. 15 (no locality, but found in Scotland) is a brooch of this period. The chief modification noted is the rounding of the snout tip, making it almost bulbous. The remaining features are unaltered. The hoop is plain. The head form is still in the initial evolved style. Strangely, this brooch can be paralleled only with one from Limerick (No. 17).[108] This latter brooch (now lost) is a rather delicate affair, with light-weight hoop and pin, probably the chief reason why the hoop broke (it has been rather clumsily repaired). There is a fine feeling for line throughout, the pin-head has been fashioned with delicacy, and, whilst by no means exceptional, the moulding of the pin-head has been well carried out. There is a saltire on the pin near the head, and worming near the pin point. There are three small bands of ribbing on the hoop. With this style can be coupled the brooches from Aikerness, Evie, Orkney (No. 18)[109] and another from Pike Hall, Derbyshire (No. 19). Although the Limerick brooch is Irish made, the liaison with Scotland was still in being. The British brooches are getting heavier, more robust, at this stage, and

this tendency affected Irish production. In all cases the snout tips are bulbous, and this is their main distinguishing feature. Had the northern British workshops not been destroyed, it is possible there would have been a parallel increase in size and weight in both countries. The ultimate for Britain is brooch No. 20, from Pinhoulland, Walls, Shetland.[110] With this brooch we are introduced to a further development, the medial ridge on the snout. There was a suggestion of this in No. 18, and it was probably intended as relief for an otherwise plain snout. It was an idea that persisted in Ireland for a very long time. But pin-head style is still unbalanced, with weight at the top, and a thin, short pin below. The Oldbury, Wiltshire,[111] pin-head is another. The terminals of this brooch show a falling off of ability, and the general technique is poor, with debased snouts and eyes. It is possible that this specimen and the next from Leicester[112] are both copies, the Leicester brooch in particular being a somewhat hideous attempt at imitating the zoomorphic form.

The British brooches all have short pins. Their length is slightly in excess of the diameter of the hoop. In Ireland the pins were very soon lengthened, until ultimately the pin-length is double that of the hoop diameter. In Ireland, also, dramatic transformations led to various forms of elaboration, both with line and with enamel. The movement began with the Irish response to the medial ridge on the snout, referred to above, which was triangular in section, with sharp edges above and below, giving a pelta shape to the snout tip. Otherwise the terminal form is essentially the same. Another new feature to emerge is the chased capital N design on the reverse sides of the terminals. This was a sort of Irish trade-mark which remained in use for some time, cropping up from time to time on brooches of later groups. Brooch No. 23 (no locality) possesses all the features discussed above. The pin-head is nicely moulded, with decorative nicks on the pin. A curiosity is the worming of the hoop forward of the snout tips, and the ribbing is somewhat haphazard.

A more stable and better form is that of brooch No. 24, from Kirkby Thore, Westmorland.[113] It is possibly contemporary with the last brooch, but here there is overt superiority of style and manufacturing care. The pin-head has a delicacy of outline combined with strength; the terminals are faithfully similar. All features are sharply defined and fashioned with precision. The hoop is plain. On the reverse sides of the terminals the capital N pattern has been chased on. The association of this brooch with the Roman fort of Kirkby Thore (*Bravoniacum*) is interesting. Kirkby Thore was a town that never lost its military connection, but nevertheless became a thriving centre for trade, relaxation and eventual retirement. Any one of these advantages which the town possessed would have been sufficient to tempt a third-century Irishman to tarry. But how would he have got to the town without local help?

Plain hoops have dominated the scene. Hoops tended to go plain in the early stages, when ribbing, which had been common to most of the early brooches, went out of fashion, temporarily, with the Roosky specimen. But now a brooch which in most senses is parallel with No. 16 is No. 25 from Abingdon, Oxfordshire;[114] its hoop is well covered with finely executed ribbing, in the normal four bands. The same hand probably made this brooch and No. 16, and both are of about the same period. But the real step forward is in the enamelling of the terminals, an entirely new departure. The pin-head is less satisfying than that of No. 16, but it is well moulded none the less. These features, including the Abingdon form of pin-head, are included in the make-up of the next brooch, No. 26, from the neighbourhood of Armagh.[115] Here is the same handiwork; but now the snouts are enamelled as well.

Once the desire for more exotic forms arose, the days of the Initial Form were numbered. Enamelling, or any other type of decoration, demands space. The Initial Form did not have it. An attempt had been made in the case of No. 26 to overcome this disadvantage, and this is why the overall dimensions of the brooch show an increase. This desire to utilize enamel may have resulted from contact with the brooches of Group B_1. The application of enamel to the terminals of brooches like the Abingdon and Armagh specimens, essentially of the Initial Form, was equivalent to the last throw of the dice by an overt gambler. Up till now, each terminal, its eyes, its ears, its head and snout, had been hand-trimmed. Now a new technique makes itself apparent, the technique of casting all these features, and hand-trimming was cut to a minimum. The early results were not very good, as can be seen in the case of No. 27 (no locality), a plain brooch with barrel-shaped pin-head. The misshapen features are due to bad casting, or a lack of skills in pattern-making. The sole mode of trimming was to file the terminals flat, thereby emphasizing the imperfections of bad workmanship.

The new process opened up a whole new field in brooch-making. Casting was more suited to larger, more robust forms: there is no evidence for the casting-in of zoomorphic features in Britain, so that the new departure must have been an Irish innovation. The changes resulting from this innovation are evident in the brooches of Groups A_1 and A_2.

Brooch No. 28 is a small one of the Initial Form which was found in a bog at Rathruane, Parish of Schull, Co. Cork. There is no obvious relationship with any other brooch. The terminals have been filed flat, then the features of ears, eyes, and snout were formed by the use of a small sharp-edged file. The pin-head is a little primitive. Altogether, a rather frail little brooch that may date from the same period as No. 27.

GROUP A

THE brooches of Group A are plain. They are a direct development from the Initial Form. But, although the distributions of both are not dissimilar, there is now a noticeable tendency for the brooches to congregate in the central belt which stretches from Galway and Mayo in the west to the eastern seaboard. One brooch got to the Isle of Mull.

There are two distinguishable series within this group. The distinguishing feature in both cases is eye shape; in the one series they are pyramidal, in the other they are rounded. This divergence of eye shape represents a new departure in brooch-making; it is also sufficient to show that more than one hand was engaged in making them. This probably means that there were two workshops: the first was perhaps situated in central Ireland, whereas the second was situated nearer to the east coast.

FIRST SERIES, A₁

Some of the earliest brooches in this series have points in common with some of those belonging to the Initial Form. But there is a marked change. Snout and head generally are now of equal length, which gives to a narrow terminal an elongated appearance. The most obvious feature of this first series is the pyramidal shape of the eyes: they stand out midway along the length of the terminal. One is reminded of crocodile's eyes. When studied together, these brooches will be seen to bear a strong family resemblance, one to the other. The distribution map (fig. 9), suggests that the workshop is most likely to have been in central Ireland, perhaps not too far from the Shannon.

Seemingly the earliest brooch is No. 29 (no locality). It is not very different from some of the brooches of the Initial Form, except for the curiously shaped and cast eyes, and there is an increase in the length of the snout, with a bulbous upturned end, the tip of which is about to come in for a considerable amount of development. This curious eye shape is very suitable for casting, and the fact that it is cast may have, in some measure, influenced its shape. The brooch itself is a simple enough form, as befits a casting. The pin-head shape is a little reminiscent of that of the Armagh brooch of the Initial Form. In the present series, pin-heads soon settled down to a standard pattern, which was repeated all through the series, although there was some carelessness with regard to shape in the later specimens. No. 31 is a good representative of this standardized pattern; but by the time No. 36 was made the shape was losing its importance, and the outcome of this careless approach can be seen in No. 38. There is virtually no shape to this pin-head.

Brooch No. 30, from Co. Longford, is little different from the first, except that it is larger, and the pin-head has become compressed sideways into very nearly its ultimate form for this series. There are also signs of movement in the snout tip: there is about to be a dramatic upturn to it. The metalworker has just discovered that snout tips make a convenient stop for the pin-head. The result of this thinking is clearly seen in the case of brooch No. 31, from Toomullin, Co. Clare.[116] Terminals are growing, too. There is a marked medial ridge on the snouts. It is curious that, although the eyes have been cast with such precision, the metalworker was content with ears represented by chased or filed lines across the squared corners.

This might appear to be a crude method of representing ears, but it might have been a question of balance: prominent ears would have added a clumsy touch to the design as a whole.

An increase in terminal size means an increase in weight. Perhaps as a weight-saving idea, the terminals will now become thinner at the squared end. This was achieved by hammering out the metal: hammering 'spreads' bronze, which is why terminals are splayed, being widest where they are thinnest. The whole process was carried to extremes in the case of No. 34, and the large plain brooches of Group B. Brooch No. 32 (no locality) shows the process under way: it has a stout appearance, and the increase in terminal width has been rapid.

Fig. 9. Distribution: Group A₁ brooches

This is an interesting brooch: it began by being plain, but later somebody decided he wanted enamelled terminals. The right-hand terminal is untouched; but in the case of the left-hand terminal, a continuous line has been chiselled round the head, on its upper surface, in preparation for undercutting. The snout has been undercut in two places. This undercutting was for the purpose of providing a sunk base for the enamel. This is valuable evidence, since it shows beyond doubt how the metalworker set about applying enamel to the terminals of brooches.

The Derryhale, Co. Armagh, brooch (No. 33) is a tidy specimen of its class, and the quality of the moulding comes out in the fine details of the terminals. The feeling for line is evident also in the pin-head. Whilst terminal widths may vary, and in fact do, the cause is not so much intentional as brought about by the amount of hammering to which each terminal was subjected. The head of No. 34 (no locality) is wider because the metal here is thinner. Otherwise there is a marked similarity between these two brooches, and indeed between these and those that follow, because essentially the design is similar. But, as happens with constant repetition, the quality of workmanship tended to deteriorate. A steady if slow deterioration is noticeable from the moment brooch No. 35, from Ballyglass, Co. Mayo, was made, with its rather elongated heads, and the careless marking off of the ears, which is the last occasion in which this feature will be seen in this series. The pin-head of No. 36, from

the Isle of Mull, Scotland, also bears signs of this carelessness, which becomes more marked in the case of brooch No. 37 (no locality). The worst brooch in this series is No. 38, from Co. Kildare, and here even the poor quality casting has been left untrimmed.

There are now evident signs of boredom. This does not mean that the workshop went out of business. But this design of brooch was obviously losing its impact. Strangely, the next two brooches show a slight improvement all round. The pin-heads of Nos 39 and 40 are identical. No. 39 comes from Belleisle, Co. Fermanagh, but No. 40 has no locality. The terminals and hoops are similar, so it may be inferred that both came from the same mould. However, as brooches they would excite no one, being simple productions made with the minimum of effort.

It seems clear that these brooches of the A_1 series are of third-century A.D. manufacture.

SECOND SERIES A_2

When compared with the first series above, the innate differences noticeable in the brooches of this second series are three-fold: clumsy design, rounded eyes, and pronounced upturn to the snout tip. All three characteristics are common to all the brooches making up this series.

Brooch No. 41, from Co. Waterford, is a typical example. It is clear it was made shortly

Fig. 10. Distribution: Group A_2 brooches

after the last series had ended, perhaps in the fourth century. Everything about these brooches indicates careless manufacture. Their most characteristic feature, the bulbous upturned snout, varies in shape from brooch to brooch, and the eyes, so often of ill-matching proportions, are frequently off-set. Ears are carelessly indicated, and the technique of representation again varies from brooch to brooch. In No. 41 all these shortcomings are clearly noticeable, particularly the ugly bulbous snout tip. No. 42, from Mullingar, is only slightly less crude. The eyes are narrow ridges, but the snout tip is of more acceptable proportions, whilst the pin-head shows that a slight revival of interest has taken place in the barrel-like moulding, which is a nicely balanced design, and it is even better in No. 43, from Co. Mayo. Pin-heads tended to occupy the minds of these craftsmen, as will be seen later.

But, even if there are small differences between these three brooches, their close relationship is obvious.

Of course, no two hand-made products are ever identical, so that discussion of minor details relating to differences makes for dull reading, and serves no useful purpose. An analysis of minor details is unnecessary, when the family relationship is clear. But changes in technique are of interest, as with No. 44 (no locality) in which, for the first time, the feature known as the ear has been cast in, instead of being chased on as hitherto. Otherwise the brooch is similar to the last specimen. The next one, No. 45, which comes from Co. Donegal, has similar ears, but now the head is hollow, to save weight. The pin is modern. Brooch No. 46, from Schull, Co. Cork, shows a new departure from the norm: the terminals are filed flat, from the ears to the snout tip. This may indicate a reaction against the shoddy workmanship seen in Nos. 47 and 48 (both without locality). This filing did not add any degree of refinement to the design. But it put emphasis on the ears, which are now about to disappear. The prominence of the ears was an embarrassment to the design as a whole, so that ears, as a feature, were omitted from all future productions. A transverse line was chased on the highest part of the snout tip, perhaps in an attempt to attract attention away from the ears.

The filing of the terminal heads also entailed filing of the medial ridges on the snouts, to maintain an even plane. The result was that the snouts were given a sort of three-faceted appearance, as can be seen in the case of No. 49, from Drogheda, Co. Louth. The same is true of all subsequent brooches, but filing stopped short of the snout tip, because this had a functional purpose. This filing emphasized the brooch's plainness. Perhaps the craftsman felt the impact of this, for he made a brief attempt at adding some interest to the pin-head, by giving it two channelled lines. This attempt was followed by others, leading to a sudden outburst of decorative skill, not devised, but borrowed from elsewhere. There was a temporary pause in the case of the Longford brooch (No. 50), a nice conservative specimen, but the final plunge was taken with brooch No. 51 (no locality), with its ornate pin-head, which looks slightly experimental, but may have been badly copied from elsewhere. The whole idea heralded a change in style, from the strictly plain to the ornate. Apparently it was this craftworker's last throw, for, whilst No. 52, from Ballintore, Co. Kildare, is a most creditable brooch, there are no more in this tradition. But this man had by now come in contact with other productions from other workshops, copying criss-cross and herringbone patterns, which he mixed with traditional ribbing on the hoop. A very sure touch is evident in the case of No. 52's pin-head; this style, coupled with the lentoid petal decoration on the terminal sides, and the insets of millefiori in a bed of red enamel all lead to the conviction that this craftsman was borrowing heavily from other traditions.

Two hands appear to have been involved in the manufacture of these brooches; the first up to No. 46, and the second craftsman's efforts are represented by No. 47 onwards.

GROUP B

ALTHOUGH zoomorphic penannular brooches are quite rightly regarded as being within the range of products made by Celtic craftsmen, nevertheless very few are decorated with typical Celtic art motifs. This is perhaps a somewhat curious situation when it is seen that in many instances craftsmen were searching for suitable decoration for the embellishment of their brooches, but having to do with a lot of meaningless circles and so-called designs which make it clear that the Celtic art tradition was a long way off, even out of reach. The few motifs and patterns that remained were jealously guarded by the few.

The traditional art areas had always been those inhabited by the Soghain and the Cruithin. The former lived in parts of the present counties of Galway and Roscommon, on both sides of the river Suck. Others of the same tribe lived in Meath and Monaghan, and there were colonies at Bantry and in the Muskerry country which lies to the west of Cork city. The Soghain were in possession of their midland territories until they were displaced in the fifth century A.D. by the Sept Ui Maini.[117] From the territories of the Soghain come such well-known examples of Celtic art as the Turoe, Castlestrange and Killycluggin stones, the Loughcrew trial pieces, the Cork horns, and the Lough-na-Shade trumpet. The Soghain, who have been described as 'the ancient kin of the old plain', therefore possessed an art form that was very old, very strong, and, from the quality of the productions, very pure. The Cruithin (Picts), cousins of the Soghain, had autonomous territories mostly in eastern Ulster, there being at least seven (and perhaps nine) petty kingdoms, which existed as late as A.D. 563. These territories stretched from Dundalk Bay to the mouth of the river Bann, and there were offshoots of these people in Kildare/Laois and in Galloway. Within their territories they had Lisnacrogher, the find-spot of the Bann disc and the Newry workshops, responsible for latchets and the like.

It will therefore come as no surprise to discover that Celtic art motifs are confined to brooches which come from Soghain territories. By the time these brooches were made, this artistic tradition was a lingering one. It was one that persisted after the rupture of liaison with the north British. Clearly, two workshops are involved: one, the earlier of the two, could have been situated in the Meath area, whilst the later workshop was somewhere on 'the old plain of the Soghain'. The brooches produced by these workshops are worthy additions to the long list of outstanding works produced by the Celts: the standard of workmanship and general finish is far above those of any other group in Ireland.

FIRST SERIES, B₁

This series of brooches is that made by the older of the two workshops.

The first brooch is a frail specimen which was found in a pre-Christian deposit at Knowth, Co. Meath (No. 53).[118] It is an early brooch, as may be judged from the small size of the terminals, and the general overall lightness of its construction. It should be compared with No. 15 of the Initial Form, and possibly it dates from about the same period, the end of the second century A.D. This date is fairly well confirmed by the decoration on the snout of the left-hand terminal, to be discussed presently. Being of early form, both terminals are slightly

oval, as befits a late second-century type. There is a slight resemblance to the Roosky brooch terminals, even to the dots on the ears and eyes. The decoration on the right-hand terminal consists of nothing more than an oval of red enamel. On the left-hand terminal there is a primitive looking double spiral on a red enamel background. If the execution of this spiral leaves something to be desired, the reason is not hard to find — the amount of space available. The lack of success here probably prompted the plain enamelled terminal to the right.

The main point of interest here is in the decoration on the left-hand short, upturned snout, again an early form. The superimposed pattern is a miniaturized version of a similar one which appears on the handle of the mirror from Nijmegen, Holland.[119] The confusion that attended the introduction of this pattern into Ireland has already been discussed.[120] Clearly, the time-lag factor is involved here, for the mirror is of late first-century date, whereas this brooch must date from a full century later. This time-lag factor is one of the most disturbing features which have to be taken into account when dating Irish art objects. Later, the gap widens even further, as discussed above. However, the connection with the Celtic art of Britain is clear, and the Knowth representation appears to be the only one so far in Ireland. Later, the pattern was misconstrued, being mistaken for paired spherical triangles, of which there was a sudden rash on brooches and latchets for a short period. Other decorative points worthy of mention are the grooving on an otherwise plain pin-head, and the close ribbing, in three bands, on the hoop. The brooch's guaranteed Irish feature is the worming near the pin point.

Dots were much favoured by the Irish metalworkers of the third century. They appear profusely on the terminals of the Roosky and Knowth brooches. But the ears of brooch No. 54, from the river Greese, Co. Kildare, have hollowed out centres for enamel. This is a sturdier brooch, with enlarged terminals; but the snout is still of the upturned short form, and common to the Initial Form. This brooch may not be very much later than the one from Knowth. But now spirals have been dropped; in their place are paired spherical triangles, obviously a throw-back to the pattern on the left-hand terminal of No. 53. Single spherical triangles occupy triangular recesses filled with enamel on the snouts. All these spherical triangles have dots at their centres. These motifs are basic. The general design was quite attractive when seen against a background of red enamel. The disappearance of the art underground in Britain was beginning to have repercussions in Ireland. Local inspiration could not be prevented from drying up, leaving nothing but a conglomerate residue of patterns that most people failed to respond to. But not so the metalworkers of this workshop and the next, who still had a few surprises up their sleeves.

On the reverse sides of the terminals of No. 54 is the saltire, which from time to time appears on different brooches, but is nevertheless a marked feature of this series. The pin-head form again belongs to the Initial Form, being most like those of Nos. 10, 11 and 16. The inner mouldings have been angled to give a wedge form to the top of the pin. Ribbing has virtually disappeared from the hoop.

What remained, of course, was the divisions between the normal form of ribbing, reversing the procedure elsewhere. The idea is pursued in the case of brooch No. 55 (no locality), but here a sort of ladder pattern has been used. In addition to its appearance on the hoop, this ladder pattern is used to decorate the pin-head, and it appears transversely on the snouts, and has been applied to the reverse sides of the terminals in the form of a saltire. This

pattern had a short life, and disappears after its representation on the next brooch. But spherical triangles are to remain in favour for a while. On brooch No. 55 they have been used (in paired form) as decoration for the snouts. Decoration on the terminal heads is dissimilar, though in both cases of an ornithomorphic character. On the right-hand terminal head there is a single spiral with a finial swollen in the form of a bird's head. These birds' heads are repeated on the left-hand terminal head, but now there are two, and they occupy positions at the ends of a capital U, or maybe the design is a reflection of the simplified palmette. The centres of the eyes have been drilled out for enamel. There are dots at the centres of the spherical triangles. A saltire, or plain cross, appears near the pin point. The pin-head is an evolved form, and an advance on No. 54. Lastly, there is vertical hatching on the ears when seen in profile.

Fig. 11. Distribution: Group B_1 brooches

Saltires have been elevated almost to the status of a trademark in the present series. Once more they appear on the reverse sides of the terminals of brooch No. 56 (no locality) another specimen very much in the same tradition represented by the previous three brooches. It is notable that in every case, the terminals are of an early form. The perseverance of this form, in the hands of skilled craftsmen, without any attempt being made to advance the style, is indeed amazing. Although all component features of the brooch as a whole have become bigger, a constant ratio has been maintained. This survival of an early form was probably due to the whim of one man, but his preference ceased with the present brooch. With experience had come a penchant for sinuosity: note how the eyes resemble a piece of paper folded back upon itself. The whole head consists of a series of flowing curves, and some of this fancy has been extended to the decoration, which, presumably, is based upon the simplified palmette. Spherical triangles within triangular hollows decorate the snouts, still short, but not too upturned. There is a movement here towards a breakdown in the artistic tradition, which in eastern Ireland seems to have led to a complete breakaway. No art can

survive these tendencies here, and right enough it did not. Dots had been omitted from all features on the obverse sides of the terminals: they appear only on the reverse sides, and then only in threes, like shamrocks. The so-called ladder pattern is also represented here, and it appears again on the pin-head mouldings. This pin-head lacks feeling, and it contrasts strongly in that respect with the brooch as a whole. The hoop carries closely spaced ribbing, every sixth one being omitted to make a gap between small bands. This must have been a local idea, for it was never repeated.

Examination of the dots shows that they were applied by means of a hollow punch. This fact indicates a considerable advance in tool-making, as well as in metallurgy.

At this point there was a complete breakaway from the then current form. Its place was taken by another most typical of third-century brooches. Clearly two hands are represented by the two collections of brooches; but the second did not possess the skill of the former. The change is so dramatic as to suggest that two workshops were involved in their production; but this thought has been ruled out for two reasons: the pin-head form last seen in No. 55 is retained for the first of the new brooches, No. 57, which comes from the Ford of Toome, Lough Neagh,[121] together with the pattern of paired spherical triangles as decoration for the terminals. Another survivor is the saltire, here appearing on the reverse side of the pin-head. The second reason is based on the fact that brooch No. 60 was found in a site where the same tradition was still strong.

The quality of workmanship is not what it was, though still competent. The new style must have had a short history, because there are not more than four brooches, and all, with monotonous repetition, have precisely the same terminal decoration, which is the paired spherical triangle. In the case of No. 57 these have dots at their centres, but the rest have none. There is steady deterioration in the quality of artistic effort: in the case of brooch No. 58, from Blackrock, Co. Louth,[122] the dots have been omitted from the spherical triangles, and the ribbing which is represented on No. 57 in the form of four bands, widely separated, is here crudely scored on the hoop for short distances from each terminal snout. As a result, the hoops of Nos. 59 and 60 are plain. The Killoughy, Co. Offaly, brooch (No. 59) is about as plain as any enamelled brooch could be expected to be. Brooch No. 60, from King Mahon's Fort, Ardagh, Co. Longford, [123] is very similar, except for two small points: the terminals are here hammered thin, and the paired spherical triangles have lost their impact, and are breaking up. Of greater importance is now the eye-shaped central enamel filling, so that the whole emphasis in the representation of patterns is changing.

King Mahon's Fort was a minor heroic centre, and as such its history may have ended at much the same time as did that of the other great heroic centres, about the middle of the fifth century. However, brooch No. 60 is considerably earlier than the fifth century. It was found in a very thin sealed occupation level at this fort, and from this same level came an ibex-headed pin. Ibex-headed pins are early. One was found at Dunfanaghy, Co. Donegal,[124] in the same dark occupation level that produced a first-century Roman brooch.[125] These pins are not Irish; rather are they British. Stevenson thinks the type may have had its origin in Scotland, but suggests a fourth-century date for it.[126] A re-think is called for here. In fact, ibex-headed pins are as unreliable a guide to date as are the brooches themselves, the main cause being their longevity. However, on aggregate, ibex-headed pins are more likely to be early than late, making Stevenson's fourth-century date unacceptable. Presumably, ring-

headed pins, projecting-head pins, ibex-headed pins and their like antedate the hand-pins, many of which bear decoration that can be paralleled on the brooches.

Can it be said we are any nearer to dating brooch No. 60? There was a metalworker's shop at King Mahon's Fort, as indicated by the finding here of crucibles for pouring metal. Somehow it seems unlikely that the brooch would have been made here, for the distribution of this series has an eastern emphasis. In loose filling there was found part of an armlet (?) decorated with a circle of enamel, at the centre of which is a pattern made up of three linked triskeles, all interlocked at a common point in the centre, thus forming a central triskele as well — a similar pattern can be seen on the Kingston hanging-bowl escutcheon, and in Ireland on the Lambay scabbard mount, in openwork form. This pattern would therefore be an unreliable guide to date. All that can be said is that it proves the existence of a continuing tradition in Celtic art in Longford during this darkest period of the protohistoric age. The fort itself is unlikely to have had any actual association with King Mahon: in Liam de Paor's view, the ascription is likely to have been a later one, to give added importance to this site.

As a general guide, the history of the present series of brooches probably started in the late second century, and lasted for much of the third century.

SECOND SERIES, B₂

The homeland of this second series of Group B brooches is the old plain of the Soghain. This workshop began operation in a traditional enough manner, then broke away to produce a series of extravaganzas, never equalled elsewhere. Brooches were both decorated and plain. The final productions, of eccentric proportions, are plain enough from every point of view. They are also the largest brooches made, and were intended for mass production, two identical specimens having been found. This workshop must have gone in for quantity production of decorated brooches as well, for there are two exceedingly fine specimens which are in every respect identical. Here also the Celtic art tradition lived on in its later outcome, spirals, here arranged in triskele pattern. The toolwork is latterly first class.

Brooch No. 61, from Belcoo, Enniskillen, Co. Fermanagh,[127] is out of the traditional mould, with plain hoop and expanded terminals, the heads of which are decorated with triskeles on a background of red enamel. The snouts, with their bulbous tips, are also enamelled. But there is a breakaway in the pin-head form, which has some unusual qualities: it is heavily grooved, and this gives a sort of corrugated effect to it.

The triskele, as here exemplified, is tentative, but it is about to start a fashion. The ends of the arms have been expanded; soon these will be twisted into spirals, albeit simple ones at first, but later these develop into doubles. The Irish double spiral emerged because the inner finial became swollen, and later these swollen finials were hollowed out. At a quick glance these look like double spirals. This development appears to have been localized in Ireland. The whole sequence has already been discussed above.

In brooch No. 62 (no locality) the first step forward is made evident. It was not a very long one. Here the triskeles, with dots of enamel at their centres, now have ends expanded and twisted into small spirals, four single and two double. Again the snouts are enamelled, and the hoop is still plain. The same triskele style is repeated in brooch No. 63 (no locality),

though great confusion seems to have arisen with the arrangement and setting out of the pattern on the left-hand terminal. It will be noted, too, that what look like double spirals are in fact singles, with hollowed out finials. For some reason the snouts have been shortened, but they are still enamelled. Hoop and pin-head now bear decoration; the former with ribbing in many bands, the latter with a most pronounced zigzag design in false relief. There are deep grooves on the pin.

A characteristic of this series is the amount of attention that was given to the pins. All pins are decorated. The pin of No. 64 (no locality) has a short herringbone pattern above the point of contact with the hoop. The moulded pin-head, its shape obviously based on that of brooch No. 61, also bears some relationship to the pin-heads of brooches Nos. 55 and 57, but

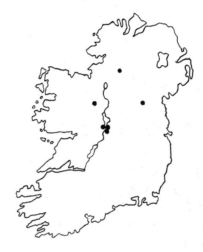

Fig. 12. Distribution: Group B_2 brooches

here it is further embellished with ribbing, and this pattern and style are repeated in the following brooches, Nos. 66 and 67. Brooch No. 64 is a very mature specimen. It is both larger and sturdier than any specimen up till now. The proportions of hoop size to terminal size are good and well conceived. The multiple zoning of the ribbing on the hoop is also a characteristic of this series, and is somewhat reminiscent of that on brooch No. 56 of the B_1 series. There has been a breakaway in the setting out of the decoration on the terminal heads, which here, for perhaps the first time, are hammered out. As to the spirals, these are mostly double, but there is one triple spiral on the left-hand terminal. These spirals are delicately executed, standing proud on a sunk background intended for red enamel. Spherical triangles are now but a memory, though here they may be seen on the snout tips. On both sides of the medial ridges on the snouts are hatched lines. Ears are back in fashion: they had been omitted from the previous three brooches. Whilst eyes are ever present, ears come and go. But even if they do go, they are certain to come back.

Throughout the present series, eyes are triangular in form. The form makes for ease of trimming: none other could be simpler.

This series includes both ornate and plain brooches. The first plain specimen is brooch No. 65, found in a bog in Cornalaragh townland, Co. Monaghan.[128] In the matter of form, it is not unlike No. 62, with well splayed terminal ends, a condition due entirely to excessive hammering of the metal. It is fairly clear that in the case of this brooch, and also of Nos. 68 and 69, that, to begin with, the metal formed a continuous circle; and after the hammering process had been completed, the expanded end was cut through the middle. Plain and ornate: no other workshop produced both, side by side. This plain style made for cheapness, for it demanded the minimum of attention: moulding is confined to the snouts and eyes, and these could be fashioned very quickly. It is a well thought out design for a cheap brooch.

Allowing for the fact that these brooches are all hand-made, the similarity between Nos. 66 and 67 is remarkable. Small differences are noticeable, but no more than would be expected in one copied from another by hand. The similarity is all the more remarkable in view of the high degree of sophistication which has been attained in both design and finish. It is no easy matter repeating these spiral patterns with such accuracy. The basis of that pattern is again the triskele, not in true form, but as a setting out pattern for the design as a whole. Both these brooches were dredged from the bed of the river Shannon, near Athlone;[129] they represent the apex of achievement in the manufacture of zoomorphic penannular brooches, and, for workmanship, the designs on the terminals will stand comparison with those on the best of British hanging-bowl escutcheons.[130] But there are obvious differences between the two: on the escutcheons, the central spiral is triple, its three finials providing suitable links with its surrounding three spirals, and the links are in trumpet form. Here, in the case of Nos. 66 and 67, the spirals are linked by means of C-scrolls, and the central spiral is double. This leaves three free floating finials to each pattern, an idea not to be found on any of the British hanging-bowl escutcheons. The design is therefore not so mature, and cannot be contemporary. Although a link between the two has been considered possible, it must be remarked that the distribution of Irish spirals is limited, for reasons that escape explanation, being confined for the most part to the lands of the Soghain; whereas hanging-bowl escutcheons of the type referred to have come mostly from Saxon sites within the political boundaries as set out at the end of the sixth century, meaning the eastern, southern and midland areas of England. The two areas are far apart, and so far there are no links.

On the old plain of the Soghain the mood could change at will, from the ornate to the stark plain. Another pair of brooches, identical in all respects, except for their pin-heads, were this time found far apart, the one (No. 68) coming from the bed of the river Shannon near Athlone, the other (No. 69) coming from Co. Roscommon.[131] Both are out of the same mould. Here is flagrant unsophistication, and grossness of size. The impression is one of weight. Actually, the brooches are lightweight, the saving having been achieved by the fact that the metal is almost paper-thin, at the terminals, whilst the hoop's diameter has been kept down to a minimum. By contrast, the pins are long and stout, and the pin-heads differ in form. Curiously, both pins are squared at the middle. They would have left a sizeable hole in any material. The bold barrel shaped pin-head of No. 69 is of a form that in the multivallate fort at Garranes, Co. Cork,[132] was reliably dated to about A.D. 500, by association with post-Roman pottery and sherds of amphorae of eastern Mediterranean origin. But the Garranes pin was independent of any associated brooch, and looks like being a stray, and a late one at that. The pin-head of No. 68 is a surprise: the pear-shaped central moulding is

new to this class of brooch, and whilst in Ireland its origin is obscure, a similar moulding appears on the zoomorphic-headed hook of the Castle Tioram, Moidart, hanging-bowl.[133]

In summary, this workshop produced an evolved design of zoomorphic penannular brooch, decorated with Celtic art designs of traditional style. The brooches are the work of more than one hand, but possibly of a single workshop which existed in the fourth and fifth centuries, and was situated (possibly) somewhere in the Lough Ree area. The form of brooch produced is more individual than that of any other series.

GROUP C

NUMERICALLY, this is the largest group. Many of these brooches are expertly made, robust, often impressive, but the decoration is sometimes intangible for the reason that it is based on no known artistic tradition. These metalworkers had to borrow designs, but what they made of them often proved interesting, and sometimes striking. The distribution of Group C brooches shows it to be essentially an eastern one, with no more than two brooches having been found west of the Shannon.

FIRST SERIES, C_1

These brooches were made somewhere in the Lough Neagh area, as suggested by the distribution map (fig. 13). The first of this series is a rather remarkable brooch, which is No. 70, from Lough Neagh.[134] In form and decoration the source of inspiration for this production must have been found in the brooches of the B_2 series. The general layout is similar to that of Nos. 66 and 67, although the pin-head has No. 69 over-tones. Perhaps the explanation is to be found in the fact that this brooch was found at Lough Neagh, which is situated in Cruithin territory. The Cruithin were related to the Soghain. Of the borrowed decoration, one is a pattern of running spirals, which, though unlike any seen in the B_2 series, nevertheless was clearly inspired by the Athlone spirals. This contact was fleeting, and when it was lost the brooches of this series became less ornate. The terminals of No. 70 are too long for their width, which makes them look out of proportion, though they are in keeping with the less than robust hoop. The hoop is undercut between the bands of ribbing, an idea that must have created problems for anyone using the brooch, since this undercutting would impede the free movement of the pin-head. Running spirals also appear on the snouts, the tips of which are not raised. The eyes are rounded, which is an eastern rather than a western characteristic. The ears are represented by carefully chased lines across the squared corners. The pin has a few points of interest, not the least being the chevron pattern on the lower end, at that point where the pin touches the hoop. Chevron patterns were seen in Britain in the mid-first century A.D., on imported provincial Roman objects,[135] and later are common on the second-century massive armlets.[136] The Lough Neagh area was or had been in contact with Scotland, as is proved by the finding of one of these massive armlets at Newry, Co. Down. Although the pin-head resembles that of brooch No. 68, there are already essential differences. The central moulding is now less pear-shaped, being rather more elongated, and later will take on seed-like proportions which will become the standard for the pin-heads of many of the following brooches. The pin-head is not well moulded, for the hollows are squared, and in addition they are cross-hatched. The reverse side of the brooch bears rather unusual decoration, with the traditional capital N pattern chased on the terminals, but the hoop carries a series of K patterns. The general effect is not very satisfying.

The remaining brooches in this series are of more moderate proportions. Also they are sturdier, the hoop is heavier, the terminals wider and thicker. Sometimes they are very thick. Little attempt has been made at weight-saving. There are three brooches which undoubtedly are more or less contemporary, and are by the same hand. These are Nos. 71, 72 and 73. All

three have identical pin-heads. These pin-heads are of most unusual design: three seed-like mouldings, each enclosed within its own oval panel, have been placed side by side to make a rather weighty pin-head, though the overall effect has a certain charm, and blends in well with the designs on the terminals, which are themselves thick and weighty. This form of pin-head was never repeated again, either here or elsewhere, so that it must have been one man's idea. The ingenuity he showed here was applied equally to terminal decoration, which, whilst being eye-catching, can best be described as a conglomeration of motifs and ideas. For instance, in the case of No. 71, from Co. Antrim, this man has had, at the back of his mind, the simplified palmette. Although this craftsman lacked a delicate touch, preferring a

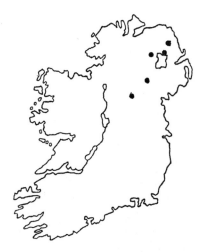

Fig. 13. Distribution: Group C$_1$ brooches

bolder approach, the quality of his work is as good as the best in this whole collection of brooches. The same standard is maintained in the case of brooch No. 72 (no locality),[137] and again in the case of brooch No. 73 (no locality). Another tribute to his ingenuity is his ability to devise different decorative patterns for all three brooches. In the case of No. 72, the pattern is based on three spirals, the inner finials being given an ornithomorphic character. Similar spirals occur on some of the hand-pins. It is an idea that keeps cropping up from time to time, and was seen on the Oldcroft proto-hand-pin. In the case of the third brooch, No. 73, the layout suggests that the metalworker had some knowledge of the spiral layout of Nos. 66 and 67. This happens to be his version, not very satisfying from an artistic viewpoint, but eye-catching none the less. Looped scrolls decorate the snouts of Nos. 71 and 72, but in the case of No. 73 a small square punch has produced a passable representation of the multiple lozenge pattern. All hoops are ribbed, as normally in four bands. Pins have not been neglected: all bear decoration of one form or another, that on No. 72 being the chevron pattern.

Brooch No. 74 from Co. Cavan is obviously by the same hand, but time has passed and the design has come in for some alterations. The pin-head is essentially the same, except that there are now additions in the form of little knobs top and bottom. This man was possibly

a hand-pin manufacturer, and this feature may have been suggested by the hand-pins. We are now in the period when the sort of decoration seen on the last three brooches had to give way to the preference for millefiori enamel. Millefiori was a cheap and nasty way of decorating terminals, and far less ability on the part of the craftsman was demanded by the new fashion. However, this man had not lost his touch, as is proved by the application of lentoid petal decoration to both the snouts and to the sides of the terminals. The hoop is ribbed, but this time the ribbing is in three bands. The reverse side of the brooch has not escaped attention. Here compass work is responsible for two large and two small twin concentric circles, between which are hollow dots made with a hollow punch. Other similar dots occur near the edges. The large and the small twin concentric circles are joined diagonally by ladder pattern. This same pattern occurred on the pin-head of brooch No. 73. The minuteness of the tools used may be judged from work like this: the hollow punches were excessively small, and so were the chisels which were responsible for the 'steps' on the ladder pattern. On the right-hand side it will be noted that the tool skidded four times. The moulding of the reverse side of the pin-head is most unusual.

No further brooches can be traced in this style. Those above may be representative of the life-work of one man. Workshops such as these, which enjoyed favour for a century or longer, must have seen several changes of personnel. Breaks in style may mean a change of personnel. That forms persisted in spite of this is a tribute to the hold which those same forms had on public taste. In the next four brooches the tradition is carried on, but the change of personnel is clear — the brooches have a different personality, therefore their style is different. But some of the old patterns and ideas are carried forward, to be repeated on these brooches.

First, there is the case of the misshapen triskele on the terminal heads of brooch No. 75 (no locality). It is clear that this brooch-maker did not possess the same ability as the former craftsman, and his main interest was elsewhere, in pin-heads. But he reverted to an earlier pattern for terminal decoration, and he put a square of opaque enamel at the centre of each. The heads of the remaining brooches are empty of enamel, except No. 76A, which has a single piece of millefiori still adhering to each terminal. Otherwise, there is no indication of any further means of decoration. There are irregularly shaped hollows on the snouts, and a peculiar mixture of hoop decoration. Everything here is a bit slipshod, but the man was happy with his pin-heads. He took to the form seen in No. 70, and developed it a stage further. He gave to the central moulding an elongated form, which is what it needed to give it impact. At its base there is a sort of 'butterfly-bow' form of moulding, which is very clever, for it helps to relieve the general design. He felt he had a winner here, for soon he set about improving the head, by enlarging it overall, as may be seen in the case of brooch No. 76, from Magherafelt, and again in No. 76A, from Castleport, Co. Donegal. One could debate as to which of these two brooches is the earlier. The proportions in both these specimens are good, and attractive, and development should have stopped here; but it did not. The metal-worker decided to enlarge further, as in the case of No. 77 (no locality), while No. 78, from Caledon, Co. Tyrone, which is the largest here, shows that by this time the design was beginning to fall apart, and, because of its size, the form has become untidy.

All these brooches have ribbing on the hoops. There is a mixture of decoration on the snouts, and it varies from brooch to brooch. Lentoid petals appear on two specimens, Nos. 76 and 78. The multiple lozenge pattern appears on the terminal sides of brooch No. 76. The

curious shaping of the ears is a new departure: on all five brooches, Nos. 75–78, they tend to be protrusile. In this respect they imitate the ears of No. 74.

SECOND SERIES, C_2

Rounded eyes are a distinguishing feature of this series, just as they were of the A_2 series of brooches. Curiously, the distribution of both is very similar (fig. 14). In some instances, there is a fairly clear resemblance, so that inevitably the question must arise as to whether or not both series of brooches originated from the same workshop. Even the period of manufacture is roughly the same. There is no ready answer to this question, so that in the course of this study both series are being treated as separate phenomena, as indeed they must, in view of certain divergent characteristics.

The first brooch, No. 79, from Clonard, Co. Meath, is a puny enough affair, and it has been badly cast. A rather puerile attempt at linear decoration can be seen on the left-hand terminal, omitted altogether from the right-hand terminal. However, both heads and snouts are enamelled, and the snout tips are excessively upturned for a small brooch. There is coarse ribbing on the hoop. The form of pin-head is uncertain: two deep channels give the impression of moulding. Altogether, here was someone learning his trade.

Brooch No. 80 (no locality) is better, but plain. The only relief is in the enamelling of the terminal heads. It is very like an early brooch in the A_2 series, apart from the enamel. Here again the pin-head is formless. On their reverse sides, the terminals are decorated with the capital N pattern. Brooch No. 81 (no locality) is large, heavy, and clumsy in appearance; plain, except for a poor attempt at ribbing on the hoop, and the enamelling of the terminals. The hoop is disproportionately heavy. But there is a coming interest in pin-head design; formlessness is relieved by deep parallel channelling. The idea was retained in the case of No. 82, from Co. Westmeath, and now one is reminded of the old barrel form in the rather poor moulding of this pin-head. Patterns are rare in this series; here, on the terminal heads of No. 82, are linked simplified palmettes that are slightly reminiscent of a somewhat similar design on a mount from Site III at Richborough, found in association with late pottery.[138] On brooch No. 82 the workmanship is quite competent.

The similarity between this and the next three brooches is quite marked. They are more or less of equal size, and the terminal forms are nearly identical. Brooch No. 83, from Lough Ravel crannog, Randalstown, Co. Antrim, tells the story of a continuing interest in decoration, which from now until near the end of the series will show a steady build up. Here are lentoid petals on the snouts, there is ribbing on the hoop, whilst the true barrel form of pin-head is fast developing. This brooch has a square of millefiori at the centre of each enamelled terminal head. Ears will become more pronounced. But for some reason weight appears to have been a controlling factor in all these brooches, and until later, when the terminals were hollowed (Nos. 86 and 87), nothing was done to save weight. There is no valid reason for this weight, and it made for a heavy brooch; except, of course, it gave increased depth to the terminal, and made possible side decoration. This profile decoration came in for quite a lot of attention from the metalworker, and the sides served as a vehicle chiefly for lentoid petal decoration.

In the case of brooch No. 84 (no locality), terminal decoration is a repeat of No. 83.

Attention is now being concentrated on the pin-heads. The metalworker was clearly searching for something different; and whilst No. 84 is not very different from what has gone before, No. 85 (no locality) clearly shows where his researches were taking him. Here is his attempt at a representation of the seed-like moulding which was typical of the brooches at the latter end of the previous series. The attempt is a bit tentative. This is a hint that these brooches might predate those of the C_1 series, which would push back the history of the C_2 series to the first half of the third century. If agreed, this remark would give added weight to the suggestion put forth in the first paragraph.

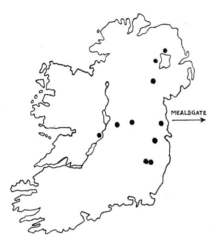

Fig. 14. Distribution: Group C_2 brooches

A sudden increase in size and weight had taken place by the time that brooch No. 86, from the Castledermot region, Co. Kildare, was made. However, some weight was saved by casting the terminals hollow. Apart from its weight, this brooch is showy and rather vulgar. The snouts are too big, and the snout tips too bulbous. The eyes are rounded, the ears triangular in profile. Lentoid petals decorate the snouts and the sides of the terminal heads. Circular wells were prepared in the heads for the reception of millefiori, and both had a red enamel background. A small amount of ribbing appears on the hoop. Generally, the finish is excellent, and this quality is seen also in the pin-head moulding, which exhibits a great feeling for line. The design is an improvement on No. 85; but this is as far as the metalworker got with this pattern, for he dropped it in preference for another, of his own devising. The newly designed head is seen for the first time in No. 87, a brooch which comes from Arthurstown, Co. Kildare. The seed-like moulding has been moved to the top of the pin-head, and a square of enamel takes its place at the front. It is a curious idea, but not without appeal. It is vastly preferable to the horror of No. 89, on which the seed-like moulding has been moved again, this time to the back of the pin-head. In between there is No. 88, which shows an enlarged central square of enamel, but otherwise the moulding is of a more delicate nature.

The Arthurstown brooch has a nice balance between hoop weight and terminal size, though basically the terminal form is the same as that of No. 86. The snout tips are still too bulbous.

But, remarkably, there is a return to terminal decoration, away from millefiori and plain enamel backgrounds. Obviously, the whole basis of this decoration is the simplified palmette. There are lentoid petals each side of the medial ridges of the snouts, and zoned ribbing on the hoop. In fact, this is an attractive brooch, not too ostentatious.

For sheer ostentation, the next two brooches would be hard to beat. Both impress by their size and weight, but not by their quality as artistic productions. No. 89 is in fact rather vulgar. The decoration cannot by any means be called restrained; almost every known decorative device has been packed in to make these two brooches florid. In the case of No. 88, from the neighbourhood of Armagh,[139] terminal head decoration is a conglomerate of simplified palmettes and millefiori. As set out, the central pattern is the palmette, enclosing a square of millefiori, and there are other squares of blue and white millefiori. If these squares of millefiori alone are considered, it will be noted that the layout is precisely the same as that in brooches Nos. 66 and 67; in other words, this pattern represents the complete prostitution of an art form, and its combination with the palmette is a hang-over from No. 87. Lentoid petals decorate the sides of the terminals and the snouts, and snout tips remain bulbous. Possibly the preferences of the times dictated the whole layout, of hybrid patterns and so forth. Only the well-proportioned pin-head serves as a means of toning down the vulgarity of the decoration.

Brooch No. 89, from Ballinderry crannog No. 2, Co. Westmeath,[140] is plainly pretentious. It is also the most complex of all the brooches listed. The contemporaneity of all the decoration is in doubt. The pin-head has been modified: the pin and the central moulded section, with its square filled with chippings of millefiori on a red enamel background, is original, but the flanged sides have been added. This operation was achieved at a later date by inserting a copper (or bronze) tube as a vehicle for supporting the flanges, and the lot were then sweated together, not very thoroughly, since there are gaps in the solder.

This composite pin-head causes one to look with suspicion at the decoration on the brooch. The secondary flanges bear identical decoration with the hoop, a series of criss-cross patterns and herring-bone designs. Stevenson[141] has pointed out that this type of decoration can be matched by similar patterns on the circular Sutton Hoo escutcheons.[142] A *terminus post quem* for the Sutton Hoo burial is roughly A.D. 625, but, as Bruce-Mitford has remarked,[143] the Celtic hanging-bowl bearing these escutcheons had been repaired by Saxon craftsmen. A notable feature of these Sutton Hoo escutcheons is that they are embellished with millefiori enamel, but their spiral decoration cannot be matched. Since this bowl was old and decayed when it was repaired by the Saxons, it must be a good deal earlier than the seventh century. But some of the spirals are indeed not spirals at all, but consist of two ornithomorphic heads backing on each other. This style is seen on the kite-shaped Faversham escutcheon,[144] and again on another from Barrington.[145] On these grounds, the Sutton Hoo hanging-bowl could be as early as the fifth century A.D.

What now is the position with regard to brooch No. 89? Stevenson[146] was right to protest that the eighth-century date previously given to this brooch in the 1937 paper is 150 years too late. The period of liberal use of millefiori is the fifth century, and this date fits in well with the occurrence of 'ladder' pattern on the seed-like moulding on the reverse side of the pin-head, though ladder patterns were more common at an earlier period. Again the occurrence of lentoid petals is in keeping with this line of thought. The consensus of opinion must

be that, seeing the flanges are a later addition to the pin-head, and they bear decoration in every way similar to that on the hoop, the first modification must have taken place not too long after the brooch was made.

A second modification has been made to the reverse sides of the terminals. Here bronze plates, bearing engraved sixfoil motifs and parts thereof, have been soldered on. Although the motif is as described, the metalworker may have had other thoughts, and have regarded each as composed of six spherical triangles with dots at their centres. As Hencken has pointed out in another context,[147] this form of the sixfoil motif is virtually undatable, having been used by pagans and Christians alike, and even occurs on whalebone from Elizabethan times.[148] Brooches, valuable possessions to the people of those days, had long histories, like the Hunterston brooch, so that additions or alterations can be expected. All in all, this is probably a fifth-century brooch, but bearing later additions.

Also, with this brooch, the craftsman seems to have exhausted his ingenuity. Two small and rather ineffectual specimens bring this series to a close. By any standard they are crudely produced. In the case of No. 90 (no locality) the sole relief is the enamelling of the head and snout. But the pin-head form of No. 87 is retained. Brooch No. 91, from Clonfert, Co. Galway, has badly formed terminals, but the hoop is nicely ribbed. There was once a square of millefiori at the centre of each terminal head, on a red enamel background.

Many of these brooches had the stamp of barbaric vigour. The workshop was perhaps situated in the Meath area, and it functioned mostly in the fifth century.

THIRD SERIES, C₃

The brooches making up this series tend to have pyramidal eyes. A depressingly large number have no localities; but of those that have, the find-spots (fig. 15) tend to be nearer to the Shannon. The series starts early, in the post-development era after the discontinuation of the Initial Form, and it lasted well into the fifth century.

Brooch No. 92 (no locality) still retains some semblance of the Initial Form, except that the snouts have been lengthened. The same remarks apply to brooch No. 94, though by this time there is an overall increase in size. But any increase in overall size called for some form of relief: in No. 92 this has been achieved by applying a meaningless pattern, perhaps with the simplified palmette in mind, to the terminal heads, which in the case of brooch No. 93 (no locality) has become more complex, with the addition of the multiple lozenge pattern[149] to the snouts. Ribbing in three bands has been applied to the hoop, and in the case of No. 94 it is in seven bands. To the reverse sides of the terminals of both Nos 93 and 94 the capital N pattern has been applied. Pin-heads were not very imaginative to begin with, which is in line with what could be expected at such an early period. However, by the time No. 94 was made the possibilities of good pin-head moulding had been fully realized. Yet the promise shown here was not followed up, for many of the subsequent pin-head mouldings are somewhat careless. One of these is seen on brooch No. 95 (no locality), a somewhat haphazard affair set on the end of a thick pin. It is unsatisfying because the shallow mouldings are out of proportion to the size of pin, but the deep channelled decoration helps to relieve some of the tedium. This brooch is a rather crude affair, with an even cruder attempt at representing

5

a triskele for terminal head decoration, but there is neat ribbing on the hoop. This disjointed triskele has a round piece of millefiori at the centre.

Two developments are afoot. One, the lesser of the two, concerns the reduction in width of the pin-heads. No. 95 is the first example of the new style. The second of the developments, and the more important, is the lifting of the snout tip, suggested in the earlier brooches, but much more pronounced in the case of No. 95. This is a device to keep the pin-head captive. It also meant that the pin-head had more freedom to move on the hoop, for on the earlier specimens, on brooches without this upturned snout feature, it had to be closer fitting to prevent its sliding off the hoop. Some snout-tips are very bulbous, because the pin-heads are very loose fitting. The device was simple enough, and it is curious it was so long a-coming.

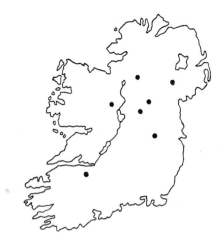

Fig. 15. Distribution: Group C₃ brooches

The men of this workshop are not noted for imagination, and they never achieved the distinction of producing even one exciting brooch, the final flower, so to speak, that justifies the recording of a lot of dull facts. Yet these brooches are by no means decadent. Neither are they brimming over with novel ideas. This is because the men were not originators; they were competent metalworkers content with what they had. Brooch No. 96, from Co. Armagh, is typical of their work. It follows closely behind No. 95, with its capital N pattern on the reverse sides of the terminals, a form of decoration we will not see generally until the end of this series. Decorative relief tends to be minimal all along, and there was none of the ostentation seen in the last series. If decorative relief is present on the terminals, it is well executed, like that on Nos. 98 and 101. Otherwise the easy method of using a few chips of millefiori on a bed of red enamel was adopted for most brooches, by way of decoration for the heads. This was the case with brooch No. 97 (no locality), an otherwise dull brooch with lentoid petals on the sides of the terminals, and zigzags on the snouts.

A word or two must be said here about pin-heads. This workshop clearly had no set pattern, so that there is continual change. The pins are always too heavy, which puts them out of proportion with the heads. The head of No. 96 has finer mouldings than was the case with No. 95, and the central channelling has been turned into a ladder pattern. But a return

to plain channelling is evident in No. 98, a well-proportioned pin-head that is not without some attraction. This Shantemon, Co. Cavan, brooch (No. 98) is a much finer production altogether, all edges being sharp and well trimmed, and the corners squared. The scroll pattern on the terminals cannot be faulted. Note the swollen finials. Lentoid petals decorate the snouts, and there is ribbing, not too closely spaced, on the hoop.

This performance was disappointingly brief, since No. 99 (no locality) is typical of more normal production methods, with its clumsy, ill-balanced terminals and bulbous snouts. An unidentifiable pattern decorates the heads, and the hoop ribbing is continuous and unrelieved. The mouldings on the pin-head are unequal, but the central ladder pattern is so finely executed as to be almost indistinguishable without some aid. The pin is too heavy for its length. The terminals are better proportioned in the case of No. 100, from Belleisle, Co. Fermanagh. This brooch was gilt, hence the safety device of the coiled bronze wire. But the form of pin-head is loose, and it is poorly moulded, and decorated with three deep channels, and a saltire below.

Little has been said so far about eyes and ears. Generally the eyes are pyramidal, and are always present; but ears, starting small, are more pronounced in the mid-period brooches, being triangular when seen from any angle. They retained this form until the end of the series; and the combined features of eyes, ears and heads in the forms shown are the distinguishing characteristics of this series. The brooch No. 101, from Bloomfield, Co. Roscommon,[150] is no exception, except there is now a slight change in snout form. It is more pronounced and bulbous in character, and this results in a certain malformation of the snout itself, which here is decorated with enamel. The decoration on the terminal heads is interesting, firstly because it is presumably inspired by the simplified palmette motif, and secondly because the inturned ends have an ornithomorphic character.[151] These birds heads are similar to those seen on the kite-shaped Faversham escutcheon, discussed above, which might have put the brooch into the fourth century if due allowance were not made for the time lag in Irish art. This is more likely to be fifth-century work, but perhaps early in that century. The pin-head is nicely moulded, and there is a chevron pattern down the middle. A variation of the capital N pattern appears on the reverse sides of the terminals.

The next three brooches are virtually all similar, even if there is some variation in size. Nos. 102 and 103 (both without localities) have no pins, whilst the pin-head of No. 104 (no locality) is almost formless. The ribbing on Nos. 102 and 104 is similar and continuous, whilst on No. 103 it is in three bands. Millefiori remains on the terminal heads on No. 103, and it is assumed that the other two specimens were similarly decorated. Snouts are enamelled in the cases of Nos. 103 and 104, whilst the snouts of No. 102 are decorated with a criss-cross pattern.

At this point an attempt was made to improve the appearance of some of the brooches. Pins and pin-heads come in for more attention. A square punch has been used to decorate the pin of No. 105, from Co. Westmeath, whilst a pronounced zigzag pattern in false relief has been applied to the pin-head. Otherwise, except for the ribbing on the hoop, and the capital N pattern on the reverse sides of the terminals, the brooch is rather plain. However, brooch No. 106 (no locality) shows a rather surprising development, or rather an evolved pin-head that may have been copied rather than developed. The central moulding has a medial line, and in this it is a little reminiscent of the ear shapes seen on some of the dragon-

esque brooches. The hollows, again like the dragonesque brooches, must have been filled with enamel, for two dots of red enamel still remain just below them. The sides of the terminals are decorated with lentoid petals, and there is a scatter of millefiori on a red enamel background on the terminal heads. The bulbous snout tips are relieved by a transverse line which almost encircles them.

Pin-head form had been finalized by the time brooch No. 107 (no locality) was made. The same pin-head form can be seen in Nos. 108 and 109. The central seed-like moulding and the heads generally are reminiscent of Nos. 75–78, but there is a subtle difference in that there is no lateral extension to the central moulding in any of the pin-heads in this present series. This puts them apart from those of the C_1 series. These similarities may indicate a certain amount of commercial rivalry, but each workshop contributed its own interpretation of what was probably a fashionable design.

Possibly the most ornate brooch in this series is No. 108, from the Old Castle of Carbury, Co. Kildare. A curiosity is the ribbing on the pin. There are five bands of ribbing on the hoop, each band separated from the other by a cross, which is really a quatrefoil. Similar decoration can be seen on one of the proto-zoomorphic pins (fig. 2:4). Transverse lines all but encircle the bulbous snout tips, the snouts themselves are decorated with triangles of red enamel. The decoration on the terminal heads is in the form of paired simplified palmettes, on a background of red enamel. Technically, the work here is good, but the brooch is heavy.

The last three brooches are smaller. No. 109 (no locality) is an attractive little specimen, well cast and expertly finished. All mouldings are well proportioned, and this goes for the pin-head as well. Even the ribbing on the hoop has been relieved by the presence of the triangles in front of the hoop-swallowing snouts. But the style of terminal-head decoration defies description, though perhaps it is based on the triskele. There is a square of millefiori at the centre. The snouts are enamelled, whilst a couple of lines take away something of the bulbous character of the snout tips. Lentoid petals decorate the sides of the terminals. On the reverse sides, the capital N pattern has degenerated to a zigzag line. All the same, great attention has been paid to all the features of the zoomorphic form.

As so often happens, a noticeable improvement all round sometimes presages an end to a series. The present is no exception. Brooch No. 110, thought to be from the Limerick area,[152] is a retrograde specimen, with simulated Maltese crosses on the terminals, indicating that this brooch may have been made during the first flush of Christianity in Ireland, in the fifth century. The snouts and heads are enamelled, and there is coarse ribbing on the hoop. The reverse sides of the terminals of this and of the next brooch, No. 111, from Knockfeerina Hill, Td. Killoughty, or Common, Co. Limerick,[153] are decorated with the capital N pattern. Technically speaking, No. 111 is superior to No. 110, though all pretence at imitating correctly the zoomorphic form has been dropped. There are no ears, eyes or snout, the last being replaced by a circle of enamel. Yet the pin-head, with its central panel containing lentoid petals, is nicely executed.

FOURTH SERIES, C_4

This short series of brooches has a personality of its own. There is a monotonous repetition of terminal decoration, the theme of which is the simplified palmette. The distribution map (fig. 16) suggests that once again this workshop was somewhere in the Meath area.

The little brooch, No. 112, would seem to head the series. It was found in early Christian occupation debris at Knowth,[154] but it does not belong to the Christian period. The key to its age is to be found in the style of decoration on the terminal heads, which can be compared most clearly with that on the proto-hand-pin found at Oldcroft, near Lydney, Gloucestershire,[155] which has a *terminus ante quem* dating of A.D. 354–9. But, as discussed above, this pin was at least 100 years old when it was buried, therefore the style of decoration, derived from early to mid-first-century forms, should be thought of as belonging to the third century. The slight form of the brooch, together with the occurrence on the snout of a spherical triangle, is in keeping with this early date. Micro-decoration, composed of extremely finely chased lines, almost invisible to any but the short-sighted, is a style seen on the early brooches of the B_1 series, and in this respect is equivalent to that other Knowth specimen, No. 53. The matter of dating a brooch such as No. 112 is fraught with problems, not the least of which is the one of survival. Clearly the style is early third-century, and this is as much as can be said.

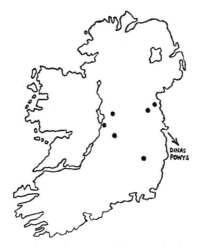

Fig. 16. Distribution: Group C_4 brooches

However, the style was prolonged, as can be seen in the case of the next two brooches, Nos. 113 and 114, both without localities. It was prolonged in the sense that the decoration on the terminals of No. 113 is a development of that on No. 112; and the decoration on No. 114 is a degenerate form of that on No. 113. The brooches themselves are very similar to the first, except that there has been a general enlargement. There is ribbing on the hoop of No. 113, but No. 114, like No. 112, has a plain hoop. The pin-heads are of true barrel form, like No. 113, with parallel lines on the central moulding, a style maintained in most heads except for the last in the series.

Millefiori was never used in this series, only red enamel, which is used as a background for the patterns on the terminal heads. In No. 114 it will be noted that those terminals are becoming more splayed. This was followed by an overall increase in size and weight, as may be seen in the case of No. 115 (no locality). The decorative pattern on the terminal heads is the same as that on No. 114, but now the 'tail' has taken on the form of paired spherical triangles, with dots at their centres. Still maintaining the same style, brooch No. 116, from Togher, Clonmore, Co. Louth, is the largest and the heaviest. The increase in terminal size

has necessitated a modification being made to the decorative pattern, which now has lost all meaning, and even the metalworker failed to understand it, for the two patterns do not match. There is a well-executed chevron pattern on the pin.

All brooches have enamelled snouts. Except for two instances, this enamel is contained in two tear-shaped hollows. These hollows were made in an interesting manner: brooch No. 115 shows how this work was commenced by the drilling of four holes, two to each snout: this made the chiselling out of the metal a simple matter, and also ensured that the wide end of the hollow was truly round.

The terminals of all brooches in this series have been cast in a predetermined style, in which all eyes are triangular in shape, and they are a prominent feature of all brooches. Representation of the ears is minimal, normally little more than a line scratched across the corners. Snouts are long in the earlier brooches, but foreshortened in the later specimens. All except the early brooches had bulbous tips to the snouts. Head shapes, long to begin with, become foreshortened in the late brooches. The overall shortening of heads and snouts is due to the fact that from No. 116 onwards brooches will become smaller again.

The heads of the terminals of brooch No. 117, from near Athlone, differ in that they are more triangular in shape. This shape causes the eyes to protrude. The foreshortening of the snouts has already started; but for the rest the old tradition is carried forward. There is so far no variation in pin-head shape; but from this time onwards this will change. Experiment with form usually spells disaster, for degeneration follows. This is about to happen, and does happen as may be seen in the case of brooch No. 118 (no locality), in which the snout tips have been modified by the addition of a spot of enamel. This has changed the decoration on the snouts from enamel to a few crude lines. Even the ribbing on the hoop is breaking up, not to be seen again. However, the terminal-head decoration is creditable, as indeed it is on No. 120. In both cases a return has been made to the simplified form of palmette as the basis of both designs. But see how fast the pin-head form is degenerating in No. 120 (no locality).

No. 119 is an imaginative reconstruction of a form that must have been cast from a mould for which there is part of a lead pattern. This was found at Dinas Powys, Glamorgan.[156] The decoration on the heads and the terminal form are both common to this present series. The presence of this lead pattern in Glamorgan is thought to indicate local manufacture.

The few remaining brooches are poor specimens of their kind, the products of a dying industry. All bear the minimum of decoration. No. 121, from Co. Westmeath, with its Maltese crosses on the terminals, is one of those fifth-century specimens made during the spread of Christianity in Ireland. The utter plainness of the brooch is relieved by red enamel. The finish is mediocre, and the same can be said of the pair of brooches, Nos. 122 and 123, from the Bough, Rathvilly, Co. Carlow.[157] These two brooches were found together, making a pair, and they are so much alike that they must have been simultaneous productions. Yet the terminal-head decoration is totally dissimilar. This fact highlights the folly of drawing up typological sequences by reference to decoration.

Although this series is short, it covers a long period, and many hands must have been involved in the manufacture of these brooches. Even so, it is curious how a style will persist, making it possible to get together a series such as this one.

THE BROOCH FACTORY AT CLOGHER, CO. TYRONE

A CLAIM that it is the nearest equivalent in Ireland to Maiden Castle in Dorset[158] had been advanced on behalf of the hill-fort in the Clogher Demesne. However, the so-called multivallations turned out to be nothing more than the juxtapositioning of several different phases of earthwork, not designed as a single defensive system.[159] Continuity of development from Neolithic times until A.D. 800 is a marked feature of the occupational history of this site.

Excavation of the fort's interior produced imported pottery of 'B' and 'E' types, and others 'which may be Roman or sub-Roman'. Penannular brooches were also found, and in addition debris from a factory producing penannular brooches of the 'Irish developed zoomorphic type'. A late Roman bracelet, of perhaps fourth-century date, had been cut up as raw bronze. This activity is seen to belong to the fifth and sixth centuries A.D.,[160] during the local Phase IIa (previously Phase Ib).

The brooches[161] from this site distinctly belong to Groups C and D, and appear to be representative of two periods of activity in brooch-making. Those of Group D appear to be dated to the fifth century, by their association with B-amphorae. Perhaps the earlier brooches belong to the period when Clogher became the capital of the Airgialla, in the fourth century. Possibly this is the nearest to an exact dating for Irish brooches it will ever be possible to achieve, without the aid of written history.

FIFTH SERIES, C₅

These Group C, fifth series, brooches are clearly the work of one individual, who was excessively short-sighted. His work is also characterized by its inconsistencies. On the one hand, decoration is meticulously carried out, the tool work being of extreme delicacy. Where lines are concentric, or run parallel, they are so closely defined that some artificial aid is required for their close examination. On the other hand, there is often imbalance between the design on one terminal and that on its neighbour. There is also a production trick which nobody else had thought of: some brooches have sweated-on terminals. This suggests fabrication rather than casting. He may have been a poor bronze founder, and devised these means of overcoming his shortcomings. All this metalworker had to do was to get two pieces of metal, the one a length of thick drawn wire, the other a piece from a beaten-out sheet of bronze, and then to sweat them together. This method is successful only if the sweating has been properly done; if not, the joint is termed 'dry'. Dry joints caused the loss of terminals in the cases of Nos 124 and 128. The idea cut down on the cost of manufacture, but was only suitable when thin terminals were in fashion.

This Clogher craftsman was to some extent versed in Celtic art motifs. He was familiar with spirals, as may be judged from his successful attempt at reproducing a single spiral on the first of the Clogher brooches, No. 124. At a quick glance this looks like a double spiral, but here the inner swollen finial has been hollowed out, to give that impression. This is strictly an Irish manifestation, and is to be respected as such. Spirals of this nature are really circles made with a diminishing radius, and here the coils are so closely spaced as to make

examination difficult. The choice is not really a good one, for the background is meant to be of red enamel. Triangular-shaped cloisons, filled with enamel, are on the snouts. There is also a large dot of enamel on each snout tip, and two smaller dots on the eyes. The pin-head is formless, but is relieved with lightly incised parallel lines. From the same site came the remains of brooch No. 125, but little or nothing can be said about the decoration, except that it was enamelled, and there is ribbing on the hoop, whereas the hoop of No. 124 is plain.

In this series there are permutations of decorative themes associated with enamel, as against decorative themes on an enamel background. This is the difference, and the difference is clear and marked. This is one more eccentricity to which this worker was prone; another is his inability to repeat a design, even from one terminal to its neighbour without some inconsistency being evident. Regard any of the designs in brooches Nos. 126, 127, 129 and 130 and this

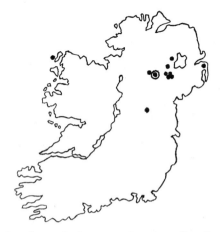

Fig. 17. The Clogher brooch factory, showing distribution of its brooches

point will be understood. Not that this craftsman was incompetent; far from that, the quality of workmanship is almost equal to that of the Group B workshops, and indeed he may have been trained there. Unfortunately, so many of his brooches are now in poor condition.

Brooch No. 126, from Killucan, Co. Westmeath, is very like No. 124, but the decoration on the terminal heads differs. Here it is reminiscent of much seen in the C_4 series. The inconsistencies of the unmatched layouts are clear, as indeed they are in No. 127 (no locality). In the latter, the terminal decoration is clearly based on the simplified palmette. On the snouts of both Nos. 126 and 127 there is elaborate enamelling, but in both cases pin-heads are still formless. In the former, four deep channels relieve the flat frontal surface, but in No. 127 some attempt has been made to mould the head. This effort brought this man to consider the barrel shape, and this form is fairly well represented in the case of No. 128 (no locality), but the deep channelling is retained, to appear here on the central moulding.

There has been a steady increase in size overall, including an increase in terminal width, and with these increases went an all round improvement in technique and the quality of the finish. All this is evident in the case of brooch No. 128. Snout tips are never very prominent, which is understandable, seeing that the brooches are not cast. Eyes are always triangular, and ears barely noted. The later brooches are more ornate than are the early specimens, and

in the case of No. 128 there is now a rather uncertain attempt at ribbing. Only one terminal remains, because the left-hand joint had been dry. But the decoration on this remaining terminal is very interesting: it consists of a combination of Christian and pagan symbols. The Maltese cross is enclosed within a circle,[162] and the space between it and the eyes is filled with three spherical triangles, with dots at their centres. This brooch must date from the early fifth century, and this is either a late revival, or a late survival, of the spherical triangle motif. Form has now become traditional, particularly with regard to the pin-head, with its true barrel shape; and although there is still an almost imperceptible increase in size overall, none of these points is forgotten.

The most mature specimen is perhaps No. 129, from Navan Rath, Co. Armagh, good enough to grace the cloak of one of the Red Branch Knights of Emain Macha. Workmanship is indeed expert, and a most remarkable steadiness of hand is evident in the chased lines of the left-hand ornamentation which keeps strictly to the middle of the raised terminal pattern, which differs on the right-hand terminal, although both should be alike. If these terminal patterns do not match, neither does the form of enamelling on the snouts. These inconsistencies suggest impatience; but this feeling is not supported by the finely chased and regular line referred to. The barrel-headed pin is attractive: the central zigzag line in false relief on the head is an improvement on deep channelling.

At this point there was a change in technique; for brooch No. 130, from the Bog of Clogher, Co. Tyrone, is cast. With casting, delicacy of touch went by the board. This specimen, with its hollow terminals, is crude by comparison. This final brooch in this series still shows up the old inconsistencies; terminal-head decoration does not match, neither does the decoration on the snouts. The layout of the terminal-head pattern is obviously suggested by that on brooches Nos 66 and 67, or it may be a crude representation of the kind of design seen on objects such as the Kingston, Kent, disc,[163] which basically is made up of three linked triskeles, all interlocked at a common point at the centre. Here, at Clogher, there were no sweeping lines, or C scrolls in the proper sense. The design was known to the Soghain, for one appears on an enamel background on a fragment from a bracelet, found in King Mahon's Fort at Ardagh, Co. Longford.[164] Snout decoration, differing in its representation on both snouts (there are two small panels on one snout, and three on the other) is peculiar, in that it is made up of Vs on an enamel background. The ribbing, in four bands, is traditional.

At this point, there was a complete break with tradition at Clogher. What brought this about is not clear. The brooches which follow, of Group D, are quite different. Eyes are omitted, and emphasis is transferred to the ears, which go on developing until they assume 'Mickey Mouse' proportions.

GROUP D

The inner 'citadel' — a large ring-fort — at Clogher is bounded by a palisade trench, contemporary with which were coarse ware and 'Roman pots'. Outside this there is a very large ditch. The upper part of this ditch was filled with several thick sheets of clay. Between them were bony occupation layers, one of which produced a post-Roman imported sherd and a Group D brooch.[165] Again, associated with B amphorae, and belonging to a later Iron Age reoccupation of the site, was a slightly devolved specimen of the Group D form. The suggested date is from the fifth to the sixth century A.D.

There is thus a plurality of finds of Group D brooches from this large ring-fort at Clogher. The finds included a raw terminal casting, and there is no lack of evidence for local manufacture. It is therefore understood that here was situated the workshop responsible for perhaps all the brooches of this group; and the distribution map (fig. 17), would seem to bear this out. The period of manufacture would appear to be from 'the post-Roman era' until some time in the sixth century, by the association of a 'devolved' specimen with Bii amphorae.[166]

The form is not truly zoomorphic. There are no 'eyes'. It is doubtful if there is a snout, in the true sense. There is a head and ears, and a grossly exaggerated snout tip, retained as a stopper to keep the pin-head captive. The main variations are in ear and pin-head forms. There is nothing to show how this new form evolved: it sprang suddenly into being, fully developed, and the only change is a small devolutionary one.

The first object, No. 131, is the raw terminal casting found at Clogher. It is easy to see why this was discarded, for there must have been a fault in the mould. This casting perhaps serves as a poor introduction to the series, for the early brooches were expertly finished. One of these, No. 132 (no locality), is a much decorated specimen exhibiting all the finer points in brooch making — the pin-head is particularly well moulded. The style might be thought to resemble (say) that of No. 76, and in some ways it does, but there is a subtle difference: the central seed-like moulding is not only larger (for the overall size of head) but there is balance in an up and down extension. But this is the sole instance: in No. 135 the pin-head returns to the form expressed in No. 76. There is no means of knowing how or where or when these brooch-makers were influenced by this form.

Decoration is confined to the earlier brooches. Five squares of millefiori, arranged in the form of a cross, are sunk into an enamel background on the heads of No. 132. A round of millefiori is sunk into enamel on the high snout tips. Between these and the heads, and along the sides of the terminals is the multiple lozenge pattern. On the hoop is ribbing in four bands. The reverse sides of the terminals are decorated with sixfoil motifs, but these are thought to be a later addition.

There is a little relaxing in the finish of No. 133 (no locality). The pin is obviously a later addition. Decoration of the heads is similar to No. 132, and there is no other decoration but the mixture of ribbing and a criss-cross pattern on the hoop. Enamelling of the snout tips is common to Nos. 133, 134, 136 and 138. In the case of No. 134, from Gransha, Co. Down,[167] the hoop decoration consists of two bands of criss-cross pattern. The heads are reduced in size, and a single piece of millefiori, on an enamelled background, was the sole decoration here. The pin-head is a degenerate form of No. 132.

Brooch No. 135 (no locality) represents a breakaway in some respects. Dots of pink coral decorate the middle of a sort of 'sun' pattern, which occupies most of the heads, whilst the ribbing is more in the nature of channelling. The form of pin-head has been commented on. All the decoration on this brooch could have been done with a wide-edged chisel, which would give the channelled effect. The same tool was used in the decoration of brooch No. 136 (no locality).

What can be said about most of this decoration, except that it is non-Celtic, and there were other influences at work? The sole surviving pattern at this stage is the lentoid petals seen in little panels on the terminals of brooch No. 137 (no locality); and at this same stage decoration in any form peters out altogether. We have a last view of millefiori, and of the

moulded pin-head form adopted for Group D: here, on No. 137, the central moulding has been extended, and a little 'cap' has been placed on the end. Just a reminiscence of this form is noted in the case of brooch No. 138 (no locality), which must be the ugliest brooch ever produced. This crude horror is extensively enamelled; even the 'Mickey Mouse' ears have been hollowed for enamel. Large ears such as these were not popular — at least not for the brooches, for none of the remaining specimens has them — but their continued use was with the pin-makers, all four examples having these ears.

Another five brooches bring this series to an end. These are Nos. 139–143. All are plain, except for the enamel filling on the heads of No. 143. There is a marked deterioration noted after No. 139, from Eaglish, Co. Armagh. Workmanship is good, the finish smooth, and the moulding of the pin-head fair. But from this point pin-head forms lose their meaning. The only other localized brooches are Nos. 142 and 143, which are from Armagh.

It is not known if Clogher suffered the same fate as Emain Macha, when the latter was destroyed about A.D. 450. If it was, this could well be the cause of the break noted in brooch-making. With the Iron Age reoccupation of the site in the fifth to sixth century perhaps went the refurbishing of the workshops, and it is to this period that Group D belongs. But of one fact we can be certain: these brooches present the final expression of zoomorphism, and with the last of them, the motif bows out.

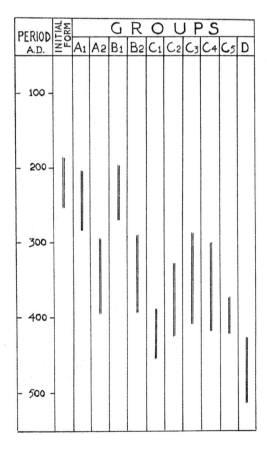

Chronological table.

PINS

THE pins considered below can be divided into two categories: those that were designed as pins, and pins that have been found detached from penannular brooches with zoomorphic terminals. The former clearly belong to a style allied to the Group D brooches, and it is assumed that they were made by the brooch-makers.

GROUP D PINS

These pins can be distinguished from the brooches by the reduced diameter of the hoop, and by the increased length of pin: the proportion of one to the other is greater. There is very little variation from one to another, except in the size of terminal, but the design is basically the same. That design appears to have been taken from brooch No. 138: all that has happened is that the hoop and its terminals have been reduced in size. But whereas the 'Mickey Mouse' ears of No. 138 have hollows for enamel, in the case of the pins the ears have been drilled through, so that, in a sense, they are rings.

The smallest ears are those of No. 144, from a hut site on Inishkea North, Co. Mayo.[168] Thereafter, ears get progressively bigger. The snout tips of Nos. 145 (no locality), 146 (from Lough-a-Trim, Co. Westmeath), and No. 147 (no locality) have hollows for enamel, and all heads were enamelled, except for No. 147, which must have had some form of insertion, since there are rivet holes in the middle of the sunk circular hollows. All these penannular rings are plain. Pin-heads are unremarkable, and all differ in form, which is small, and in the slight relief that has been given to them, apparently at the will of the craftsman.

PINS (VARIOUS)

Under this sub-heading are included pins detached from zoomorphic penannular brooches, and one made of lead, which is a pattern.

It has been suggested that these solo pins might have seen service as hair-pins, especially as one was found in association with a female skeleton. Whatever their secondary use, they come from widely scattered areas. One was found at Garranes, Co. Cork,[169] another at Silchester, Hampshire,[170] and a third at Nassington, Northamptonshire.[171] Only the last had any active association; it was found with the skeleton of an adult female in Grave II in the Anglo-Saxon cemetery. Other grave goods included three swastika brooches (circular). This association only provides evidence of its secondary use.

What is the likely date of these pins? At Silchester, various penannular brooches of the Lydney type were found, but the pin itself had no associations. Whereas the Nassington pin is plain, that from Silchester (No. 148) has a saltire on the pin near its point. This feature is known on early brooches from Ireland, and for this reason the pin is most likely Irish. It can be compared with the pin of brooch No. 17, which means that it is early, and probably followed the path taken by the Lydney brooches to Silchester. The Garranes pin-head (No. 149) closely resembles that of No. 58, and may therefore date from some time in the second half of the third century. But the occupation of Garranes is regarded as having been in the

late fifth century because of the discovery there of A and Bi and Bii wares. This trivallate fort was also a centre of metalworking, but it is situated outside the normal distribution areas for zoomorphic penannular brooches. Indeed, a brooch in course of manufacture, discarded because it had been badly annealed, was found here, but it is not of the zoomorphic form. Therefore the pin was probably acquired at second hand, and treated as a curiosity. However, on another note, some of the finds, such as a cooking pot paralleled at Colchester, where the form was of first-century A.D. date, pointed to earlier activity. Another object was a fluted metal knob, similar to some on Roman brooches of the first and second centuries A.D.[172] The acquisition of the pin must be regarded in the same light.

Pin No. 150 is of lead. It was found in cutting X at Clogher,[173] and it was the pattern for some of the pins of the Group D brooches. Its nearest bronze equivalent is No. 135. This is further proof of the manufacture of Group D brooches at Clogher. It provides an interesting insight into the number of variations that must have existed of this form of pin-head. But perhaps the most interesting point noted here is that the pin is not round, but hexagonal. After the casting process, the pins, in their rough form, must have been rounded by filing. This pin is most likely to be of late fifth-century date.

PSEUDO-ZOOMORPHIC PENANNULAR BROOCHES

BROOCHES included under the above title are those which Savory has termed 'small'. They have been the cause of much confusion in the past, particularly with regard to the dating of zoomorphic penannular brooches, because they have hitherto been lumped together with the 'large' brooches. Better that they should be regarded as a separate phenomenon. Actually, these small brooches are copies; they imitate the zoomorphic form without adding to its development. Because of that, they must be regarded with reserve. Since some have bent-back terminals, they could be the products of the bent-back terminal brooch makers. The quality of workmanship is often poor, and sometimes bad.

Most brooches are really small: the smallest is a bare 2.3 cm. in diameter. Their size is their main distinction, making it possible to set them aside from their larger counterparts. Together, they add up to a motley collection. Some brooches have bent-back or simulated bent-back terminals, often characterized by a notch in the centre of the fold line. Possibly this came about because it was common practice to simulate the ear presence by filing in from the ends, rather than from the sides. No less than seven brooches have medial lines on the heads. The terminals can be of almost any shape: long and narrow, short and broad, and sometimes splayed. Some are fair copies of the zoomorphic form. Because they are pullulant, these brooches cannot be arranged in a typological series which at the same time would show some clear development, because there is none. It might seem a little odd that the brooches remain small; but this is in line with what might be expected from something that belongs to a unitary phenomenon which started out small and failed to grow with the years. There is no reason why these little pseudo-zoomorphic penannular brooches should not remain part and parcel of Mrs Fowler's evolutionary sequence. At the same time they tend to emphasize the exclusiveness of the zoomorphic penannular form.

The distribution of these small brooches is interesting (fig. 18). There appear to be two concentrations: the one at the top of the Severn estuary, the other in Brigantia. With regard to the first, Lydney stands out as a centre of manufacture, for it should be recalled that every form from the bent back terminal to the more sophisticated brooch shown in fig. 52:1 was found here.[174] If any site showed a simple progression from the plain bent-back type of terminal, through a series of 'trial and error' products, up to and including the pseudo-zoomorphic form, then this is it. It is pleasing to observe how this was accomplished, and another point to note is that even in its final form, fig. 52:1, the terminal remains bent back. It is realized, too, that bent-back terminal brooches also have ribbed hoops.

Another Welsh site with a less obvious history of brooch-making is the Roman fort of *Segontium* (Caernarvon).[175]Here there is proof of contact with the Initial Form (No. 8). But at *Segontium* there were bent-back terminal brooches, one of simple form; and whilst something like the Lydney series is absent here, at least there are two quite sophisticated pseudo-zoomorphic specimens, shown here in fig. 52:17 and 18.[176] George Boon writes[177] that if the associations are to be relied upon, then this fig. 52:17 brooch must date to some period before A.D. 200. This date is very pertinent to the history of the Initial Form of zoomorphic penannular brooch, for a glance at this pseudo-zoomorphic specimen will show that the right-hand

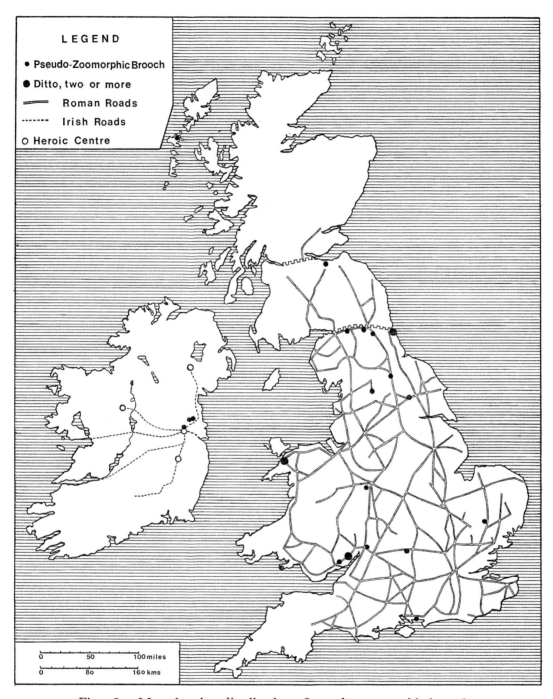

Fig. 18. Map showing distribution of pseudo-zoomorphic brooches

terminal is a very fair copy of the developed Initial Form. So here is confirmatory evidence that the history of the whole zoomorphic series began in the late second-century. The second brooch, fig. 52:18, has continuous ribbing on the hoop, and whilst it is very similar to the first, and is probably the work of the same hand, the features of head, snout, eyes and ears are not so well represented; but now there is a medial line on each head, reminiscent of the Minchin Hole and Stratford-on-Avon brooches, Nos. 6 and 7.

So far, two points have been established: the first is that brooches of the pseudo-zoomorphic type were undoubtedly made in both north and south Wales, and, secondly, that the period before A.D. 200 has been established as being one in which manufacture took place. This early date can be substantiated to a degree by the evidence provided by the Caersws, Montgomeryshire, brooch (fig. 52:9).[178] At this site extensive excavations failed to reveal any trace of occupation later than the third century. Valid support for this early date is forthcoming from far-away Orkney. The brooch (fig. 52:8) from the broch of Okstrow, Birsay,[179] is associated with an occupation that also produced three pieces of a thick sigillata bowl, Type D.45. This bowl has an upright rim, and normally a lion head mouth-piece, and belongs probably to the latter part of the second century.[180] A similar lion's head was found at Traprain Law. Also from the broch of Okstrow came sherds of an orange-red jar. Similar ware was found in another Orkney broch, that at Midhowe. At yet another broch, the broch of Lingrow, denarii of Vespasian, Hadrian and Pius, and two coins of Crispina were found. The implication of the association of these Roman objects with the brochs has already been discussed above; but here, in summary, it can be stated that their presence in Orkney resulted from the debacle of A.D. 196, when the lands in the Lowlands and in Brigantia were ravaged by the northern tribes.

Acceptance of a late second-century date for the manufacture of these pseudo-zoomorphic brooches should not be too difficult. Apart from Wales, the other centre of manufacture appears to have been in Brigantia; for there is a marked concentration of brooches in the Wall area, and in the countryside to the south of it. The Birdoswald brooch (fig. 52:2) could well be of local manufacture. It has a finely ribbed hoop, and whilst the head is squared, with well-delineated ears at the corners, there are no eyes. Moreover, it has bent-back terminals, and on that score it ought to be early. Yet it was found in a sealed deposit of the fourth Wall period, dated to A.D. 369–83.[181] Because it is the only brooch ever to have been found in a sealed deposit, this date has been treated as a *sine qua non* in every discussion concerning the origin of the species. The full story will probably never be known, whether it is one of survival, or whether manufacture in Brigantia took place at a later date than it did in Wales. The other Brigantian brooches throw no additional light on this subject, for all are unstratified. These include the brooches from *Cilurnum* (Chesters) (fig. 52:16)[182] and South Shields (fig. 52:10 and 11).[183] The first of these South Shields brooches attained a higher degree of refinement than did any others, for the terminal features have been executed with understanding. There is good, if coarse, ribbing on the hoop, and the pin-head is barrel-shaped. By comparison, the second South Shields brooch is crude. The Roman fort of South Shields was occupied at various times from the Hadrianic period down to the late fourth century as revealed (for example) by the amount of Crambeck pottery that it has produced, as well as by the structural evidence. *Cilurnum*, too, had a long history, and all that can be said about this brooch is that it can hardly be later than the fourth century. The Catarac-

tonium brooch (fig. 52:14)[184] is again unstratified. It was found in the south-west corner of Room I, Building I, but associated with masses of late fourth-century pottery. The Dowker-bottom Cave[185] and York specimens complete this list of Brigantian brooches.

Thus there seems to be an emphasis on a fourth-century dating for the Brigantian brooches of the pseudo-zoomorphic class. The Birdoswald evidence has been the root cause of all past confusion. How can one reconcile this information with the Welsh evidence? No additional support is forthcoming from the few brooches yet to be considered. That other Welsh specimen, the brooch (fig. 52:12) from Whitford Burrows, Glamorgan,[186] was a chance find. It is neither a good nor a bad specimen of this cheap form of penannular brooch; what matters is that the implications of the zoomorphic motif were fully understood. The pin must have been of iron. The Woodeaton, Oxfordshire, brooch (fig. 52:4)[187] with its bent-back terminals is early. The brooch (fig. 52:5) from the Roman villa at Witcombe, Gloucestershire,[188] was unstratified. The long, narrow, ugly heads have a medial line. Ribbing on the hoop is continuous on both sides for roughly one-quarter of a circle, after which there are five widely spaced beadings, formed by deep undercutting on both sides. Other finds from this villa included a coin of Domitian (A.D. 77–8) and two others of the second century. A first-century Hod Hill type brooch and Samian of the first half of the second century complete this picture of second-century occupation. However, there were squatters on the highest terrace at a later date, and contemporary with this occupation are coins of Valentinian and Valens (A.D. 364–75) and pottery of native type dating to the fourth and fifth centuries. There is no support here for associating the brooch with either of these two occupations. The last of these southern brooches is an ugly one found in a general layer at Portchester Castle, Hampshire.[189] This brooch (fig. 52:15) is perhaps the crudest of all brooches.

Turning to the north, the Barnton brooch (fig. 52:19) is well known. Its importance is in the fact that the end moulding on the left-hand terminal imitates that on the *Isurium Brigantum* (Aldborough) bangle, and therefore the brooch is early. A very small specimen was found in North Uist.[190] For such a small brooch (fig. 52:20) the one remaining terminal is surprisingly well finished. All the zoomorphic features are here, well defined, and there is a medial line on the head. The very lightweight hoop is covered with fine ribbing.

It is now known that these 'small' brooches crossed the Irish Sea, for recent excavations in Ireland have been responsible for adding to the numbers already known in Britain. The first of the Irish brooches is fig. 52:3, which was found at Knowth.[191] There is coarse ribbing on the hoop, and the terminals appear to be simulated bent-back ones. Because of its poor condition little more can be said about this brooch. It was found in a disturbed layer of soft dark earth. Knowth has yielded a piece of Samian of Form D.37, of central Gaulish manufacture, and of Antonine date.[192] A picture is beginning to form of second- to third-century connections with Roman Britain; for at nearby New Grange[193] five gold ornaments were found in 1842, reputedly near the entrance to the passage grave. One of these, a gold chain made up of figure of eight links, can be dated to the second or third centuries. Along with it were two gold bracelets, which can be dated to the third century. A more exact date is provided by an associated denarius of Geta (A.D. 209–12).[194] During the course of his excavations at New Grange, Professor M. J. O'Kelly found a 'small' brooch of the type under consideration. A third brooch comes from Tara, where it was found during the late Sean O'Riordain's excavations in the Rath of the Synods. This brooch (fig. 52:21) is another frail

6

specimen, only one half of which remains, in poor condition.[195] Fine ribbing decorates the hoop, and the zoomorphic features are well represented. There is a medial line on the head. In style, this Tara brooch most closely resembles No. 18 of fig. 52, which is one of the Segontium brooches, and both are copies of one style seen in the Initial Form, and exemplified by Nos. 5, 6 and 7. A late second-century date is most probable.

It is generally agreed that the presence in Ireland of Roman or Romano-British products is suggestive of raids by the Irish on the coasts of Roman Britain. Assuming that this is true (though the presence in Ireland of refugees from Roman rule must not be entirely overlooked) maximum activity seems to have occurred in the late second century and again in the late fourth century. To take this second period first: the *barbarica conspiratio* involved concerted raids on the west coasts in A.D. 367, and these were followed in 388 by the Irish pouring into Wales. Then in 405 there was the harrying of the south coasts of Britain by Niall of the Nine Hostages. As far as the coin evidence is concerned, the majority of Irish finds belong to this second period of activity. About 1717 coins, gold, silver and copper, belong to the period from A.D. 306 to 387, but there was an additional hoard of *siliquae*, the latest being one of Honorius (395–423). There is no doubt that the presence in Ireland of these coins can be attributed to these raids. The first period of activity is represented by something like 800 or 900 coins. The earliest are of Vespasian (A.D. 69–79) whilst the latest appears to be one of Commodus (176–92). This evidence of activity could be linked in some manner with the ingress of the northern hoards into a defenceless province after the withdrawal of the troops by Clodius Albinus, which resulted in the total destruction of the northern workshops in A.D. 196. This fate was shared by Nor'nour, in the Scilly Isles, at the same time.[196] The presence at New Grange of the gold hoard, dated by the denarius of Geta, suggests that successful raids continued until A.D. 212. This fact should cause no surprise, since the Romans did not reduce the northern tribes to unconditional surrender until A.D. 209.

The purpose of this diversion into other fields is to demonstrate that in all likelihood the Knowth, New Grange and Tara brooches got to Ireland in the late second century. This fits in very nicely with the Welsh evidence, which, though not very clear, is suggestive of destruction at the end of the second century. Extensive reconstruction took place at *Segontium* (Caernarvon) after 198, and the situation was well in hand by 209, when even road repairs were in progress in Caernarvonshire. The Irish brooches might very well have come from here.

One matter that has been highlighted during the course of this discussion is the differentiation of date that exists between the Welsh and the Brigantian brooches. The Welsh evidence is important, in that it supports an early dating of the Initial Form of zoomorphic penannular brooch. The Brigantian evidence seems to point the other way. The result, in the past, has been confusion. That the Welsh and Brigantian evidence appears incompatible at the moment is doubtless the result of a number of chance circumstances, survival being among them.

EPILOGUE

ELABORATION, by means of decoration, of objects of utility such as brooches and pins can be regarded as one of the minor arts. From being purely utilitarian, such articles are turned into objects of personal adornment. This is one reason why pins which were worn in the hair[197] were decorated. The decoration of pin-heads was an age-old custom. The Romans too produced some elaborate examples, such as the pin-heads carved in imitation of Venus, or of other female figures.[198] The stimulation of trade, due to increased wealth, gave impetus to this urge to elaborate and to decorate. The native Britons took note. They switched from making harness mounts to making objects of utility which were also objects of personal adornment, and amongst these were brooches. These Britons operated not from within the civil province, but from fringe territories; and their output reached its maximum during the second century. The Nor'nour factory, situated on a small islet in the Scillies, was pouring out over 50 forms of brooch. The Brigantes concentrated on trumpet brooches, and after A.D. 140 they devised a cheap imitation for mass production.[199] Some of their workshops were producing dragonesque and disc brooches, both enamelled in various colours. These were eye-catching articles of personal adornment. Amongst this collection of eye-catching objects what chance had the miserable bent-back terminal brooch got of finding a purchaser in the agora?

The Votadini must have been aware of this situation. They were familiar with the bent-back terminal penannular brooch, for some were found in the lower levels at Traprain Law. At this oppidum, the Votadini were making pins and dress-fasteners and even glass bangles, but apparently not brooches. There was therefore a gap in their production of articles intended for the dress. For the time being they had to make do with proto-zoomorphic pins. They were too far away to have ready access to the rich markets of the civil province, though they did quite well with their dress-fasteners and their glass bangles. However, they must have looked with envy at the success the Brigantes were having with their trumpet brooches, which were suitable for fine clothes. The temptation to design a new form of brooch, which they could call their own, must have been very strong. Then one day they saw a Brigantian bangle, the seed was sown, an idea grew, and very quickly a zoomorphic terminal was being shaped. The rest of the story has already been given in detail.

Something stood in the way of their exporting these brooches. Not one zoomorphic penannular brooch got as far as Newstead, or the Wall area. Perhaps its heavy pin was against it, for as such it was more suited to homespuns; or perhaps the Brigantes stood in their way. The brooch would have been suited to fastening the short fringed cloak on the shoulder.[200] For this reason it is strange that the demand remained local. It was left to the Irish to market this newly-designed brooch on a national scale.

As with every new invention, there were bound to be imitations. It is these imitations, which Savory separated from the rest and termed 'small', that have been the cause of so much confusion to research workers in the past. They have to be considered separately, on their own merits. They were probably the work of the bent-back terminal penannular brooch-makers.

The less than colourful story of the 'large', or zoomorphic, penannular brooch in Britain is one of a too conservative approach to a new design. The initial development work was done inside the oppidum of the Votadini at Traprain Law, where there were well-equipped workshops. They had a new design, but they did not know how to make the most of it. Then, before much more could be done, the northern workshops were overrun during the debacle of A.D. 196. Three brooches were taken to Caithness, Orkney and Shetland, travelling in company with some Roman artefacts, all of which were probably spoils acquired during the foray in the south by the broch people from the north. One or two brooches got to the south, mostly to the upper Severn estuary, but from this time forward the Irish alone were left to carry on this tradition of zoomorphic penannular brooch-making. The Irish had become familiar with the Initial Form, had copied it, and then set about making these brooches in their own workshops. Distribution in Ireland was wide; some brooches were taken to the territory of the Silures, in south Wales, from whence they travelled inland as far as Abingdon. Proto-zoomorphic pins, which the Irish had copied also from the Votadini, are found in the same area, penetrating as far as Silchester. Another Irish-made brooch was found at Kirkby Thore, Westmorland, and by the same route Irish proto- and zoomorphic pins travelled as far as *Cilurnium* (Chesters). It has to be assumed that all this happened after Clodius Albinus had stripped the province of troops for his ill-fated expedition to Gaul. On the return journey, the Irish brought back to Ireland hundreds of Roman coins, as well as non-numismatic finds, amongst which were three pseudo-zoomorphic brooches.[201]

Even if the Irish continued to paddle their coracles up and down the Irish Sea (as we are told), their successful incursions into Britain must have been in somewhat limited numbers until the fourth century, for the coin evidence in Ireland points to successful raiding only in the second and fourth centuries. The largest number of coins belong to the fourth century, and this is no surprise, in view of the amount of organization that must have gone into the *barbarica conspiratio* of A.D. 367, and the pouring of the Irish into Wales in 388. But the second-century evidence is a little surprising, and the presence on Irish soil of so many second-century coins can be accounted for only by the fact that entry into Britain must have been easier at that time. The part played by the Silures is somewhat nebulous; but Tacitus thought of them as Iberian, and if by that he meant Hibernian then their nearest relatives were in Ireland.

The Irish found the Initial Form to be too conservative for their tastes. Very soon the brooches start to enlarge. Some stood by the plain brooch (which may have been gilt), others added decoration and enamel, and immediately the whole distributive pattern altered. The new area of distribution is bounded on the north by Lough Neagh, on the west by the Shannon, and on the south by the counties Kildare and Laois (map, fig. 19). The area in question is enclosed by an imaginary peripheral line connecting the main heroic centres of Emain Macha (Navan Fort), Cruacha (Rathcroghan) and Ailenn (Knockawlin), whilst Tara was situated somewhere near the middle. Emain Macha was the seat of the kings of Ulster; Cruacha was the seat of the kings of Connaught (a house for Queen Maeve was built here). Ailenn was one of the royal residences of the kings of Leinster; whilst Tara (teamair na Riogh) was the seat of the high kings of Ireland, its period of greatest glory extending from the time of Cormac MacArt, in the third century, to the reign of Dermot MacCearbhaill in the middle of the sixth century. The kings of Ulster at Emain Macha gathered round them

a celebrated body called the Red Branch Knights, of whom Cuchulainn was one of the foremost. They were famed for their deeds of prowess and chivalry.

Kings and knights they may have been, but they were also freebooters. Theirs was a life of fighting, raiding and feasting. This was the heroic age in Ireland, and Emain Macha, Cruacha, Ailenn and Tara were its main centres. But, once the source of booty was exhausted, the parasites who lived off it were doomed. Disintegration of their society soon followed. Emain Macha was burned and pillaged when Fergus was king of Ulster as some say, in the fourth century, though this date is now disputed, and an alternative tradition places this

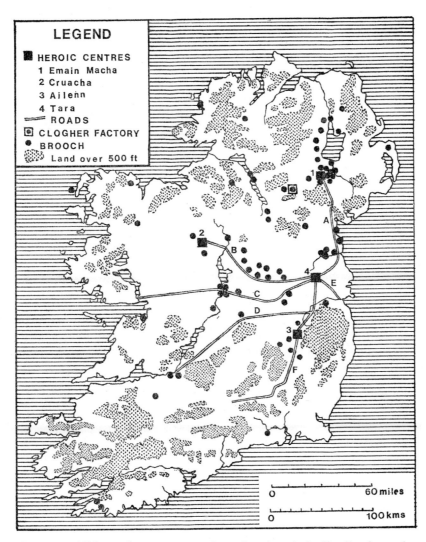

Fig. 19. All brooch groups together, showing their distribution; also situation of the heroic centres and of the second-century roads: A, Slighe Midluachra; B, Slighe Asail; C, Slighe Mor; D, Slighe Dala; E, Slighe Cualann; F, Road of the Great Wood

event as late as A.D. 450.[202] The Roman withdrawal took place in 410, and the Irish were driven out of north Wales by the Gododdin in 440. These two events must have been disastrous for the Irish economy.

The distribution map (fig. 19), makes it clear that these zoomorphic penannular brooches were being sold to the people of these heroic centres. Fine figures need fine plumage. The metalworkers were kept busy providing these heroic figures with large brooches brilliantly coloured with enamel on their terminals. Some of the largest are overloaded with decoration, and border on the vulgar. The best and most ornate belong to the fourth and fifth centuries, during the decline of Roman power in Britain. The large number remaining is testimony to the large number produced. Then, for the metalworkers, the prosperity came to an end, just as it did for the Brigantes, but for a different reason. The source of wealth had dried up. Nothing illustrates better this retraction of wealth than do the brooches of Group D. Of the other groups, there is not a sign. The metalworkers at the Clogher factory managed to soldier on for a while, since they worked in a hillfort, whose people may have assumed some kind of authority after the collapse of Emain Macha.

No story can be more complete than this, since historical records of the times do not exist. This period of the Irish Iron Age is dark indeed, and is illumined neither by the brooches themselves (for most are chance finds) nor to any extent by datable material of a personal nature. As a final gesture, it might seem pertinent to associate the dispossession of the Soghain from their midland territories by the Sept Ui Maini in the fifth century with the collapse of the heroic centres, and that the two might be looked upon as a single event in the history of Ireland. To a large extent, the Soghain had been the custodians of what was left of the Celtic art movement in Ireland, and with the Soghain (presumably) went their workshops. Most workshops were clearly situated in different areas in the midlands, only Groups C_1 and C_5 having been situated in the north. It was the C_5 workshop at Clogher which endeavoured to soldier on after the general collapse.

Perhaps the picture is a little clearer. A little more detail has been added by the separate history of the pseudo-zoomorphic brooch. In some ways, this is a somewhat blurred reflection of that of the 'large' brooch, the true zoomorphic form. A boost to the late second-century dating of the Initial Form is given by one of the *Segontium* (Caernarvon) brooches, and the Irish brooches found at Tara, Knowth and New Grange may be of equal date. It is interesting to note that the largest concentration of non-numismatic Roman finds is between the mouth of the Boyne and Dublin Bay,[203] which are the nearest ports to north Wales.

The zoomorphic penannular form had needed Irish romanticism to cause it to flower. However, the notable exuberance in the art of the eighth century was in no manner the result of an instillation of vigour from within; for the zoomorphic form and the styles of decoration that went with it had gone the way of the heroic era itself, of which it was a part.

ACKNOWLEDGMENTS

In a work of this magnitude it is inevitable that numbers of individuals become involved, either to a small or to a large degree, in the getting together of data, and in making objects available for inspection. To one and all my grateful thanks are due. George Eogan made

available to me all the unpublished brooches from Knowth. To Seamus Caulfield, Liam de Paor and Leo Swan thanks, for allowing me to draw the Tara, King Mahon's Fort and Corbettstown brooches. Most of the zoomorphic penannular brooches housed in the National Museum of Ireland were drawn during Dr. Adolf Mahr's directorship; the more recent ones with the cooperation of the present director, Dr. Raftery. To Laurence Flanagan for his cooperation, and to Richard Warner for permission to examine and draw the unpublished Clogher brooches, much appreciation, for a valuable addition to the present study; and to C. J. Lynn for permission to draw the Gransha brooch. Thanks to Mrs Leslie Webster and to Dafydd Kidd, of the British Museum, not only for much help willingly given, but also for making my time spent in the B.M. such a pleasurable occasion. Thanks also to David Brown, of the Ashmolean Museum, for providing facilities for the examination of the brooches under his care, and for his part in arranging with Ray Inskeep for similar facilities at the Pitt Rivers Museum, and to Ray Inskeep himself for his cooperation.

Roger Weatherup gave permission for the examination of the Armagh Museum brooches; and M. J. Flynn, Public Library, Limerick, allowed me to rummage through all the stored material, kept in the library, in the search for brooches. Eric Birley and the late W. Percy Hedley allowed me the run of the Chesters Museum, with happy results. Robert Stevenson, always helpful, forwarded drawings of the Shurrerary and North Berwick brooches. Jack Scott, of the Kelvingrove Museum, Glasgow, was good enough to forward excellent photographs of the Roosky brooch. James Graham-Campbell provided details and Xerox copies of those brooches from Ireland noted down in the O.S. Papers and in the Rev. Dr Porter's notebook, as well as that in the Walters Art Gallery, Baltimore, at the same time providing stimulating conversation about zoomorphic penannular brooches. George Boon was most helpful and cooperative in supplying information and pictures of the unpublished Welsh brooches, and Francis Pryor very kindly sent drawings of the brooches in the Royal Ontario Museum.

It is indeed a pleasant duty to make all these acknowledgments to so many helpful people, without whose cooperation it would have been impossible to undertake the present study.

NOTES

1 H. E. Kilbride-Jones, 'The evolution of penannular brooches with zoomorphic terminals in Great Britain and Ireland', *Proc. Roy. Irish Acad.* xliii, C (1937), 379 ff.
2 E. Fowler, 'Celtic metalwork of the fifth and sixth centuries A.D.', *Arch. J.* cxx (1963), 99.
3 The ends of penannular hoop brooches were bent back upon themselves as a simple expedient for preventing the pin-head from slipping off. The pin thus remained captive.
4 H. N. Savory, 'Some sub-Romano-British brooches from south Wales', in D. B. Harden (ed.), *Dark Age Britain* (London, 1956), pp. 40–58.
5 E. Fowler (*née* Burley), 'A catalogue and survey of the metalwork from Traprain Law', *Proc. Soc. Antiq. Scot.* lxxxix (1955–6), 138.
6 The absence of zoomorphic penannular brooches from areas of Britain with known historical associations with Ireland has prompted Mrs Fowler into making the suggestion that these movements of Irish people had taken place before the full flowering of the zoomorphic form in Ireland. Acceptance of such a postulate would make the brooches impossibly late. In fact, the reverse is the case. See *op. cit.* in n. 2, 98.
7 J. Raftery, 'A bronze zoomorphic brooch and other objects from Toomullin, Co. Clare', *J. Roy. Soc. Antiq. Ireland* lxx (1941), 59.
8 *Op. cit.* in n. 4, 43.
9 F. Henry, 'Hanging bowls', *J. Roy. Soc. Antiq. Ireland* lxvi (1936), footnote 47.
10 G. C. Boon, 'The latest objects from Silchester, Hants', *Med. Arch.* iii (1959), 86.
11 As in the case of the association of a Roman patera with the Longfaugh, Midlothian, brooch. The late Dr. Graham Callander confirmed that the association was an active one.
12 *Op. cit.* in n. 2, 103.
13 *Op. cit.* in n. 5, 138.
14 R. B. K. Stevenson, 'The earlier metalwork of Pictland', in J. V. S. Megaw (ed.), *To Illustrate the Monuments* (London, 1976), p. 247.
15 L. Alcock, *Arthur's Britain* (1971), p. 236.
16 *Op. cit.* in n. 2, 98–135.
17 e.g. *ibid.* 101.
18 R. B. K. Stevenson, *op. cit.* in n. 14, now accepts Fowler's derivation.
19 *Vide* the Snailwell bracelet, an import, and thought by Savory to be a possible source of zoomorphism in Britain. For this bracelet, see T. C. Lethbridge, 'Burial of an Iron Age warrior', *Proc. Camb. Antiq. Soc.* xlviii (1954), 30, pls. V and VII.
20 *Op. cit.* in n. 5, 131.
21 J. Curle, *A Roman Frontier Post and its People* (1911), p. 337, pl. XCII, 11.
22 This matter of a time lag is discussed at length below.
23 G. C. Boon, 'Two Celtic pins from Margam Beach, West Glamorgan', *Ant. J.* lv (1975), 400.
24 E. A. Wallis Budge, *Catalogue of Roman Antiquities in the Museum at Chesters* (1907), No. 1216.
25 *Op. cit.* in n. 23, 403.
26 R. B. K. Stevenson, 'Metalwork and other objects in Scotland', in A. L. F. Rivet (ed.), *The Iron Age in Northern Britain* (1966), p. 32.
27 Information kindly supplied by George Eogan.
28 Information by courtesy of M. J. O'Kelly.
29 M. U. Jones, 'Aldborough, West Riding: excavations at the south gate and bastion and at extramural sites', *Yorks. Arch. J.* xliii (1971), 39, fig. 22, 20.
30 *Ibid.* 39.
31 *Proc. Soc. Antiq. Scot.* ii (1859), 237. *Ibid.* v (1865), 188.
32 R. C. Bosanquet, 'A Roman bronze patera from Berwickshire with notes on similar finds in Scotland', *Proc. Soc. Antiq. Scot.* lxii (1928), 249.
33 J. Curle, *op. cit.* in n. 21, pl. LXXVI, 1.
34 *Op. cit.* in n. 24, Nos. 1470, 1475, 1491, pp. 382, 1216–23.
35 T. C. M. Brewster, 'Garton Slack', *Current Archaeology*, 51 (July, 1975), 112.
36 S. P. O'Riordain, 'The excavation of a large earthen ring fort at Garranes, Co. Cork', *Proc. Roy. Irish Acad.* xlvii, C (1942), 134, fig. 25.

37 J. Curle, 'Objects of Roman and provincial Roman origin found in Scotland' *Proc. Soc. Antiq. Scot.* lxvi (1931–2), 343, fig. 37.

38 A. O. Curle 'Report on the excavation of a vitrified fort at Rockcliffe, Dalbeattie, known as the Mote of Mark', *Proc. Soc. Antiq. Scot.* xlviii (1913–14), 125, figs. 13, 14, No. 8. See also A. Young, 'Excavations at Dun Cuier, Isle of Barra', *ibid.* lxxxix (1955–6), 290.

39 E. Rynne and A. B. O'Riordain, 'Settlement in the sandhills at Dooey, Co. Donegal', *J. Roy. Soc. Antiq. Ireland* xci (1961), 58.

40 A. O. Curle and J. E. Cree, 'Account of the excavations on Traprain Law in 1915', *Proc. Soc. Antiq. Scot.* l (1916), 124, fig. 37, 2.

41 Information kindly supplied by Laurence Flanagan.

42 H. H. Coghlan, *Notes on the Prehistoric Metallurgy of Copper and Bronze in the Old World* (Pitt Rivers Museum Occasional Papers, No. 4, 1951), p. 44.

43 *Op. cit.* in n. 36, fig. 7, 441.

44 Herbert Maryon, 'Some prehistoric metalworkers' tools', *Ant. J.* xviii (1938), 249, fig. 17.

45 J. E. Cree, 'Account of the excavations on Traprain Law in the summer of 1923', *Proc. Soc. Antiq. Scot.* lviii (1923–4), 281, fig. 19, 8.

46 *Arch.* liv (1894), 146, fig. 9.

47 Déchelette, *Manuel*, II, 1373.

48 *Ibid.* 1375. The files and the hammer were of the La Tène period.

49 A. O. Curle and J. E. Cree, 'Account of the excavations on Traprain Law during the summer of 1920', *Proc. Soc. Antiq. Scot.* lv (1920–1), fig. 26, 2.

50 *Op. cit.* in n. 39, 63, fig. 8.

51 *Op. cit.* in n. 36, 110, fig. 11.

52 *Ibid.* 138.

53 *Op. cit.* in n. 9, 220.

54 R. G. Collingwood, 'Roman–Celtic art in Northumbria', *Arch.* lxxx (1930), 56.

55 H. Williams, *Gildas I*, pp. 44–5.

56 A. E. P. Collins, 'Settlement in Ulster, A.D. 0–1100', *Ulster J. Arch.* xxxi (1968), 53.

57 F. J. Byrne, *Irish Kings and High Kings* (1973), p. 50.

58 M. Richards, 'Irish settlements in S.W. Wales', *J. Roy. Soc. Antiq. Ireland* xc (1960), 133.

59 *Op. cit.* in n. 39, 63, fig. 8.

60 R. H. Forster *et al.*, 'Report on the excavations at Corstopitum in 1910', *Arch. Ael.*[3] vii (1911), 188, pl. IV, 6.

61 *Proc. Camb. Antiq. Soc.* xiii (1909), 146–63 and figures. This harness mount was probably buried along with other objects at the time of the Boudiccan insurrection in A.D. 60.

62 *Op. cit.* in n. 19, 33, pl. VII.

63 C. H. Read, in *Proc. Soc. Antiq.*[2] xxiii (1909–10), 159.

64 *Op. cit.* in n. 24, 37, No. 19.

65 *B.M. Guide to the Antiquities of Roman Britain* (1958), fig. 28, vi, b, 1.

66 L. Murray Threipland, 'The Hall, Caerleon, 1964', *Arch. Camb.* cxviii (1970), 86.

67 G. Macdonald, 'The Roman fort at Mumrills', *Proc. Soc. Antiq. Scot.* lxiii (1928–9), 555, fig. 115, 13. This is an early instance of a dress-fastener, which must have been lost during the first Agricolan occupation of A.D. 80 or 81.

68 *Op. cit.* in n. 19, pl. VII*b*.

69 *Op. cit.* in n. 39, 64.

70 J. D. Bateson, 'Roman material from Ireland, a re-consideration', *Proc. Roy. Irish Acad.* lxxiii, C (1973), 82.

71 C. Johns, 'A Roman silver pin from Oldcroft, Glos.', *Ant. J.* liv (1974), 295, fig. 6.

72 H. Harrod, 'On horse-trappings found at Westhall', *Arch.* xxxvi (1856), 454, pl. XXXVII.

73 An excellent example of longevity is the Hunterston brooch. This is an eighth-century brooch to which eleventh-century runes were added on the reverse sides. Already it had had a life of 300 years when this addition took place. How much longer would it have lasted? Its entire life span may have been of the order of half a millennium. This is a point which should be kept very much in mind when assessing the age of a brooch such as that from Ballinderry No. 2 crannog. See R. B. K. Stevenson, 'The Hunterston brooch and its significance', *Med. Arch.* xviii (1974), 16.

74 H. E. Kilbride-Jones, 'A bronze hanging-bowl from Castle Tioram, Moidart, and a suggested absolute chronology for British hanging-bowls', *Proc. Soc. Antiq. Scot.* lxxi (1936–7), fig. 2.

75 A. Small *et al.*, *Craig Phadrig* (University of Dundee, Dept. of Geography Occasional Papers, No. 1, 1971).

76 E. T. Leeds, *Ant. J.* xv (1935), 109.

77 M. J. O'Kelly, 'The Cork horns, the Petrie crown, and the Bann disc', *J. Cork Hist. Arch. Soc.* lxvi (1961), pl. IV.

78 See illustration in R. B. K. Stevenson, *op. cit.* in n. 26, pl. 6.

79 E. T. Leeds, *Celtic Ornament* (1933), fig. 11.

80 Information and details from George Eogan.

81 This mirror was found in the civil cemetery of Ulpia Noviomagus, along with cremated bones contained in a glass urn of late first- to early second-century type. See A. Fox and S. Pollard, 'A decorated bronze mirror from an Iron Age settlement at Holcombe, near Uplyme, Devon', *Ant. J.* liii (1973), 29.

82 P. Jacobsthal, *Early Celtic Art* (1944), No. 19.

83 *Ibid.* Nos. 215 and 217.

84 The swollen finial has been noted in France, as witness the decoration on the third-century B.C. pedestal urn from Prunay, Cher. *B.M. Guide to Early Iron Age Antiquities* (1925), pl. VI, 5. This type of finial seems never to have been favoured in Britain.

85 M. Duignan, 'The Turoe stone: its place in insular La Tène art', in P.-M. Duval and C. Hawkes (eds.), *L'Art Celtique en Europe protohistorique* (1976), p. 201.

86 J. V. S. Megaw, *Art of the European Iron Age* (1970), No. 256.

87 e.g. *op. cit.* in n. 5, 138.

88 *Proc. Soc. Antiq. Scot.* ii (1859), 237. *Ibid.* v (1865), 188.

89 H. C. Lawlor, 'Objects of archaeological interest in the Lough Neagh and River Bann drainage scheme', *J. Roy. Soc. Antiq. Ireland* lxii (1932), 209.

90 *Op. cit.* in n. 37, 394.

91 *Ibid.*

92 *Arch. Scot.* v (1980), 86.

93 S. Piggott, 'Excavations in the broch and hill fort of Torwoodlee, Selkirkshire, 1950', *Proc. Soc. Antiq. Scot.* lxxxv (1950–1), 92.

94 A. O. Curle and J. E. Cree, 'Account of the excavations at Traprain Law in 1915', *Proc. Soc. Antiq. Scot.* l (1915–16), 101.

95 *Op. cit.* in n. 4, pl. V, b.

96 *Proc. Soc. Antiq.*[2] xxvii (1914–15), 96.

97 R. E. M. Wheeler, 'Segontium, and the Roman occupation of Wales', *Y Cymmrodor*, xxxiii (1923), fig. 58, 6.

98 *Arch. Camb.* cxxiv (1975), 65 and note 35.

99 J. P. Gillam, in I. A. Richmond (ed.), *Roman and Native in North Britain* (1958), pp. 79–85.

100 E. M. Clifford, 'The Roman villa, Witcombe, Glos.', *Trans. Bristol and Gloucester Arch. Soc.* lxxiii (1954), 5.

101 *Op. cit.* in n. 97, fig. 59.

102 *Arch. Cant.* x (1876), 30.

103 W. O. Stanley, 'Notices of sepulchral deposits with cinerary urns found at Porth Dafarch, in Holyhead Island', *Arch. J.* xxxiii (1876), 132. Also R. A. Smith, 'Irish brooches of five centuries', *Arch.* lxv (1914), 223, pl. XXV, 1.

104 A. M. D'Evelyn, 'A sandhill settlement, Maghera, Co. Donegal', *J. Roy. Soc. Antiq. Ireland* lxiii (1933), 88.

105 C. Fox, *A Find of the Early Iron Age from Llyn Cerrig Bach, Anglesey* (Cardiff, 1946), pl. XXV, 55.

106 R. Haworth, 'The horse harness of the Irish early Iron Age', *Ulster J. Arch.* xxxiv (1971), 46.

107 R. E. M. Wheeler, *Prehistoric and Roman Wales* (1925), p. 234.

108 R. Herbert, 'The City of Limerick Public Library and Museum', *North Munster Arch. J.* ii (1940–1), 85, fig. 2.

109 Illustrated here by courtesy of the late J. S. Richardson.

110 J. M. Corrie, 'Prehistoric relics from Shetland', *Proc. Soc. Antiq. Scot.* lxvi (1931–2), 80, and fig. 10.

111 *Wilts. Arch. Mag.* xxiii (1887), 216. The correct title for 'Oldbury Camp' is Codford Circle, which is situated a few miles from Warminster.

112 *Victoria County History, Leicestershire*, i (1907), p. 228.

113 *Op. cit.* in n. 24, No. 2226.

114 *Victoria County History, Berks.*, i (1906), p. 247.

115 T. G. F. Paterson and O. Davies, 'The Craig Collection in Armagh Museum', *Ulster J. Arch.* iii (1940), 70.

116 *Op. cit.* in n. 7, 59.

117 Eoin MacNeill, 'The Pretanic background in Britain and Ireland', *J. Roy. Soc. Antiq. Ireland* lxiii (1933), 1–28.

118 Information and drawing from George Eogan.

119 *Op. cit.* in n. 79, 30, fig. 11.

120 See p. 26.

121 *Op. cit.* in n. 89, 209.

122 A. Mahr, 'The Blackrock brooch', *Co. Louth Arch. J.* vii (1929–32), 530.

123 Information and drawing by courtesy of Liam de Paor.

124 T. B. Graham and E. M. Jope, 'A bronze brooch and ibex-headed pin from the sandhills at Dunfanaghy, Co. Donegal', *Ulster J. Arch.* xiii (1950), 54.

125 *Op. cit.* in n. 70, 65.

126 R. B. K. Stevenson, 'Pins and the chronology of the brochs', *Proc. Prehist. Soc.* xxi (1955), 291.

127 E. R. Mac an Bhaird, in *J. Roy. Soc. Antiq. Ireland* lix (1929), 69.

128 'Acquisitions to the National Museum for the year 1965', *J. Roy. Soc. Antiq. Ireland* xcviii (1968), 122.

129 L. N. W. Flanagan, 'Ulster Museum acquisitions', *Ulster J. Arch.* xxviii (1965), 111, fig. 3C.

130 *Op. cit.* in n. 74, fig. 10.

131 *Arch. J.* vii (1850), 79.

132 *Op. cit.* in n. 36, 77–150.

133 *Op. cit.* in n. 74, 207, fig. 2.

134 Lane Fox, in *Proc. Soc. Antiq.*² iv (1868), 62.

135 See footnote 19.

136 J. Anderson, *Scotland in Pagan Times: the Iron Age* (1883), figs. 121, 122.

137 M. C. Ross, *Arts of the Migration Period in the Walters Art Gallery* (Baltimore, 1961), p. 114, No. 56. I owe this reference to James Graham-Campbell.

138 J. P. Bushe-Fox, *Second Report on the Excavation of the Roman Fort at Richborough, Kent* (Soc. Antiq. Research Report, No. 7, 1928) p. 46, pl. XIX, 33.

139 *Op. cit.* in n. 115, 70.

140 H. O'Neil Hencken, 'Ballinderry Crannog No. 2', *Proc. Roy. Irish Acad.* xlvii, C (1942), 34, and fig. 12.

141 R. B. K. Stevenson, 'The Hunterston brooch and its significance', *Med. Arch.* xviii (1974), 34, footnote 53.

142 R. Bruce-Mitford, *The Sutton Hoo Ship Burial* (B.M. Handbook, 1972), pl. C, and pl. 9, a.

143 *Op. cit.* in n. 142, 27.

144 *Op. cit.* in n. 74, fig. 8, 1.

145 *Op. cit.* in n. 9, pl. XXIX, 1.

146 *Op. cit.* in n. 141, 34, footnote 53.

147 H. O'Neil Hencken, 'Ballinderry Crannog No. 1', *Proc. Roy. Irish Acad.* xliii (1936), 197.

148 Victoria and Albert Museum.

149 Stevenson is wrong, for he confuses this pattern, seen for example on Romano-British material of the first and second centuries, with imitation chip-carving. Stevenson, *op. cit.* in n. 141, 34, footnote 53.

150 Found in association with a glass ring-bead. See *J. Roy. Soc. Antiq. Ireland* lxxxviii (1958), 129.

151 This style is said to be typical of a school working in the north, or north-west of Britain. *Op. cit.* in n. 79, 145.

152 *Op. cit.* in n. 108, brooch No. 4.

153 'National Museum acquisitions for the year 1968', *J. Roy. Soc. Antiq. Ireland* ci (1971), 223.

154 Information and brooch from George Eogan.

155 *Op. cit.* in n. 71, fig. 6.

156 L. Alcock, *Dinas Powys: an Iron Age, Dark Age and Early Medieval Settlement in Glamorgan* (1963), fig. 23.

157 'Two early brooches from Bough, Rathvilly, Co. Carlow', *J. Roy. Soc. Antiq. Ireland* lxiv (1934), 263.

158 B. Raftery, 'Irish hill-forts', in C. Thomas (ed.), *The Iron Age in the Irish Sea Province* (C.B.A. Research Report, 9), p. 40.

159 R. B. Warner, in *Excavations 1973* (summary accounts of archaeological work in Ireland), p. 25.

160 R. B. Warner, in *Excavations 1974*, p. 27.

161 All the Clogher brooches illustrated here have been made available to me by courtesy of Richard Warner and Laurence Flanagan (Keeper), Ulster Museum.

162 Francoise Henry has already pointed out the similarity that exists between this pattern and that, which she refers to as a Greek cross, on the Faversham hanging-bowl. *Op. cit.* in n. 9, 227, pl. XXVII, 5.

163 Faussett, *Inventorium Sepulchrale*, p. 55, pl. XVI, 5.

164 Information from Liam de Paor.

165 R. B. Warner, in *Excavations 1971*, p. 23.

166 C. Thomas, 'Imported late-Roman Mediterranean pottery in Ireland . . .', *Proc. Roy. Irish Acad.* lxxvi, C (1976), 245.

167 Published here by courtesy of the excavator, C. J. Lynn.

168 F. Henry, 'A wooden hut on Inishkea North, Co. Mayo', *J. Roy. Soc. Antiq. Ireland* lxxxii (1952), 163.

169 *Op. cit.* in n. 36, 95, fig. 4, 330.

170 *Op. cit.* in n. 10, pl. III,B1.

171 *Ant. J.* xxiv (1944), 105, pl. XXX, 11A.

172 *Op. cit.* in n. 36, 140.

173 Illustrated here by courtesy of Laurence Flanagan.

174 R. E. M. and T. V. Wheeler, *Excavations at Lydney Park, Glos.* (Soc. Antiq. Research Report, No. 9, 1932), fig. 14.

175 *Op. cit.* in n. 97, 1–186.

176 Illustrations kindly supplied by George Boon.

177 In a letter to the author. George Boon's assistance in obtaining information is much appreciated.
178 *Op. cit.* in n. 97, 138, fig. 60.
179 'Donations to the Museum', *Proc. Soc. Antiq. Scot.* xi (1876), 85.
180 *Op. cit.* in n. 37, 285.
181 *Trans. Cumb. and Westm. Antiq. Soc.* n.s., xxx (1930), 170.
182 *Op. cit.* in n. 24, 382, 1141, 1393.
183 *Arch. Ael.*⁴ xi (1934), 198, fig. 2.
184 E. J. W. Hildyard, 'Cataractonium fort and town', *Yorks. Arch. J.* xxxix (1958), 243, fig. 5, 11.
185 R. A. Smith, 'Irish brooches of five centuries', *Arch.* lxv (1914), 224, fig. 1.
186 *Op. cit.* in n. 4, pl. Vd.
187 *J. Roman Studies* vii (1917), 117, pl. VIe.
188 *Op. cit.* in n. 100, fig. 14:1.
189 B. Cunliffe, *Excavations at Portchester Castle*, I (Soc. Antiq. Research Report, No. 32, 1975), p. 119, fig. 109, 8.
190 Joanna Close-Brooks and S. Maxwell, 'The Mackenzie Collection', *Proc. Soc. Antiq. Scot.* cv (1972–4), 288, fig. 1, 958.
191 Acknowledgment is here made of George Eogan's kindness in putting all the Knowth records at my disposal.
192 *Op. cit.* in n. 70, 68.
193 *Ibid.* 70.
194 *B.M. Guide to Antiquities of Roman Britain* (1958), p. 28.
195 Thanks to Seamus Caulfield for permission to draw.
196 M. R. Hull, 'The Nor'nour brooches', *Arch. J.* cxxiv (1967), 28.
197 J. Liversidge, *Britain in the Roman Empire* (1968), p. 148.
198 *B.M. Guide to Antiquities of Roman Britain* (1958), p. 28, fig. 14, 9–12.
199 *Op. cit.* in n. 54, 57.
200 *Op. cit.* in n. 197, p. 122, fig. 43.
201 It will be noted that these were found in an area in which the greatest density of Roman finds occur. See *op. cit.* in n.70, Map 2.
202 See *op. cit.* in n. 57, 50, on this subject.
203 As against this reading of the evidence, the reader is directed to the suggestions put forward by Richard Warner, 'Early Roman imports in Ireland', *Proc. Roy. Irish Acad.* lxxvii, C (1976), 282.

CATALOGUE OF
ZOOMORPHIC PENANNULAR BROOCHES

ABBREVIATIONS

AM Armagh Museum
ASH Ashmolean Museum, Oxford
BM British Museum
KMG Kelvingrove Museum, Glasgow
NMAS National Museum of Antiquities of Scotland
NMI National Museum of Ireland
NMW National Museum of Wales
PRM Pitt Rivers Museum, Oxford
ROM Royal Ontario Museum
UM Ulster Museum

C.L.A.J. *County Louth Archaeological Journal*
M.A. *Medieval Archaeology*
J.R.S.A.I. *Journal of Royal Society of Antiquaries of Ireland*
N.M.A.J. *North Munster Archaeological Journal*
P.R.I.A. *Proceedings of the Royal Irish Academy*
P.S.A. *Proceedings of the Society of Antiquaries*
P.S.A.S. *Proceedings of the Society of Antiquaries of Scotland*
T.B.G.A.S. *Transactions of the Bristol and Gloucester Archaeological Society*
U.J.A. *Ulster Journal of Archaeology*
V.C.H. *Victoria County History*
W.A.M. *Wiltshire Archaeological Magazine*

INITIAL FORM

1 TRAPRAIN LAW, EAST LOTHIAN
 Brooch, complete with pin. Terminals squared, head lozenge-shaped, with divided mouldings front and back, simple snout. Hoop plain, except for some ribbing near terminals. Evolving barrel form of pin-head.
 D. = 5.9 cm. Pin. L. = 5.7 cm.
 NMAS
 Reference: *P.S.A.S.* lviii (1923–4), 279

2 LONGFAUGH, CRICHTON, MIDLOTHIAN
 Brooch, complete with pin. Terminals having rounded heads and ears, continuous moulding with medial line at back of head, short snout, ribbing in four bands on hoop. Pin-head in embryo barrel form.
 D. = 5.8 cm. Pin L. = 7.2 cm.
 NMAS
 References: *P.S.A.S.* ii (1859), 237; *ibid.* v (1865), 188

3 FORD OF TOOME, LOUGH NEAGH
Brooch, with unequal bands of fine and coarse ribbing on hoop, complete with pin, but point missing. Terminals having rounded heads and ears, but oval eyes, snouts pointed. Evolving form of barrel-shaped pin-head.
D. = 7.0 cm. Pin L. = 8.7 cm.
UM
Reference: *J.R.S.A.I.* lxii (1932), 208

4 TRAPRAIN LAW, EAST LOTHIAN
Plain brooch complete with pin. Terminals with rounded heads, one having narrow moulding in place of ears, otherwise ears and eyes of equal form. Longer snout. Well-moulded pin-head in barrel form.
D. = 4.2 cm. Pin L. = 4.4 cm.
NMAS
Reference: *P.S.A.S.* liv (1919–20), 88

5 TRAPRAIN LAW, EAST LOTHIAN
One half of brooch, hoop plain, pin missing. Narrow terminals, oval head with ears and eyes marked off, medial line on head. Snout long and upturned.
D. = 4.5 cm.
NMAS
Reference: *P.S.A.S.* l (1915–16), 101

6 MINCHIN HOLE, PENARD, GLAMORGAN
One half of brooch, pin missing. Terminal squared and slightly splayed, head oval with medial line. Ears marked off at corners, eyes in form of V moulding with medial line. Hoop covered with continuous ribbing.
D. (approx) = 4.0 cm.
NMW
Reference: D. B. Harden, *Dark Age Britain* (1956), pl. V*b*

7 STRATFORD-ON-AVON, WARWICKSHIRE
Large brooch, complete with pin. Squared terminals with oval head with medial line, ears triangular, eyes formed of single transverse moulding, divided both sides. Slightly upturned snout. Ribbing in four bands on hoop. Pin-head incomplete, but of embryo barrel form.
D. = 8.5 cm. Pin L. = 9.6 cm.
Reference: *P.S.A.* xxvii (1915), 96

8 *SEGONTIUM* (CAERNARVON), GWYNEDD
One half brooch, pin missing. Well-defined oval head, ears and eyes, and slightly upturned snout on remaining terminal. Worn, but hoop apparently ribbed.
D. = 6.0 cm.
NMW
Reference: *Y Cymmrodor* xxxiii (1923), 137, fig. 58, 6

9 ROOSKY, CO. ROSCOMMON
Brooch complete with pin. Squared and slightly splayed ends to terminals, pear-shaped heads with medial lines and dots on each side. Triangular ears with dots, eyes oval with dots, short

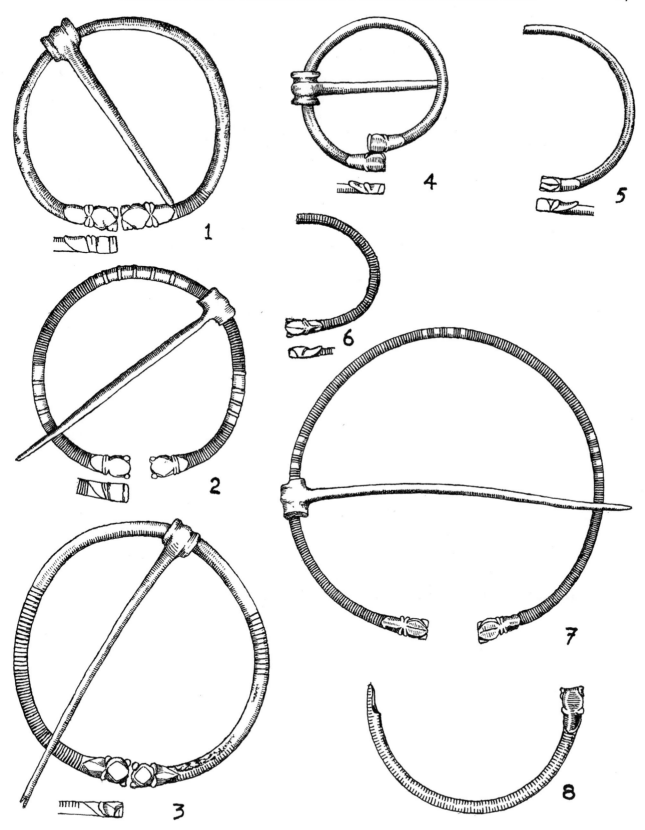

Fig. 20. Brooches of the Initial Form: 1, 4, 5, Traprain Law, East Lothian; 2, Longfaugh, Crichton, Midlothian; 3, Ford of Toome, Lough Neagh; 6, Minchin Hole, Penard, Glamorgan; 7, Stratford-on-Avon, Warwicks.; 8, *Segontium* (Caernarvon), Gwynedd. (1/1)

upturned tips to snouts with transverse lines. Ribbing in four bands on hoop. Barrel shaped pin-head, with nicks on outer mouldings. Pin decorated with transverse lines near head and near point, the latter with diagonal line in between.
D. = 7.3 cm. Pin L. = 9.0 cm.
KMG

10 WITCOMBE, GLOUCESTERSHIRE
Plain brooch, complete with pin. Round terminal heads with ears and eyes of equal oval form, short snout. Pin-head widened barrel form, one outer moulding knurled, pin wormed near point.
D. = 4.9 cm. Pin L. = 5.9 cm.
Reference: *T.B.G.A.S.* 73 (1954), 5

11 CAERWENT, MONMOUTHSHIRE
Plain brooch, complete with pin. Squared terminals with oval head, triangular ears, wedge-shaped eyes, short snout with upturned tip, and medial ridge on snout. Pin-head barrel form, with pronounced central moulding. Pin wormed near the point.
D. = 7.8 cm. Pin L. = 9.6 cm.
Newport Museum
Reference: *Y Cymmrodor* xxxiii (1923), 138, fig. 59

12 MAGHERA, CO. DONEGAL
Fragmentary brooch, with pin. Features unrecognizable, but upturned tip to snout. Pin-head in barrel form. Plain.
Pin L. = 5.5 cm.
Reference: *J.R.S.A.I.* lxiii (1933), 88

13 BIFRONS, CANTERBURY, KENT
Plain brooch, similar to No. 11. Pin missing.
D. = 6.5 cm.
Reference: *Arch. Cant.* x (1876), 30

14 PORTH DAFARCH, HOLYHEAD, ANGLESEY
Brooch complete with pin. Terminals similar to No. 11, but less well finished. Ribbing in eight bands on hoop. Pin-head in well-moulded barrel form.
D. = 6.6 cm. Pin L. = 7.5 cm.
BM
References: *Arch. J.* xxxiii (1876), 132; *Arch.* lxv (1914), pl. XXV, 1

15 SCOTLAND
One half of plain brooch, pin missing. Terminals slightly splayed, oval head, triangular ears, oval eyes in V. Long snout with bulbous tip, slightly raised.
D. = 4.5 cm.
NMAS

16 IRELAND
Plain brooch, complete with pin. Well-moulded terminals with oval head, very small knob-like ears, and very small oval eyes. Rounded snout with moulded tip. Pin-head in elongated barrel

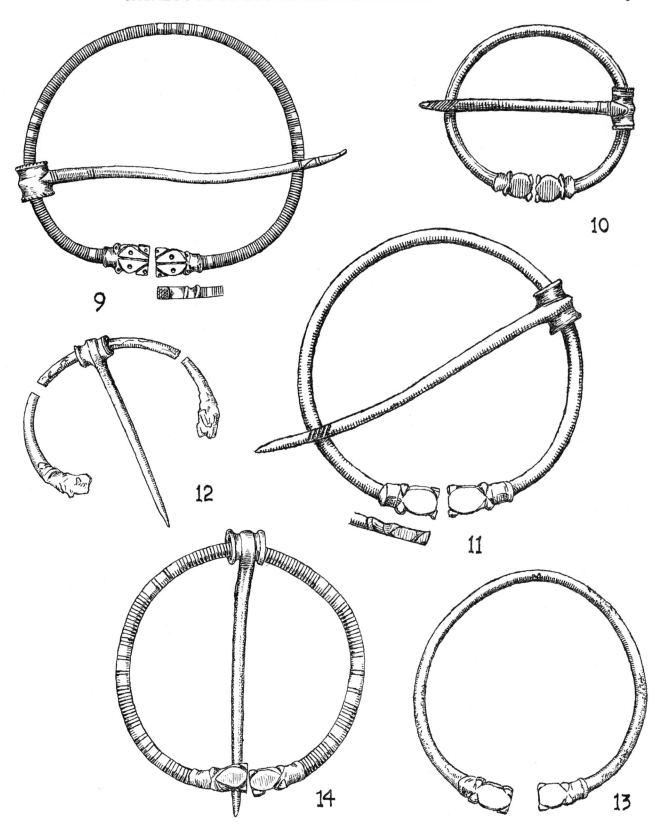

Fig. 21. Brooches of the Initial Form: 9, Roosky, Co. Roscommon; 10, Witcombe, Glos.; 11, Caerwent, Monmouthshire; 12, Maghera, Co. Donegal; 13, Bifrons, Canterbury, Kent; 14, Porth Dafarch, Holyhead, Anglesey. (1/1)

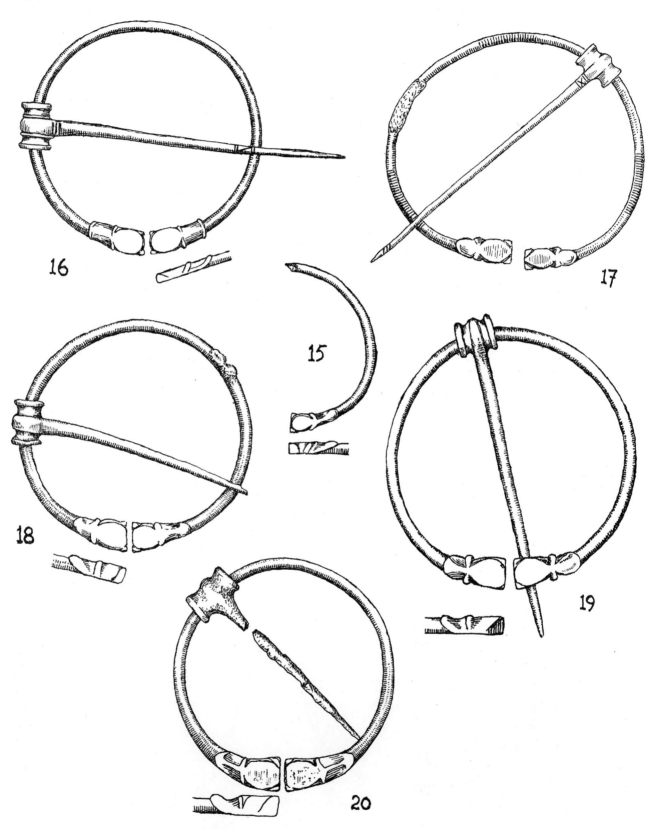

Fig. 22. Brooches of the Initial Form: 15, Scotland; 16, Ireland; 17, Limerick; 18, Aikerness Broch, Evie, Orkney; 19, Pike Hall, Derbys.; 20, Pinhoulland, Walls, Shetland. (1/1)

form, with triple inner moulding. Pin decorated with three parallel lines near head, and two sets of two parallel lines linked by a diagonal line at lower end, near point.

D. = 6.4 cm. Pin L. = 9.0 cm.

BM, 49, 3-1, 42.

17 LIMERICK

Damaged brooch, with repair on hoop, complete with pin. Elongated terminal heads, short snout with upturned tip. Heads oval, eyes wedge shaped, ears triangular. Three bands of ribbing on hoop. Delicately moulded pin-head in barrel form. Slim pin decorated with saltire near head, and wormed near point.

D. = 6.5 cm. Pin L. = 8.5 cm.

Limerick Museum, now missing.

Reference: *N.M.A.J.* ii (1940-1), 85, fig. 2

18 AIKERNESS BROCH, EVIE, ORKNEY

Plain brooch, complete with pin. Terminals splayed, heads oval, ears irregular, eyes long and rounded, medial ridge on snout with bulbous tip. Pin-head well moulded in barrel form.

D. = 6.4 cm. Pin L. = 6.7 cm. (point missing)

NMAS

19 PIKE HALL, DERBYSHIRE

Plain brooch, complete with pin. Very similar to No. 18 above. Pin-head in barrel form, with wedge-shaped central moulding.

D. = 6.9 cm. Pin L. = 8.7 cm.

20 PINHOULLAND, WALLS, SHETLAND

Plain brooch, with damaged pin. Splayed terminals, with angular features of eyes, ears and sharp medial ridge on snout. Bulbous upturned tip. Pin-head of a heavy barrel form.

D. = 6.0 cm. Pin L. = 6.5 (estimated)

NMAS

Reference: *P.S.A.S.* lxvi (1931-2), 80

21 OLDBURY, WILTSHIRE

Plain brooch complete with pin. Oval terminal heads, with badly moulded features of ears and eyes, snout almost non-existent. Pin-head in embryo barrel form.

D. = 7.2 cm. Pin L. = 7.5 cm.

Reference: *W.A.M.* xxiii (1887), 216

22 LEICESTER

Plain brooch, complete with pin. Not really zoomorphic in form, but imitative. Oval terminal heads, vertical rounded ears and eyes, with dots at their centres. Badly moulded pin-head, imitating barrel form.

D. = 6.8 cm. Pin L. = 8.3 cm.

Reference: *V.C.H., Leicester,* i (1907), p. 228

23 IRELAND

Brooch, complete with broken pin. Terminal heads oval, with rounded ears, oval eyes in V form. Short snout with sharp medial ridge, upturned snout tip. Five small bands of ribbing on hoop,

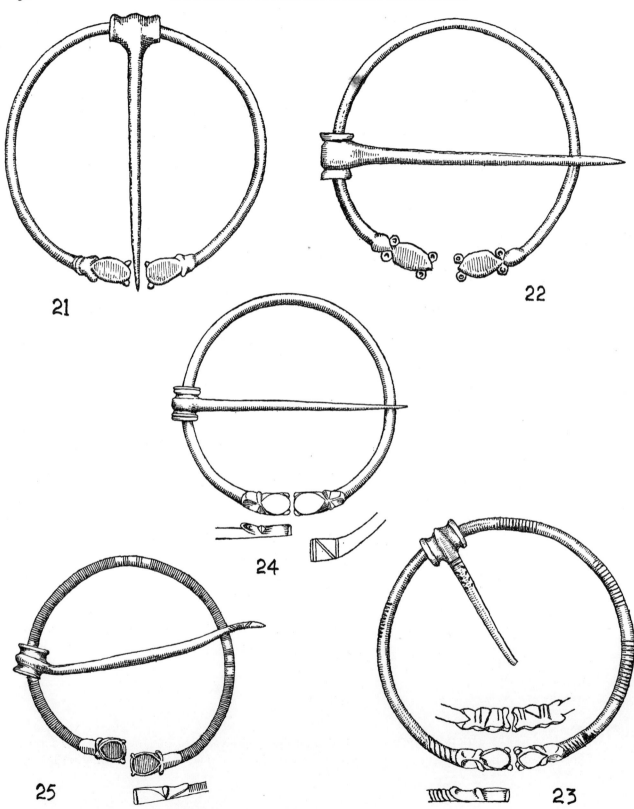

Fig. 23. Brooches of the Initial Form: 21, Oldbury, Wilts.; 22, Leicester; 23, Ireland 24,; *Bravoniacum* (Kirkby Thore), Westmorland; 25, Abingdon, Oxon. (1/1)

and worming near terminals. Reverse sides of terminals decorated with capital N pattern. Well-moulded pin-head, with wedge-shaped middle moulding, and decoration on pin just below.

D. = 7.0 cm.

UM

24 *BRAVONIACUM* (KIRKBY THORE), WESTMORLAND

Plain brooch, complete with pin. Well-moulded terminais, with oval head, slightly rounded ears, and wedge-shaped eyes. Sharp medial ridge on short snouts with upturned tips. Reverse sides of terminals decorated with the capital N pattern. Delicately moulded pin-head, barrel form, outer mouldings relieved with encircling lines.

D. = 6.0 cm. Pin L. = 6.5 cm.

Chesters Museum, No. 2226

Reference: *Cat. of Roman Antiquities in the Museum at Chesters* (1907), No. 1216

25 ABINGDON, OXFORDSHIRE

Brooch, complete with pin. Terminal heads oval with enamel filling in red. Very small features of ears and eyes, and short plain snout. Four bands of ribbing on hoop. Pin-head of foreshortened barrel form, but well moulded. Pin has worming near the point.

D. = 5.5 cm. Pin L. = 7.0 cm.

BM, No. 62, 7-17, 1

Reference: *V.C.H., Berks.*, i (1906), p. 247

26 ARMAGH (neighbourhood of)

Large brooch, complete with pin (broken). Splayed terminals with enamelled heads, triangular ears, elongated rounded eyes. Two tear-shaped hollows on each very slightly upturned snout for enamel. Four unequal bands of fine ribbing on hoop. Elongated barrel-shaped pin-head, triple moulding at centre, outer mouldings relieved by encircling lines. Pin decorated with saltire just below head.

D. = 7.2 cm.

AM, No. 39, 19, 39

27 IRELAND

Plain brooch, complete with pin. Wide-splayed terminals filed flat, and on a level with hoop. Cast features, badly delineated. Small barrel-shaped pin-head.

D. = 5.9 cm. Pin L. = 8.8 cm.

NMI

28 RATHRUANE, SCHULL, CO. CORK

Plain brooch, complete with pin. Slightly splayed terminals, with oval heads, ears marked off at corners, eyes formed by lines filed in form of X. Snouts bulbous, and filed flat with hoop. Degenerate barrel-shaped pin-head.

D. = 5.2 cm. Pin L. = 7.3 cm.

PRM, No. 133-1648

GROUP A

First Series, A_1

29 IRELAND

Plain brooch, complete with pin. Terminals splayed, heads small with ears marked off at corners,

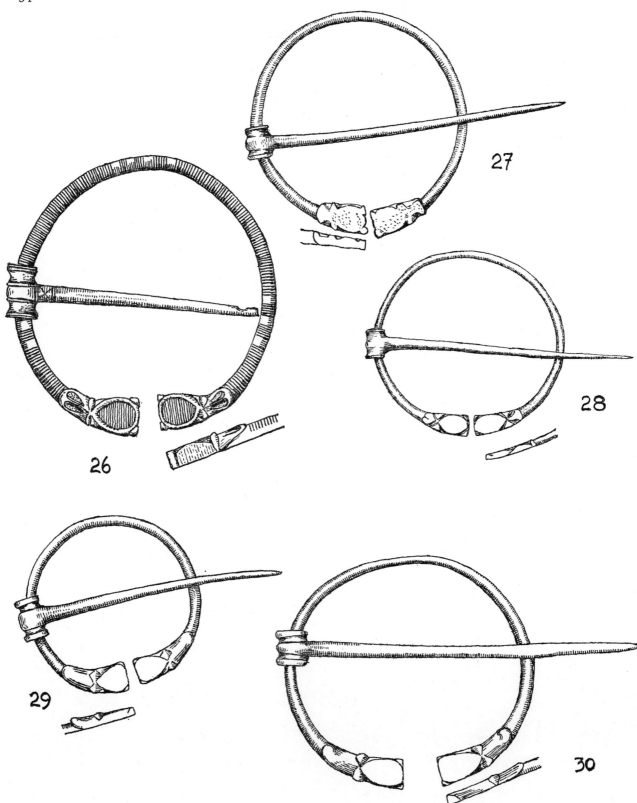

Fig. 24. Brooches of the Initial Form: 26, Armagh; 27, Ireland; 28, Rathruane, Schull, Co. Cork.
Group A$_1$ brooches: 29, Ireland; 30, Co. Longford. (1/1)

pyramidal eyes, snout elongated with bulbous tip. Barrel form pin-head, with wide centre moulding.
D. = 4.8 cm. Pin L. = 7.3 cm.
NMI

30 CO. LONGFORD
Plain brooch, complete with pin. Terminals as No. 29, but better proportion of head length to snout length. Pin-head of foreshortened barrel form, well moulded.
D. = 6.5 cm. Pin L. = 9.8 cm.
BM, No. 98, 6-18, 19

31 TOOMULLIN, CO. CLARE
Plain brooch, complete with pin. Terminals splayed, corners squared, with marked off ears, pyramidal eyes, pronounced medial ridge on snouts, bulbous tips, encircled by transverse chased line. Pin-head large barrel form, stout pin.
D. = 5.3 cm. Pin L. = 10.3 cm.
NMI, No. 1941:57
Reference: *J.R.S.A.I.* lxx (1941), 59

32 IRELAND
Plain brooch, complete with pin (pointed end missing). Wide splayed terminals, heads with ears marked off at rounded corners, pyramidal eyes, bulbous snout tip, unpronounced medial ridge on snout. An attempt has been made to decorate terminals, deep chased line on left-hand terminal, preparatory to undercutting metal for enamel. Snout also marked out for hollowing for enamel. Pin-head debased barrel form on too clumsy pin.
D. = 6.4 cm. Pin L. = 6.5 cm. (incomplete)
BM, No. 68, 7-9, 18

33 DERRYHALE, CO. ARMAGH
Plain brooch, complete with pin. Terminals hammered with squared corners and marked off ears, pyramidal eyes, medial ridges on snouts, bulbous snout tip filed flat. Pin-head in rather untidy barrel form, slim pin.
D. = 6.0 cm. Pin L. = 10.3 cm.
NMI, No. 1906.125

34 IRELAND
Plain brooch, complete with pin. Wide splayed terminals with ears marked off at corners, eyes pyramidal, pronounced ridges on snouts having bulbous tips. Barrel-shaped pin-head, with short stout pin.
D. = 5.7 cm. Pin L. = 6.7 cm.
ASH, No. 1927-101

35 BALLYGLASS, CO. MAYO
Plain brooch, complete with pin. Splayed terminals, with elongated heads having ears marked off at corners. Small pyramidal eyes, short snouts with bulbous tips. Delicately moulded barrel-shaped pin-head.
D. = 5.4 cm. Pin L. = 8.5 cm.
NMI

Fig. 25. Group A₁ brooches: 31, Toomullin, Co. Clare; 32, Ireland; 33, Derryhale, Co. Armagh; 34, Ireland; 35, Ballyglass, Co. Mayo. (1/1)

36 ISLE OF MULL, SCOTLAND
Plain brooch, complete with pin. Thin splayed terminals, tiny ears, pyramidal eyes, long snouts with medial ridges and bulbous tips. Pin-head devolved barrel form.
D. = 6.8 cm. Pin L. = 12.2 cm.
NMAS

37 IRELAND
Small plain brooch, complete with pin, point of which is missing. Hammered splayed terminals, no ears, pyramidal eyes, medial ridge on one snout only, bulbous tip, other snout filed flat. Devolved pin-head.
D. = 4.5 cm.
ASH, 1927-102

38 CO. KILDARE
Badly cast, plain brooch complete with pin. No ears, badly formed eyes, irregular snouts, but one bulbous tip. Pin-head with no centre moulding.
D. = 5.3 cm. Pin L. = 10.3 cm.
PRM, 131-1648

39 BELLEISLE, CO. FERMANAGH
Poorly finished, plain brooch, complete with pin. No ears, small pyramidal eyes, long snouts with raised bulbous tips. Devolved barrel form of pin-head.
D. = 5.1 cm. Pin L. = 10.3 cm.
NMI

40 IRELAND
Plain brooch, complete with pin, similar to No. 39. Large devolved barrel-shaped pin-head, pin point missing.
D. = 4.8 cm.
NMI

Second Series, A_2

41 CO. WATERFORD
Plain brooch, complete with pin, point missing. Heavy hoop, clumsy thick terminals, ears marked off at corners, eyes rounded, sharp ridges on snouts, large bulbous raised tips. Pin-head in debased barrel form.
D. = 5.1 cm.
BM, 88, 7-19, 108

42 MULLINGAR, CO. WESTMEATH
Plain, well-finished brooch, complete with pin. Terminals splayed, and squared, ears marked off at corners, rounded eyes, pronounced ridges on snouts, bulbous upturned snout tips. Pin-head in devolved barrel form.
D. = 4.2 cm. Pin L. = 9.0 cm.
BM, 1913, 7-15, 4

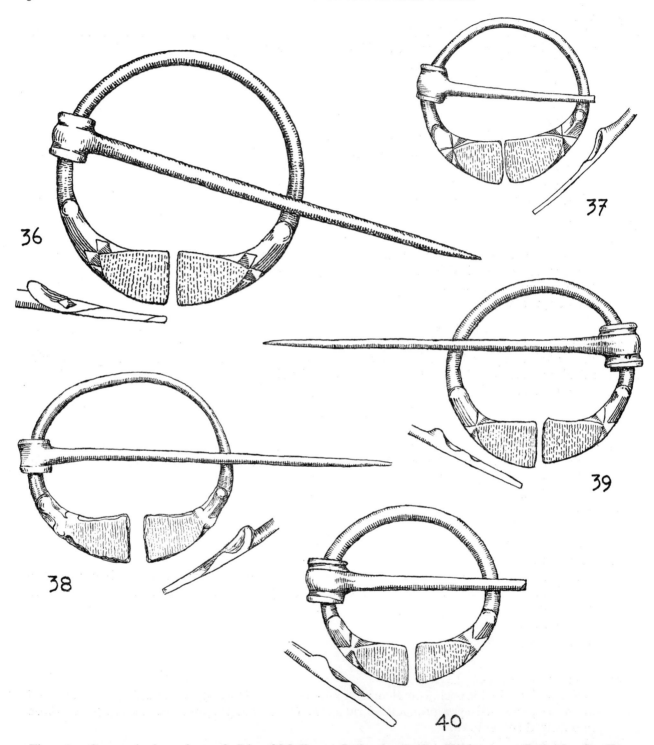

Fig. 26. Group A₁ brooches: 36, Isle of Mull; 37, Ireland; 38, Co. Kildare; 39, Belleisle, Co. Fermanagh; 40, Ireland. (1/1)

43 CO. MAYO
Plain, well-finished brooch, complete with pin, point missing. Otherwise like No. 42, but larger.
D. = 6.2 cm.
BM, Tr. 149

44 IRELAND
Plain, poorly finished brooch, complete with pin. Somewhat clumsy thick terminals, with rounded ears and eyes, prominent upturned bulbous snout. Devolved barrel form of pin-head.
D. = 6.0 cm. Pin L. = 10.9 cm.
AM, 24-1955

45 CO. DONEGAL
Rather crude plain brooch, cast with hollow terminals. Prominent ears, rounded eyes, medial ridges on snouts, snout tips raised and pointed. Pin modern.
D. = 6.3 cm.
UM

46 SCHULL, CO. CORK
Plain brooch, complete with pin with simple mouldings on pin-head. Terminals having rounded ears at corners, rounded eyes, medial ridges on snouts, upturned bulbous snout tips. Ears, head and snout ridges have been filed flat, and on an even plane.
D. = 5.3 cm. Pin L. = 10.4 cm.
NMI

47 IRELAND
Plain brooch, complete with pin, terminals with rounded corners, ears missing, rounded eyes, medial ridges on snouts, very bulbous snout tips. Debased barrel form of pin-head. Decoration on pin, in form of straight line with cross-hatching.
D. = 4.5 cm. Pin L. = 8.0 cm.
NMI

48 IRELAND
Badly cast and badly finished plain brooch, complete with pin, but point missing. Barely delineated ears on thick terminals, rounded eyes, very short snouts with medial ridges, prominent bulbous snout tips. Debased pin-head, but imitating barrel form.
D. = 4.4 cm. Pin L. = 4.5 cm. (point missing)
UM, 551-37

49 DROGHEDA, CO. LOUTH
Plain brooch, complete with pin. Angular terminal ends, no ears, pyramidal eyes, short, almost non-existent snouts with medial ridges, heavy upturned snout tips. Heavy hoop, but well-moulded and well-proportioned barrel-shaped pin-head. The terminals and medial ridges on snouts have been filed flat in one plane.
D. = 4.4 cm. Pin L. = 8.4 cm.
BM, 54, 7-14, 138

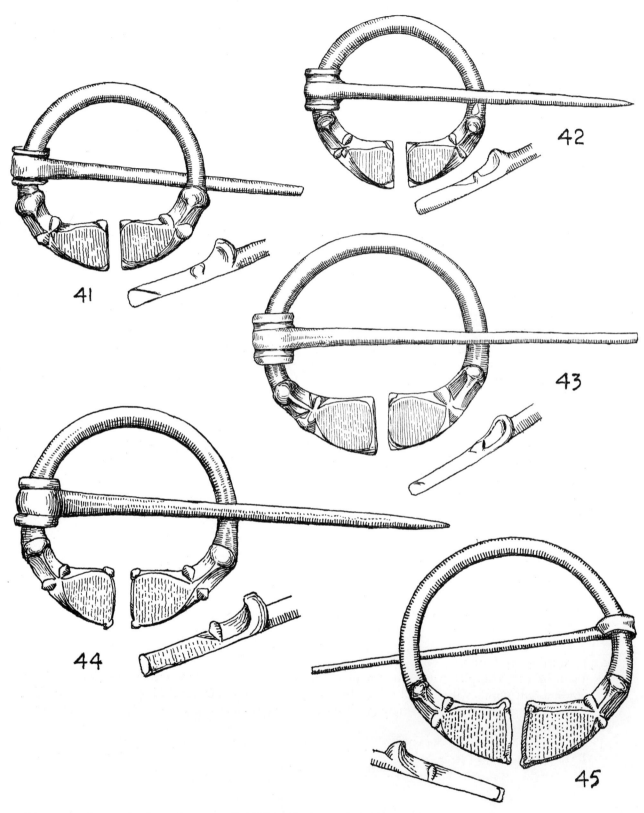

Fig. 27. Group A₂ brooches: 41, Co. Waterford; 42, Mullingar, Co. Westmeath; 43, Co. Mayo; 44, Ireland; 45, Co. Donegal. (1/1)

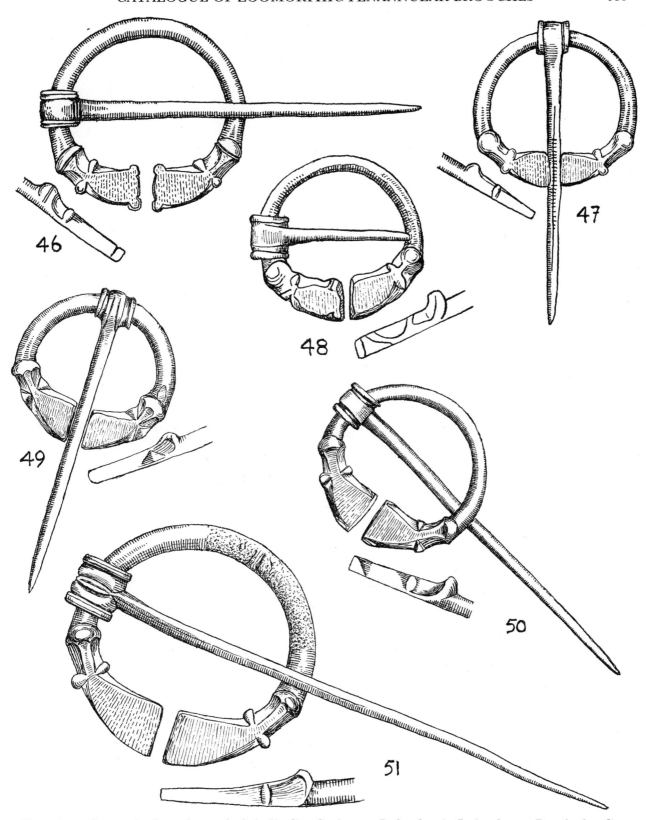

Fig. 28.　Group A₂ brooches: 46, Schull, Co. Cork; 47, Ireland; 48, Ireland; 49, Drogheda, Co. Louth; 50, Longford; 51, Ireland. (1/1)

50 LONGFORD
Plain brooch, complete with pin, and similar in all respects to No. 49, except that eyes here are
rounded.
D. = 4.7 cm. Pin L. = 10.6 cm.
NMI, 1945:21

51 IRELAND
Plain brooch, complete with pin. Similar in all respects to No. 50, but larger. Pin-head decorated
with centre moulding, long oval with medial line, otherwise debased barrel head form.
D. = 6.7. cm. Pin L. = 15.8 cm.
BM, 68, 7-9, 17

52 BALLINTORE, CO. KILDARE
Brooch, complete with pin, point missing. Heavy hoop, decorated with criss-cross and herring-
bone patterns mixed with ribbing. Large bulbous upturned snout tip, rounded eyes, no ears,
terminal enamelled, enamelling continuing to snout tip. Splinters of millefiori are embedded in
the red enamel. Large pin-head, with centre seed-like moulding, and having outer mouldings
decorated with encircling lines, and nicks along the edges. Sides of terminals decorated with
lentoid petals.
D. = 6.4 cm.
BM, 71, 4-7, 17

GROUP B

First Series, B_1

53 KNOWTH, CO. MEATH
Brooch, complete with pin. Hoop decorated with three bands of ribbing, terminals oval-shaped,
the one with a plain oval for enamel, the other having an embryo double spiral on an oval
enamel background. Ears and eyes identical, rounded with dots at their centres. One snout
decayed, the other short and decorated with pattern similar to that on Nijmegen mirror handle,
and enamelled. Narrow pin-head with four equal-sized mouldings, cross ribbing below, worming
on pin point.
D. = 4.7 cm. Pin L. = 6.3 cm.
NMI (courtesy of excavator, G. Eogan)

54 RIVER GREESE, CO. KILDARE
Brooch complete with pin. Three small bands of ribbing on hoop. Thick terminals, having oval-
shaped heads each having paired spherical triangles, with dots at their centres, on enamel back-
ground. Ears and eyes rounded, the former sunk for enamel. Snouts decorated with spherical
triangles, dots at centres, on enamel background. Reverse sides of terminals decorated with
saltires. Pin-head barrel-shaped, but centre moulding wedge shaped and bordered by narrow
secondary mouldings; encircling lines on outer mouldings.
D. = 5.8 cm. Pin L. = 7.4 cm.
NMI, 1945:312

55 IRELAND
Brooch complete with pin. Hoop decorated with five small bands of 'ladder' pattern. Square-
ended terminals with rounded heads, decoration dissimilar, but ornithomorphic in character: in

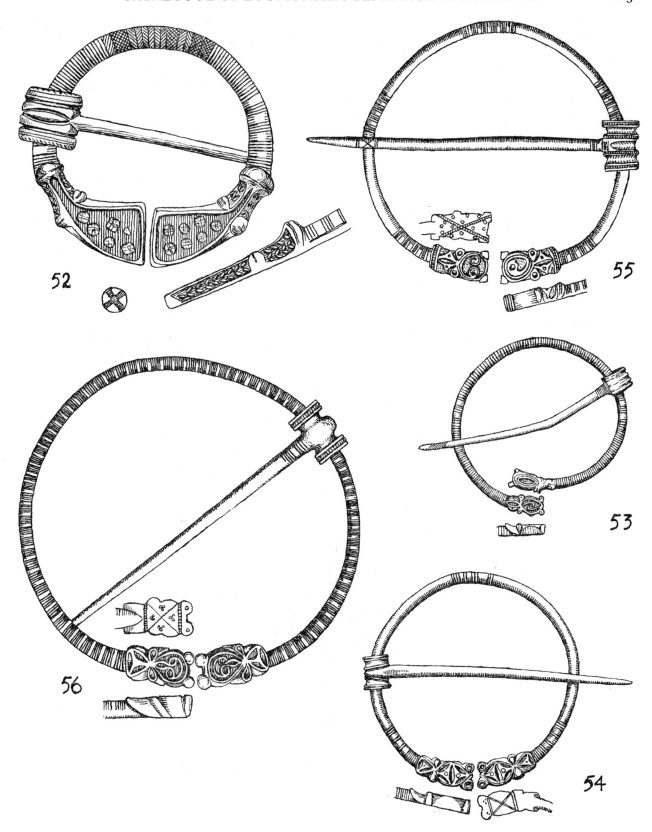

Fig. 29. Group A₂ brooches: 52, Ballintore, Co. Kildare. Group B₁ brooches: 53, Knowth, Co. Meath; 54, river Greese, Co. Kildare; 55, Ireland; 56, Ireland. (1/1)

one case a single spiral ending in a bird-like finial, in the other a simplified palmette whose inturned ends are bird-like. Paired spherical triangles, with dots at centres, decorate the snouts, transverse ladder pattern on snout tips. Triangular ears but rounded eyes sunk for enamel. Reverse sides of terminals have ladder pattern in saltire form and random dots done with hollow punch. Four narrow mouldings on pin-head each decorated with ladder pattern. Saltire between transverse lines near pin point.
D. = 7.3 cm. Pin L. = 9.1 cm.
NMI

56 IRELAND
Large brooch, complete with pin. Hoop completely decorated with very small bands of ribbing. Terminals small and deep, heads rounded, all features in a series of flowing curves, with eyes shaped like a fold and hollowed for enamel, ears rounded, spherical triangles on snouts, and head decorated and enamelled. Reverse sides of terminals have saltires and dots, enclosed within two ladder patterns. Pin-head with squared outer mouldings and a rounded centre moulding, the outer mouldings decorated with ladder pattern.
D. = 9.3 cm. Pin L. = 9.6 cm.
NMAS

56A IRELAND
Brooch, plain hoop, and complete with plain pin. Oval-shaped head, with all features in a series of flowing curves, large and prominent ears with dots of enamel at their centres, eyes slanted and

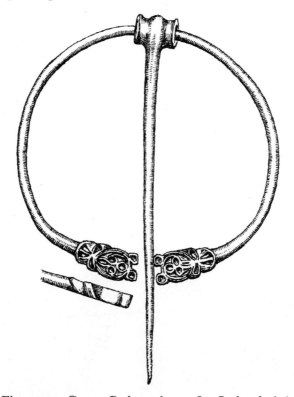

Fig 29A. Group B₁ brooches: 56A, Ireland. (1/1)

shaped like a fold and hollowed for enamel. Snouts each have two hollows filled with enamel. Heads decorated with design based on the palmette, against a background of enamel. In many respects similar to brooch No. 56, and undoubtedly made by the same hand, but earlier, the pin-head being of a simple, early barrel form.

D. = 7.2 cm. Pin L. = 9.8 cm.

Cambridge 27.706

57 FORD OF TOOME, LOUGH NEAGH
Brooch complete with pin. Hoop having four bands of ribbing. Terminals long and slightly splayed, squared with marked-off ears at corners. Heads decorated with paired spherical triangles on enamel background, snouts with medial lines, on both sides of which is enamel filling. Pin-head has four mouldings, and reverse side is decorated with a saltire.

D. = 6.9 cm. Pin L. = 10.7 cm.

UM

Reference: *J.R.S.A.I.* lxii (1932), 209

58 BLACKROCK, CO. LOUTH
Brooch complete with pin, but point missing. Very similar to brooch No. 57, but triangular hollows for enamel on snouts, and debased ribbing only near terminals on hoop. Pin-head in barrel form, with parallel lines on centre moulding.

D. = 7.4 cm. Pin L. (incomplete) = 7.3 cm.

Reference: *C.L.A.J.* vii (1929–32), 530

59 KILLOUGHY, CO. OFFALY
Brooch, hoop plain, pin missing. Eyes marked off at corners of terminals decorated with paired spherical triangles on enamel background. Enamelled snouts with upturned snout tips.

D. = 4.0 cm.

BM, 54, 7-14, 147

60 KING MAHON'S FORT, ARDAGH, CO. LONGFORD
Brooch complete with pin, plain hoop. Long terminals, but otherwise similar to No. 59. Pin-head with two deep channels, imitating barrel form.

D. = 4.5 cm. Pin L. = 7.3 cm.

In possession of Dr. L. de Paor

Second Series, B_2

61 BELCOO, ENNISKILLEN, CO. FERMANAGH
Brooch complete with pin, hoop plain. Splayed terminals, no ears, eyes triangular. Terminals decorated with triskeles on enamel background, snouts enamelled, medial ridge and slightly bulbous snout tip. Unmoulded pin-head decorated with parallel channels.

D. = 5.3 cm. Pin L. = 10.2 cm.

In private possession.

Reference: *J.R.S.A.I.* lix (1929), 69

62 IRELAND
Brooch, pin missing, hoop plain. Wide splayed terminals decorated with triskele pattern, ends

8

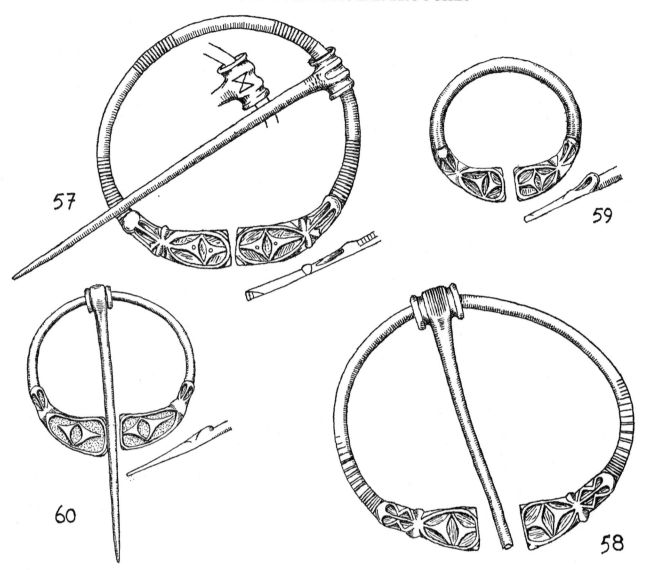

Fig. 30. Group B₁ brooches: 57, Ford of Toome, Lough Neagh; 58, Blackrock, Co. Louth; 59, Killoughy, Co. Offaly; 60, King Mahon's Fort, Ardagh, Co. Longford. (1/1)

twisted into single and double spirals, on enamel background. Snouts enamelled.
D. = 7.0 cm.
Mersey Co. Museum
Reference: *J.R.S.A.I.* lxvi (1936), pl. XXIX, 3

63 IRELAND
Brooch complete with pin, hoop having five bands of ribbing. Splayed terminals decorated in similar pattern to No. 62, but more untidy. Enamelled snouts, and triangular eyes. Middle

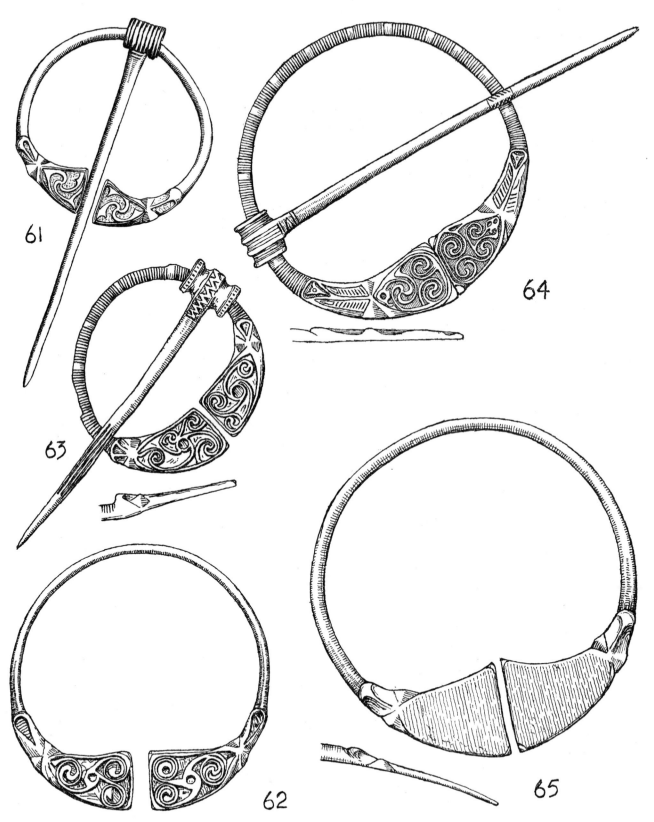

Fig. 31. Group B₂ brooches: 61, Belcoo, Enniskillen, Co. Fermanagh; 62, Ireland; 63, Ireland; 64, Ireland; 65, Cornalaragh Td., Co. Monaghan. (1/1)

moulding of pin-head carries pronounced zigzag pattern, outer mouldings dotted. Otherwise in barrel form. Deep grooves on pin.
D. = 5.3 cm. Pin L. = 9.2 cm.
NMAS

64 IRELAND
Brooch complete with pin. Thirteen small bands of ribbing on completely decorated hoop, wide splayed terminals, with ears marked off at corners. Terminals decorated with unmatching spiral designs, on enamel background. Triangular eyes, snouts decorated with herringbone pattern, snout tips decorated with a spherical triangle each, on enamel background. Pin-head with four mouldings, decorated with parallel lines. Herringbone decoration on pin.
D. = 7.8 cm. Pin L. = 12.3 cm.
NMI

65 CORNALARAGH TOWNLAND, CO. MONAGHAN
Plain brooch, pin missing. Very wide splayed and hammered terminals, exceptionally thin. Ears marked off at corners, eyes triangular, sharp medial ridges on snouts, slightly bulbous snout tips.
D. = 8.9 cm.
NMI, 1965: 315
Reference: *J.R.S.A.I.* xcviii (1968), 122

66 ATHLONE (near), CO. WESTMEATH
Large brooch, complete with pin. Hoop decorated with 12 bands of ribbing, and completely covered. Terminals splayed and squared, ears marked off at corners. Terminals decorated with expertly executed spirals, all double, and consisting of four in number. A central spiral is connected by C scrolls to three others which surround it, on an enamel background. Triangular eyes, enamelled snouts, tips slightly upturned. Pin-head with four mouldings, and decorated with chased parallel lines. Pin decorated with parallel transverse lines connected by a single diagonal line.
D. = 8.9 cm. Pin L. = 16.3 cm.
UM
Reference: *U.J.A.* xxviii (1965), 111, fig. 3C

67 ATHLONE (near), CO. WESTMEATH
Large brooch, complete with pin. Identical with No. 66.
D. = 8.5 cm. Pin L. = 16.8 cm.
NMI

68 ATHLONE (near), CO. WESTMEATH
Plain brooch, complete with pin. Lightweight hoop, exceptionally thin, beaten-out terminals, ears marked off at corners. Very large splayed heads, triangular eyes fashioned by filing in X style, rounded snouts. Pin square in the middle. Wide pin-head, in elongated barrel form, increased width being due to incorporation in centre moulding of an almost rounded, not quite pear-shaped, relief moulding. Very well finished.
D. = 11.5 cm. Pin L. = 19.7 cm.
NMI

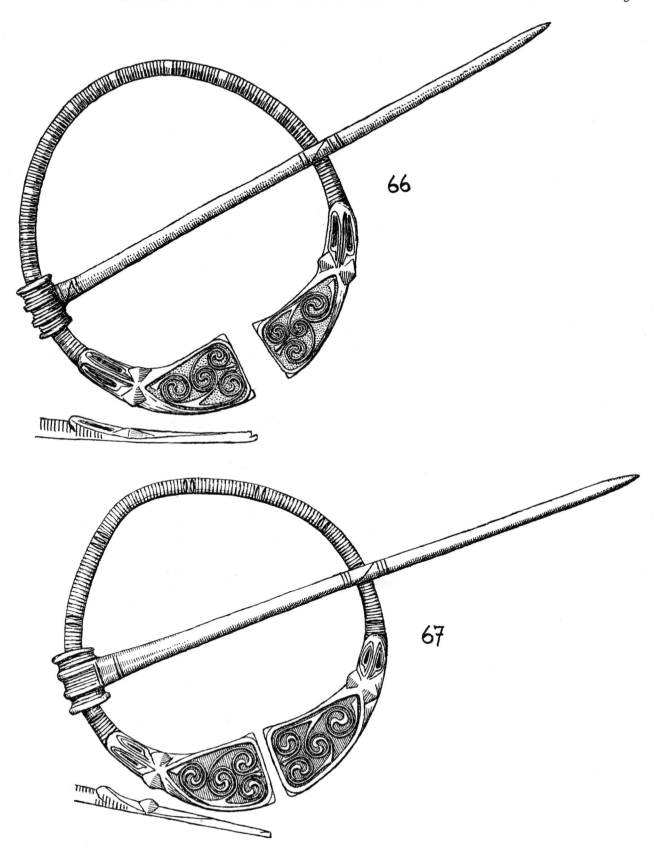

Fig. 32. Group B₂ brooches: 66, 67, from river Shannon, near Athlone, Co. Westmeath. (1/1)

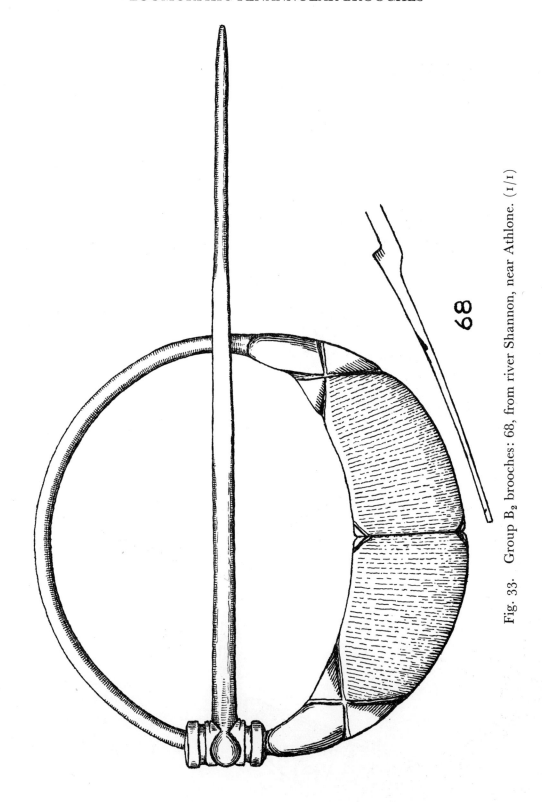

Fig. 33. Group B₂ brooches: 68, from river Shannon, near Athlone. (1/1)

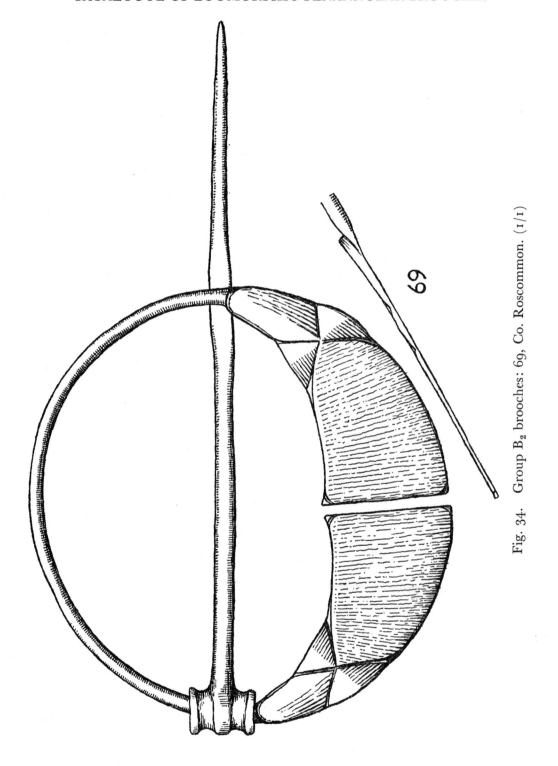

Fig. 34. Group B$_2$ brooches: 69, Co. Roscommon. (1/1)

69 CO. ROSCOMMON

Brooch, plain, and complete with pin. Identical with No. 68, except for different pin-head, here well moulded in barrel form.

D. = 11.5 cm. Pin L. = 18.9 cm.

BM, 49, 3-1, 41

Reference: *Arch. J.* vii (1850), 79

GROUP C

First Series, C_1

70 LOUGH NEAGH

Large brooch, complete with pin. Hoop decorated with unequal bands of ribbing, divisions on hoop undercut. Elongated terminals, ears marked off at corners, heads decorated with two sets each of running spirals. Eyes rounded. Medial ridges on snouts, both sides of which are running spirals. Rounded snout tip. Pin decorated near point with chevron decoration, pin-head based on barrel form, but mouldings squared. Central oval moulding, hollows each side having criss-cross lines. Entire reverse side of brooch decorated with capital N pattern on terminals, and Ks on hoop.

D. = 9.0 cm. Pin L. = 14.6 cm.

PRM, 1723, 403 blue

Reference: *P.S.A.*² iv (1868), 62

71 CO. ANTRIM

Brooch, complete with broken pin. Hoop decorated with four bands of ribbing, splayed hollow terminals, with one ear a side rounded, the others marked off, rounded eyes and snout tip filed flat, complex decoration the basis of which is the simplified palmette on terminal heads, enamelled, with insets of opaque glass in small squares, enamelled scrolls on snouts. Pin-head made up of three mouldings of equal size, seed-like, with medial lines, set side by side.

D. = 6.7 cm.

BM, 80, 8-2, 134

72 IRELAND

Brooch, complete with pin. Hoop decorated with ribbing, splayed terminals, ears marked off at corners, each head decorated with three spirals having finials of an ornithomorphic character on enamel background, angular eyes, snouts decorated with scrolls on enamel. Pin-head same as No. 71, but pin decorated with chevron pattern.

D. = 6.9 cm. Pin L. = 13.1 cm.

Walters Art Gallery, Baltimore

73 IRELAND

Brooch, complete with pin. Hoop decorated with four bands of ribbing, splayed terminals, ears marked off at corners, complex decorative pattern incorporating primitive spirals on enamel background on heads, angular eyes, pronounced medial ridge on snout, miniaturized multiple lozenge pattern bordering it on both sides, and along sides of terminals, bulbous snout. Pin-head similar to No. 71, but here medial lines on seed-like moulding are in ladder pattern. V decoration on pin.

D. = 7.5 cm. Pin L. = 12.0 cm.

NMI

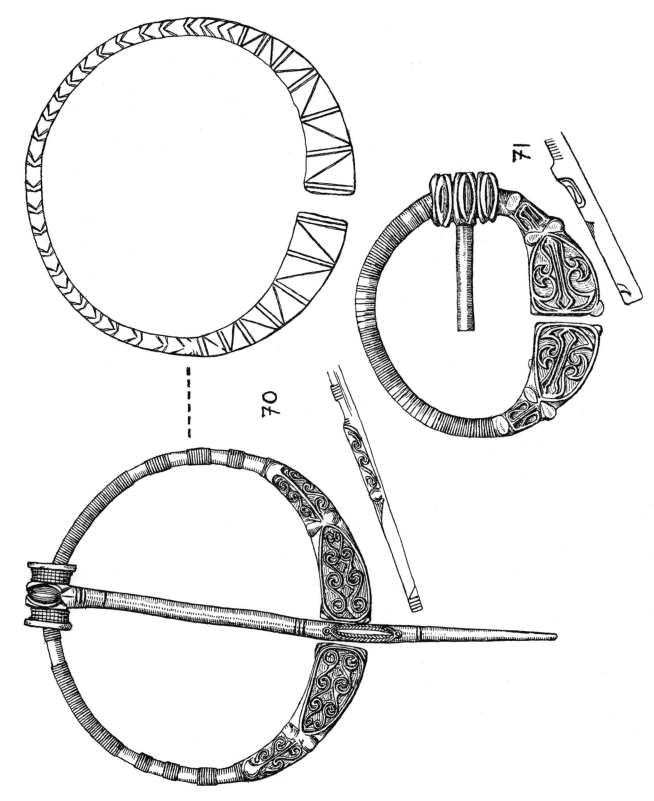

Fig. 35. Group C₁ brooches: 70, Lough Neagh; 71, Co. Antrim. (1/1)

74 CO. CAVAN

Brooch, complete with pin. Hoop decorated with three bands of ribbing. Terminals splayed, with rounded ears hollowed for enamel at corners, plain enamel decoration, snouts decorated with lentoid petals, which also decorate sides of terminals. Snout tips prominent and upturned, decorated with encircling transverse line. Reverse sides of terminals decorated with two concentric circles and dots done with a hollow punch. Both also have a diagonal ladder pattern. The pin is decorated with one long deeply incised line, and transverse lines at both ends of this. Pin-head is made up of six mouldings, side by side, and three of these have secondary seed-like mouldings at the front, each with medial line. At top and bottom of each moulding is a small round knob.

D. = 7.0 cm. Pin L. = 12.5 cm.

BM, 56, 3-20, 1

75 IRELAND

Brooch, complete with pin. Splayed hollow terminals, with rounded ears at corners, heads decorated with triskeles with tentacle-like ends on enamel background, rounded eyes, enamelled snouts with medial ridges, and knob-like tips. Hoop decorated with two small bands of ribbing, and a small band of an M pattern. Barrel-shaped pin-head with centre seed-like moulding, and bow-shaped projections below it.

D. = 6.3 cm. Pin L. = 12.5 cm.

NMI

76 MAGHERAFELT (near), CO. DERRY

Brooch complete with pin. Hoop decorated with two short bands of ribbing and one long. Splayed terminals, with rounded ears at corners, plain enamelled terminal heads, angular eyes, snouts decorated with zigzags and lentoid petals. Pin-head similar to No. 75, but centre moulding extended. Multiple lozenge pattern on sides of terminals, which have hollow backs.

D. = 6.5 cm. Pin L. = 13.9 cm.

PRM, 141-1649

76A CASTLEPORT, CO. DONEGAL

Brooch complete with long pin. Hoop decorated with eight bands, very narrow, and two wider bands of ribbing. Terminals with small rounded ears, rounded eyes, heads with single pieces of millefiori in red enamel background, snouts enamelled and having pronounced medial ridges, snout tips bulbous and raised. Pin-head similar to No. 76.

D. = 4.4 cm. Pin L. = 13.2 cm.

UM

77 IRELAND

Brooch, complete with pin. Three widely spaced bands of ribbing on hoop. Splayed terminals, with rounded ears at corners, angular eyes, heads decorated with plain red enamel. Zigzag decoration on snouts and on sides of terminals. Snout tips raised and rounded. Heavy pin-head of same form as No. 76.

D. = 5.7 cm. Pin L. = 11.4 cm.

NMI

78 CALEDON (near), CO. TYRONE

Brooch, complete with broken and damaged pin. Hoop decorated with four bands of ribbing. Terminals splayed with rounded ears at corners, angular eyes, heads decorated with plain enamel,

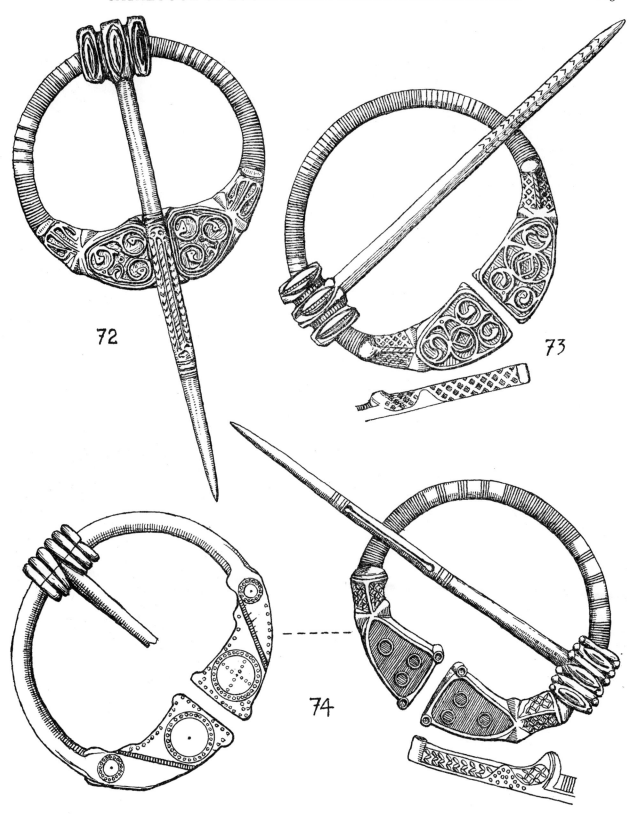

Fig. 36. Group C₁ brooches: 72, Ireland; 73, Ireland; 74, Co. Cavan. (1/1)

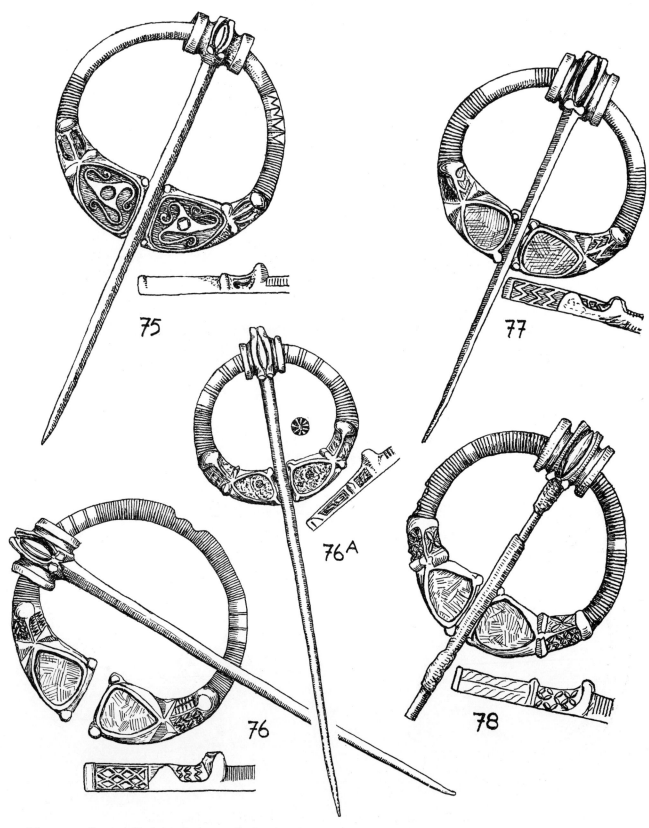

Fig. 37. Group C$_1$ brooches: 75, Ireland; 76, near Magherafelt, Co. Derry; 76A, Castleport, Co. Donegal; 77, Ireland; 78, near Caledon, Co. Tyrone. (1/1)

snouts with one half lentoid petals, the other half with quatrefoil design. Snout tips upturned and rounded. Large badly moulded pin-head, basically the same design as No.76.
D. = 6.0 cm.
Caledon House Collection, 1967

Second Series, C$_2$

79 CLONARD, CO. MEATH
Badly cast brooch, complete with pin. Narrow terminals with only one ear each, rounded eyes, one head having crude scroll on enamel background, the other plain enamelled. Enamelled snouts, pronounced medial ridges. Large raised snout tips. Pin-head of debased barrel form.
D. = 3.3 cm. Pin L. = 9.2 cm.
BM, 1962, 12-19, 3

80 IRELAND
Well-finished brooch, complete with pin. Plain hoop, short terminal heads decorated with enamel, no ears, rounded eyes, plain snouts with sharp medial ridges, pronounced upturned snout. Reverse sides of terminals decorated with capital N design. Narrow pin-head of uncertain form, but moulded.
D. = 3.9 cm. Pin L. = 7.9 cm.
ASH, 1927-120

81 IRELAND
Large brooch, complete with pin. Two bands of widely spaced ribbing, on hoop, otherwise plain. Heavy terminals, with ears marked off at corners, plain enamel on heads, rounded eyes, snouts with pronounced medial ridges and large rounded snout tips. Snouts decorated with transverse parallel lines. Pin-head of simple form but having deep channels on front.
D. = 6.7 cm. Pin L. = 10.8 cm.
NMI

82 CO. WESTMEATH
Brooch, complete with pin. Slight ribbing of hoop near terminals, splayed and squared terminals, with ears marked off at corners, heads decorated with paired simplified palmettes on enamel background, rounded eyes. Snouts with sharp medial ridges, and decorated with lines, snout tips upturned and rounded. Debased barrel form pin-head, decorated with short channels.
D. = 4.5 cm. Pin L. = 9.8 cm.
BM, 1921, 12-6, 43

83 LOUGH RAVEL CRANNOG, RANDALSTOWN, CO. ANTRIM
Brooch, complete with pin. Coarse ribbing in four bands on hoop, terminals with marked-off ears at corners, heads with sunk square for millefiori, otherwise enamelled, rounded eyes, snouts with sharp medial ridges and decorated with lentoid petals. Snout tips upturned and rounded. Pin-head devolved barrel form, with saltire on centre moulding.
D. = 4.6 cm. Pin L. = 9.4 cm.
BM, 1913, 7-15, 3

84 IRELAND
Brooch, complete with heavy pin. Numerous small bands of ribbing on hoop. Terminals with projecting rounded ears at corners, heads having squares of millefiori at centres on enamel back-

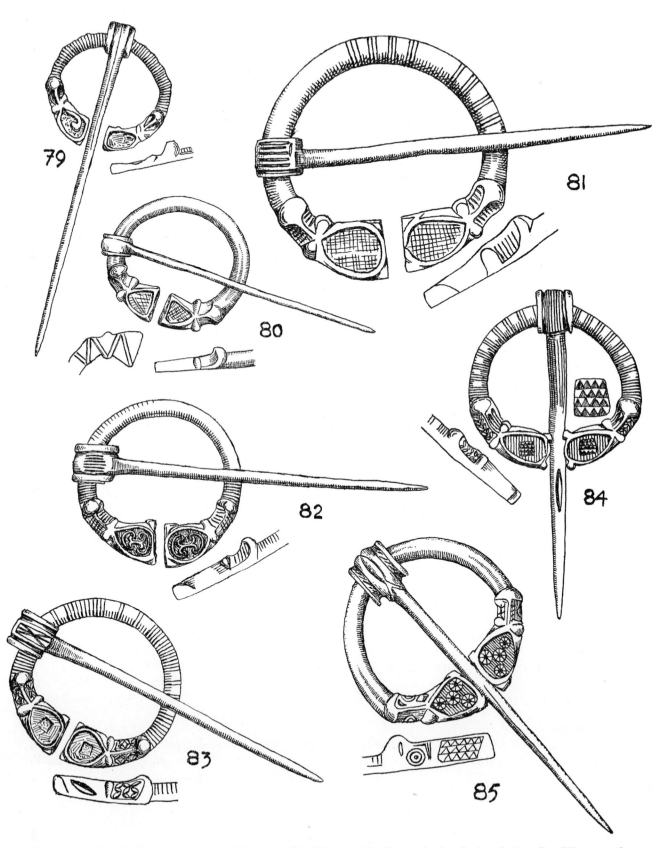

Fig. 38. Group C₂ brooches: 79, Clonard, Co. Meath; 80, Ireland; 81, Ireland; 82, Co. Westmeath;
83, Lough Ravel crannog, Randalstown, Co. Antrim; 84, Ireland; 85, Ireland. (1/1)

ground, eyes rounded. Snouts with sharp medial ridges, part decorated with lentoid petals, part deep channelling, snout tips bulbous. Devolved barrel-shaped pin-head, decorated with parallel chased lines. Chased lines on almost one half of pin, deep channel near point.
D. = 4.6 cm. Pin L. = 8.7 cm.
NMI

85 IRELAND
Brooch, complete with pin. Hoop plain. Terminals with ears marked off at corners, and slightly proud of heads, heads decorated with four pieces each of round millefiori on enamel background. Sharp medial ridges on snouts, with concentric circle decoration. Snout tips raised and rounded. Pin-head with embryo seed-like moulding at centre. Terminals decorated with multiple zigzags on sides.
D. = 4.8 cm. Pin L. = 10.2 cm.
NMI

86 CASTLEDERMOT (near), CO. KILDARE
Brooch, with heavy hollow-backed terminals. Hoop plain except for some ribbing near terminals, and having four loose coils of bronze wire. Clumsy terminals, with angular ears marked off at corners, eyes rounded. Heads decorated with two pieces of round millefiori each, on enamel background. Sharp ridges to snouts, which like the sides of the terminals are decorated with lentoid petals. Wide and heavy bulbous snout tips. Large barrel-shaped pin-head, with centre seed-like moulding having medial line. The millefiori is in blue and white.
D. = 7.3 cm. Pin L. = 15.2 cm.
NMI

87 ARTHURSTOWN, CO. KILDARE
Well-finished brooch, complete with pin. Three widely spaced bands of ribbing on hoop. Well-proportioned terminals, with angular ears marked off at corners. Heads having designs based on simplified palmette, on enamel background. Eyes rounded. Sharp medial ridges on snouts, which are decorated with lentoid petals. Upturned bulbous snout tips. The terminals are hollow-backed. Devolved form of barrel-shaped pin-head, with seed-like moulding moved to the top, and a square of enamel in front. Deep channel near centre of pin.
D. = 6.4 cm. Pin L. = 11.0 cm.
NMI, 1934:10.863

88 ARMAGH
Large brooch, complete with pin. One half of hoop decorated with ribbing, the other half plain. Very long terminals, with rounded ears projecting at corners. Heads decorated with complex pattern, at centre of which is the simplified palmette, having a square of millefiori centrally placed, and two others below and one above, making a total of four for each head: the whole on a background of enamel. Rounded eyes. Sharp ridges on snouts, decorated with lentoid petals, which also decorate sides of terminals. Bulbous snout tips, one encircled by transverse line. Colour of millefiori: white and blue. Pin-head similar to No. 87, but square for enamel on front is bigger.
D. = 8.5 cm. Pin L. = 15.9 cm.
AM, 38:1939
Reference: *U.J.A.*[3] iii (1940), 70

89 BALLINDERRY CRANNOG NO. 2, CO. WESTMEATH
Very large and complex brooch, complete with large pin. The entire hoop is decorated with a mixture of criss-cross and herringbone patterns, alternating. The heavy terminals have projecting angular ears, the heads decorated with a mixture of pieces of millefiori on an enamel background. Eyes rounded, snouts with pronounced sharp medial ridges, and decorated with lentoid petals, as are the sides of the terminals. Pronounced snout tips. Reverse sides of terminals decorated with sixfoil motifs and parts thereof on sweated-on bronze plates. The pin and centre part of head, with a sunk square containing millefiori on a background, and having at the back a seed-like moulding with a medial ladder pattern, are original; but the flanges, bearing the same decoration as the hoop, have been added later by mounting them on a bronze tube which passes through the head. There are two loose coils of bronze wire on the hoop.
D. = 8.7 cm. Pin L. = 18.3 cm.
NMI
Reference: *P.R.I.A.* xlvii, C (1942), 34

90 IRELAND
Badly-preserved brooch, complete with pin. Hoop plain. Simple terminals, with marked-off ears, no eyes, hollows on heads and where snouts should be for enamel. Pin-head similar to No. 87, but having two squares at front for enamel.
D. = 3.4 cm. Pin L. = 4.3 cm.
BM, 88, 7-19, 110

91 CLONFERT, CO. GALWAY
Brooch, pin missing. Hoop covered with four unequal bands of ribbing. Deep heads with marked-off and projecting ears, heads formerly having square of millefiori on background of enamel, projecting irregularly shaped eyes, embryo snout, large snout tips flattened on top.
D. = 4.0 cm.
BM, 68, 7-9, 20

Third Series, C₃

92 IRELAND
Brooch, complete with pin, point missing. Hoop plain. Small terminals, rounded edges, ears marked off at corners, eyes rounded. Heads decorated with scroll-like pattern on enamel background. Indented snouts with bulbous snout tips. Unresolved barrel form of pin-head.
D. = 6.8 cm.
NMI

93 IRELAND
Brooch, complete with pin. Elongated terminals, with marked-off ears at corners, heads decorated with scroll pattern on enamel background. Angular eyes, snout decorated with mutiple lozenge pattern, enamelled. Hoop completely decorated with three bands of fine ribbing. Reverse sides of terminals decorated with capital N design. Undeveloped form of barrel pin-head.
D. = 7.2 cm. Pin L. = 9.6 cm.
NMI

94 IRELAND
Brooch, complete with pin. Hoop decorated with seven bands of ribbing. Terminals plain and squared, ears marked off at corners. Triangular eyes. Snouts rounded with squared tips. Wide

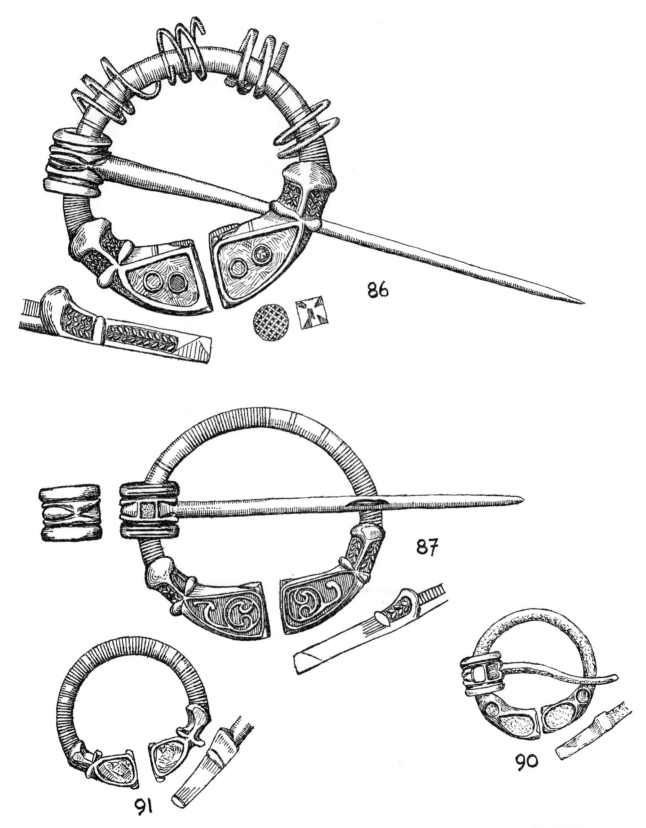

Fig. 39. Group C₂ brooches: 86, near Castledermot, Co. Kildare; 87, Arthurstown, Co. Kildare; 90, Ireland; 91, Clonfert, Co. Galway. (1/1)

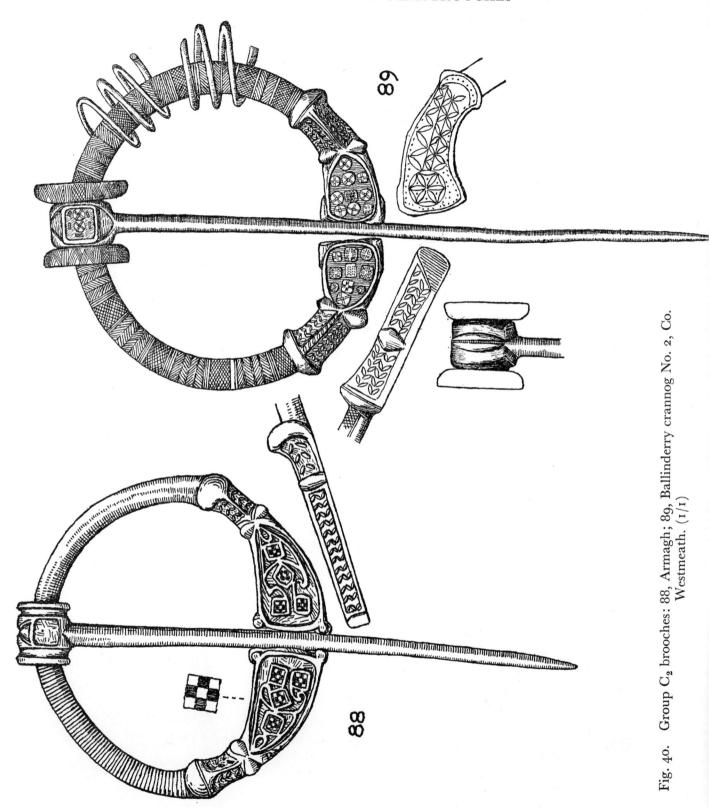

Fig. 40. Group C₂ brooches: 88, Armagh; 89, Ballinderry crannog No. 2, Co. Westmeath. (1/1)

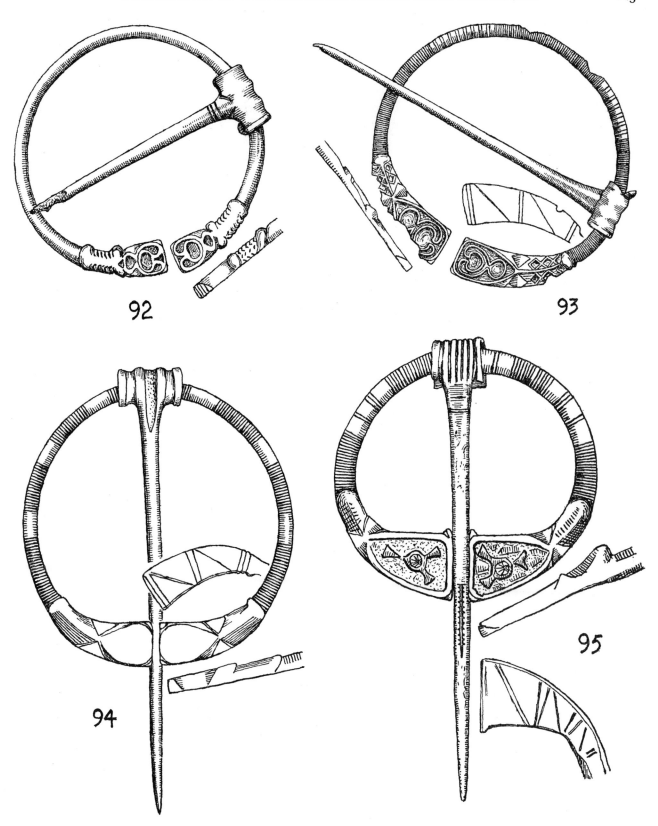

Fig. 41. Group C₃ brooches: 92, Ireland; 93, Ireland; 94, Ireland; 95, Ireland. (1/1)

pin-head with four mouldings, plain. Reverse sides of terminals decorated with capital N design.
D. = 7.5 cm. Pin L. = 11.9 cm.
NMI

95 IRELAND
Brooch, complete with pin. Hoop decorated with four widely spaced bands of ribbing, splayed
terminals with small projecting ears at corners, heads decorated with degenerate triskeles having
a round chip of millefiori at their centres, on an enamel background, triangular eyes. Snouts are
rounded and upturned, and hatched. Poorly moulded pin-head ornamented with deep channels.
Reverse sides of terminals decorated with capital N design.
D. = 7.2 cm. Pin L. = 12.3 cm.
NMAS

96 CO. ARMAGH
Brooch, complete with pin. Hoop plain. Wide splayed terminals, with ears marked off at corners.
Heads decorated with chips of millefiori set in enamel background, angular eyes. Wide snouts
having marked medial ridges, and decorated with Vs. Prominent rounded snout tips. Pin-head
well moulded in barrel form, and decorated with ladder pattern.
D. = 5.6 cm. Pin L. = 9.7 cm.
NMI

97 IRELAND
Brooch, with plain hoop, pin missing. Terminal heads enamelled, with marked-off ears at corners,
angular eyes. Wide snouts decorated with Vs, and having pronounced medial ridges, snout tips
very bulbous. Sides of terminals decorated with lentoid petals.
D. = 6.3 cm.
BM, 91, 4-20, 6

98 SHANTEMON, CO. CAVAN
Well-made brooch, complete with pin. Hoop decorated with four bands of ribbing, of uneven
widths. Squared terminals, with angular ears marked off at corners. Heads decorated with scroll
pattern with swollen finials, on enamel background. Eyes pyramidal. Lentoid petals and ladder
pattern decorate snouts with pronounced medial ridges, and upturned rounded tips. Pin-head
degenerate barrel form decorated with deep channels.
D. = 5.6 cm. Pin L. = 11.7 cm.
NMI, 1933:581

99 IRELAND
Clumsy brooch complete with heavy pin. Continuous ribbing on hoop. Small terminal heads
with ears marked off at corners, and decorated with simple pattern on background of enamel,
eyes angular. Wide snouts with pronounced medial ridges, and indented with transverse lines,
bulbous snout tip. Barrel-shaped pin-head, narrow outer mouldings, centre moulding decorated
with very fine and narrow ladder pattern. One long score on pin.
D. = 5.5 cm. Pin L. = 9.4 cm.
NMI

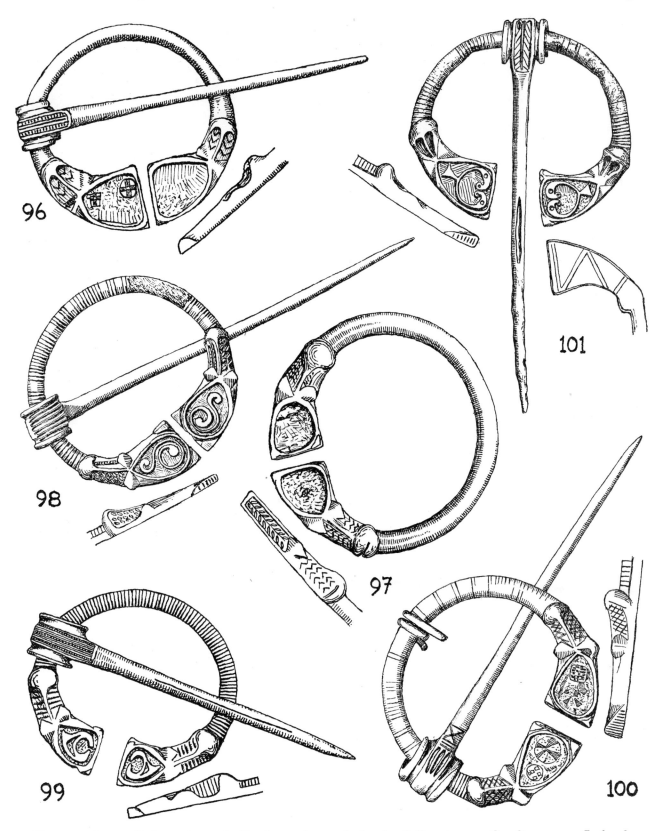

Fig. 42. Group C₃ brooches: 96, Co. Armagh; 97, Ireland; 98 Shantemon, Co. Cavan; 99, Ireland; 100, Belleisle, Co. Fermanagh; 101, Bloomfield, Co. Roscommon. (1/1)

100 BELLEISLE, CO. FERMANAGH
Brooch complete with pin. Hoop with a few scratches of ribbing, and having a loose coil of bronze wire. Terminals splayed and squared, with angular ears marked off at corners. Heads decorated with a few chips of millefiori on background of enamel. Eyes pyramidal and rounded. Snouts decorated with criss-cross pattern and having pronounced medial ridges, snout tips rounded and upturned. Degenerate barrel form of pin-head with three deep channels, and pin decorated with saltire just below head.
D. = 5.8 cm. Pin L. = 11.3 cm.
NMI, E20:696

101 BLOOMFIELD, CO. ROSCOMMON
Poorly-preserved brooch, complete with pin. Hoop decorated with four small bands of ribbing widely spaced. Squared and splayed terminals with ears marked off at corners. Heads having decoration simulating the simplified palmette, but having inturned ends in form of birds' heads, on enamel background. Eyes angular. Snouts decorated with enamel, bulbous snout tips, one with encircling transverse line. Well-moulded barrel-shaped pin-head, decorated with chevron pattern. Deep channel half way down pin. Reverse sides of terminals decorated with zigzags.
D. = 5.6 cm. Pin L. = 10.5 cm.
NMI, 114
Reference: *J.R.S.A.I.* lxxxviii (1958), 129

102 IRELAND
Brooch, with continuous ribbing on hoop, pin missing. Elongated terminal heads with pronounced squared ends, large angular ears marked off at corners. Plain enamelling on heads, eyes pyramidal but rounded. Snouts with pronounced ridges, transverse indented lines. Snout tips upturned and rounded.
D. = 5.9 cm.
BM, 91, 4-20, 7

103 IRELAND
Brooch, with three bands of ribbing on hoop, pin missing. Terminals elongated and splayed, ears in the form of small projection on inner sides only. Heads decorated with two squares each of millefiori, in enamel background. Eyes angular. Snouts decorated with enamel, and large prominent snout tips, rounded.
D. = 5.5 cm.
BM, 88, 7-19, 109

104 IRELAND
Brooch, with continuous coarse ribbing on hoop, and complete with pin. Splayed terminals decorated with plain enamel, no ears, eyes rounded. Pinched-in snouts decorated with enamel. Prominent upturned snout tips. More or less formless pin-head with side hatching.
D. = 4.6 cm. Pin L. = 10.5 cm.
PRM, 142-1649

105 CO. WESTMEATH
Brooch, with four unequal bands of ribbing on hoop, and complete with pin. Splayed terminals, with marked-off ears at corners, heads enamelled, eyes angular. Enamelled snouts with upturned

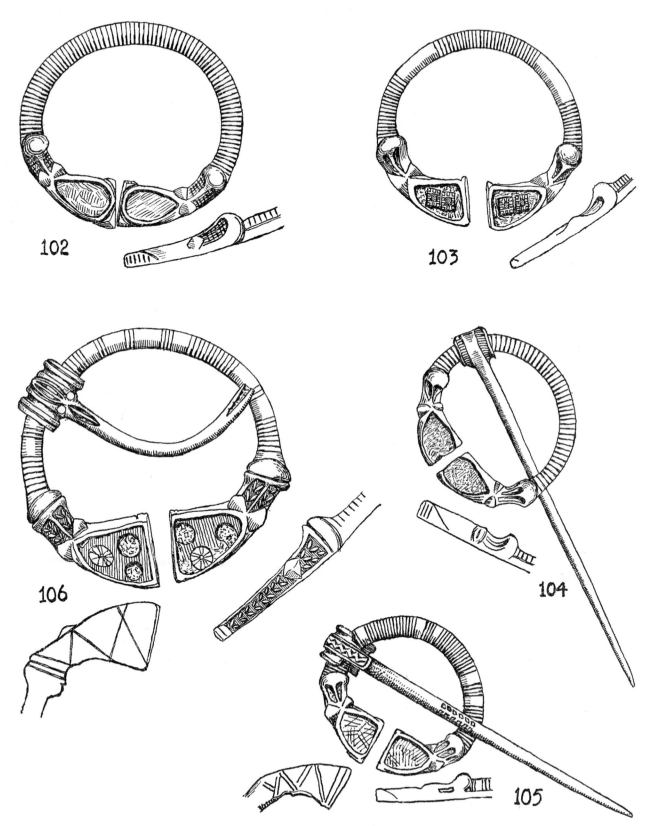

Fig. 43. Group C₃ brooches: 102, Ireland; 103, Ireland; 104, Ireland; 105, Co. Westmeath; 106 Ireland. (1/1)

rounded tips. Reverse sides of terminals decorated with capital N pattern. Barrel form of pin-head, with zigzag line in relief as decoration. Decoration on pin.
D. = 4.3 cm. Pin L. = 9.7 cm.
Location not recorded.

106 IRELAND
Large brooch, with four unequal and unequally spaced bands of ribbing on hoop, complete with pin, half of which is missing. Splayed and squared terminals, ears just indicated at corners. Chips of millefiori in a background of enamel decorate the heads. Eyes pyramidal. Sides of terminals and snouts decorated with lentoid petals. Reverse sides of terminals decorated with capital N pattern. Snout tips large and bulbous, with encircling transverse lines. Sharp ridges on snouts. Very good moulded pin-head in barrel form, with seed-like moulding at centre sunk for enamel, two dots of red enamel just below. Deep channel on pin just below head, and another half way down, which was the cause of the break in the pin.
D. = 7.0 cm. Pin L. (estimated) = 14.0 cm.
BM, 54, 12-27, 61

107 IRELAND
Brooch, with continuous ribbing on hoop, complete with pin-head and short length of pin. Small terminal heads, decorated with enamel, no ears, eyes large and angular. Wide enamelled snouts, with sharp medial ridges. Snout tips upturned and rounded. Remains of capital N pattern on reverse sides of terminals. Pin-head well moulded in enlarged barrel form, with seed-like moulding at centre.
D. = 5.5 cm.
BM, 47, 5-20, 25

108 OLD CASTLE OF CARBURY, CO. KILDARE
Brooch, with hoop decorated with five bands of ribbing each separated with quatrefoils, and complete with pin. Terminal heads decorated with paired simplified palmettes on background of enamel, ears marked off at corners, eyes pyramidal, rounded snouts enamelled, upturned snout tips encircled with transverse lines. Well-moulded barrel-shaped pin-head with centre seed-like moulding. Pin decorated with ribbing over almost its entire length. Two bored-out dots linked with a seed-like depression also occur half way down length of pin.
D. = 6.2 cm. Pin L. = 11.5 cm.
NMI

109 IRELAND
Very well finished brooch, complete with pin. Hoop has continuous ribbing but for intercession between it and the terminals of three (a side) triangles. Wide splayed terminals, with ears marked off and slightly projecting at the corners. Heads decorated with patterns having at their centres a square of millefiori, all on a background of enamel. Short enamelled snouts, with sharp upturned snout tips. Reverse sides of terminals decorated with zigzag line. Well-moulded enlarged barrel-shaped pin-head with seed-like moulding at centre. Pin decorated with zigzag in relief. Lentoid petals on terminal sides.
D. = 4.4 cm. Pin L. = 8.6 cm.
NMI

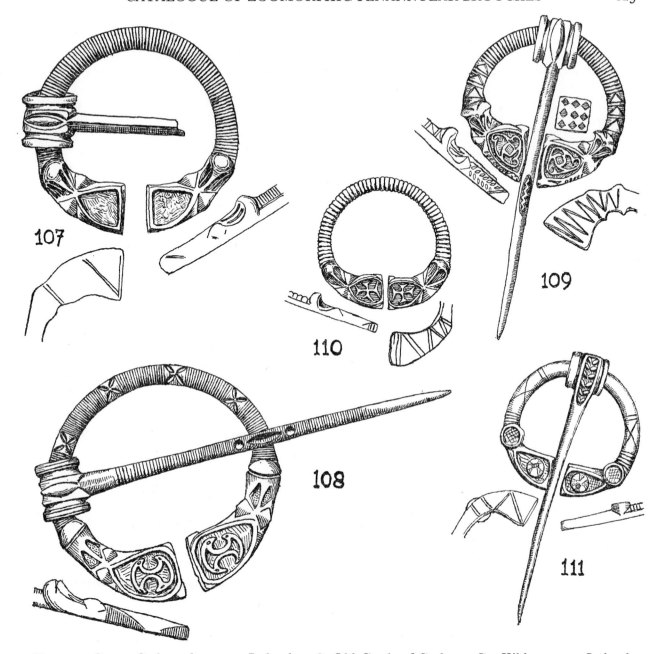

Fig. 44. Group C₃ brooches: 107, Ireland; 108, Old Castle of Carbury, Co. Kildare; 109, Ireland; 110, Limerick; 111, Knockfeerina Hill, Td. Killoughty, or Common, Co. Limerick. (1/1)

110 LIMERICK (probably)
Brooch, with continuous coarse ribbing covering entire hoop, pin missing. Terminal heads with
marked-off ears at corners, and ornamented with 'Maltese' crosses on enamel background. Eyes
angular. Snouts decorated with enamel, snout tips upturned and rounded. Reverse sides of
terminals decorated with capital N pattern.
D. = 3.5 cm.
Limerick Public Library

111 KNOCKFEERINA HILL, TD. KILLOUGHTY, OR COMMON, CO. LIMERICK
Small brooch, complete with pin. Hoop decorated with two saltires, and a little ribbing near
terminals. Squared terminals, no ears, decorated each with one chip of millefiori on enamel back-
ground, no snout, but circular snout tip sunk for enamel. Reverse sides of terminals decorated
with capital N pattern. Well-moulded pin-head of devolved barrel form, with centre panel enclos-
ing lentoid petals.
D. = 3.6 cm. Pin L. = 7.4 cm.
NMI, 1968:414

Fourth Series, C_4

112 KNOWTH, CO. MEATH
Small and rather frail brooch, with plain hoop, and pin missing. Imperfect terminals of unequal
size, no ears, but each having a design based on the simplified palmette with coupled scrolls
having swollen finials. The two designs must be viewed as one, the brooch having been annular
at first, and then cut through to make two separate terminals. Enamel background. Eyes angular.
Enamelled snouts, level snout tips ornamented on the one hand with a spherical triangle, the
other with an isosceles triangle, both on enamel backgrounds.
D. = 3.5 cm.
In possession of excavator, George Eogan

113 IRELAND
Brooch, ribbing continuous on hoop except for break on one side, and complete with pin. Squared,
splayed terminals, with rudimentary ears marked off at corners, and decorated with patterns
based on simplified palmette. Angular eyes, snouts enamelled and having medial ridges, snout
tips rounded and slightly raised. Barrel form pin-head, with parallel line markings at centre. Pin
decorated with elongated loop.
D. = 4.8 cm. Pin L. = 8.0 cm.
NMI

114 IRELAND
Brooch, hoop plain, complete with broken pin, lower end missing. Wide splayed terminals, with
rudimentary ears marked off at corners, heads decorated with patterns made up of a circle and
coupled scrolls, on enamel background. Snouts enamelled, snout tips raised and rounded. True
barrel form of pin-head.
D. = 4.6 cm. Pin L. = ?
NMI

115 IRELAND
Brooch, with six bands of ribbing on hoop, and complete with pin. Squared terminals with
marked-off ears at corners, heads decorated with same pattern as No. 114, but this time having

'tails' made up of paired spherical triangles, with dots at their centres. Enamel background. Enamelled snouts, raised and rounded snout tips. Sloppy pin-head imitative of barrel form, and having scored parallel lines as decoration. Pin decorated with three transverse lines and, an inch lower, with another two.
D. = 6.5 cm. Pin L. = 11.9 cm.
NMI

116 TOGHER, CLONMORE, CO. LOUTH
Large brooch, hoop completely decorated with unequal bands of ribbing, and complete with pin. Well-finished splayed terminals, with ears marked off at corners, decorated with complex patterns of circles and scrolls on enamel background, long enamelled snouts, eyes angular, snout tips rounded and upturned. Reverse sides of terminals decorated with a pattern made up of Xs and three transverse lines, alternating. Pin-head in true barrel form, centre ornamented with parallel lines. Pin decorated with chevron pattern.
D. = 7.2 cm. Pin L. = 12.3 cm.
NMI

117 ATHLONE (near), CO. WESTMEATH
Brooch, with worn but probably completely ribbed hoop, and pin. Terminals splayed, with ears marked off at corners, heads triangular in shape and decorated with same pattern as No. 114, on enamel background, prominent rounded eyes, enamelled snout and bulbous snout tips with encircling transverse lines. Pin-head barrel-shaped, decorated with parallel lines.
D. = 5.6 cm. Pin L. = 11.4 cm.
NMI

118 IRELAND
Brooch, ribbing in twos and threes covering hoop, pin missing. Present pin is modern. Terminals with ears marked off at corners, heads decorated with pattern incorporating the simplified palmette. Angular eyes. Snouts rounded and indented with lines, snout tips hollowed for enamel. Background of enamel on heads.
D. = 6.1 cm.
NMI

119 DINAS POWYS, GLAMORGAN
Conjectural terminals drawn from lead pattern found at this site. Terminals with marked-off ears at corners, heads decorated with a design on an enamel background, angular eyes, pear-shaped hollow for enamel in place of snout.
Reference: L. Alcock, *Dinas Powys: an Iron Age, Dark Age and Early Medieval Settlement in Glamorgan* (1963)

120 IRELAND
Brooch, hoop plain, complete with pin. Terminals with ears marked off at corners, on heads simplified enclosed palmettes on enamel background. Angular eyes, snouts enamelled, snout tips rounded and upturned. Devolved barrel-form pin-head, with criss-cross decoration. Deep channel on middle of pin.
D. = 5.1 cm. Pin L. = 10.5 cm.
NMI

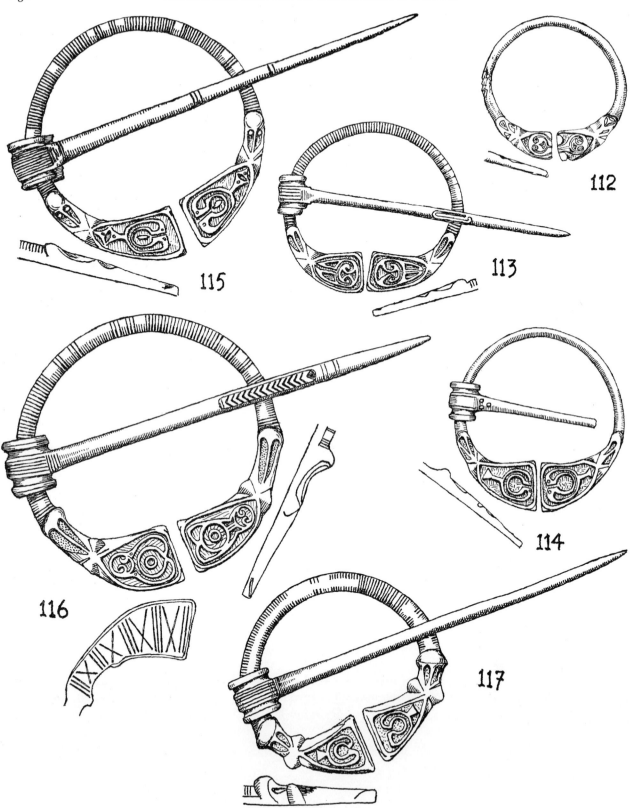

Fig. 45. Group C₄ brooches: 112, Knowth, Co. Meath; 113, Ireland; 114, Ireland; 115, Ireland; 116, Togher, Clonmore, Co. Louth; 117, near Athlone, Co. Westmeath. (1/1)

121 CO. WESTMEATH

Small brooch with plain hoop and modern pin. No ears, terminal heads decorated with 'Maltese' crosses on enamel background, eyes angular, snouts enamelled, snout tips bulbous.
D. = 3.8 cm.
NMI

122 BOUGH, RATHVILLY, CO. CARLOW

Poorly-cast brooch with plain hoop, pin missing. Irregular terminals having no ears, but decor-

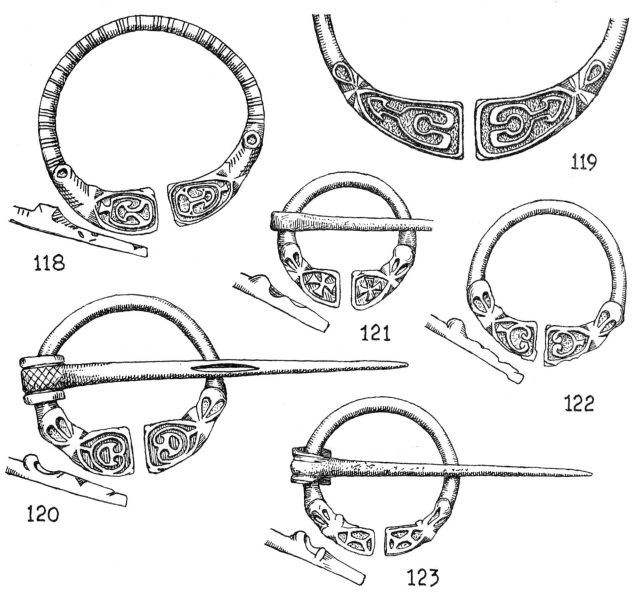

Fig. 46. Group C₄ brooches: 118, Ireland; 119, Dinas Powys, Glamorgan; 120, Ireland; 121, Co. Westmeath; 122, 123, Bough, Rathvilly, Co. Carlow. (1/1)

ation based on simplified palmette on heads, on enamel background. Angular eyes, snouts enamelled, snout tips very bulbous.
D. = 4.3 cm.
NMI
Reference: *J.R.S.A.I.* lxiv (1934), 263

123 BOUGH, RATHVILLY, CO. CARLOW
Brooch, found with No. 122, and similar, except for decoration on terminal heads, but with pin, pin-head devolved barrel form.
D. = 4.3 cm. Pin L. = 8.3 cm.
NMI

Fifth Series, C_5

124 CLOGHER, CO. TYRONE (brooch factory)
Brooch, in poor condition, with one terminal missing, and damaged pin. Hoop plain. Thin terminals, squared, with marked-off ears at corners, head decorated with one single spiral occupying maximum space, but on enamel background. Circular hollows on eyes for enamel, and another on snout tip, also for enamel. Snouts decorated with zigzags, which with pronounced medial line form themselves into triangles. Pin-head, simple with incised lines, is detached from the pin, which is incomplete.
D. = 4.8 cm.
UM

125 CLOGHER, CO. TYRONE
Three pieces of a very badly preserved brooch, ribbing on hoop. Enamelled snout, with upturned and rounded snout tip, rounded eyes. Terminals enamelled, but decoration cannot be determined.
UM

126 KILLUCAN, CO. WESTMEATH
Poorly-preserved brooch, with plain hoop, and complete with pin, also in poor condition. Very thin terminals, no ears, heads decorated with patterns made up of circles and scrolls, on enamel background, eyes angular, snouts enamelled, snout tips raised and rounded. Pin-head plain, but decorated with deep channels.
D. = 4.3 cm. Pin L. = 7.9 cm.
BM, 1902, 12-19, 2

127 IRELAND
Brooch, plain hoop, and complete with pin. Part of one terminal missing, the other squared, with ears marked off at corners. Well-executed pattern, incorporating the simplified palmette, on both terminals on enamel background, eyes rounded. Enamelled snouts, snout tips circular and rounded. Pin-head of simple form but showing the beginnings of moulding. Pin decorated with several spaced transverse lines.
D. = 5.6 cm. Pin L. = 8.9 cm.
UM

128 IRELAND
Brooch, well finished, with unequal bands unequally spaced of ribbing on hoop, complete with

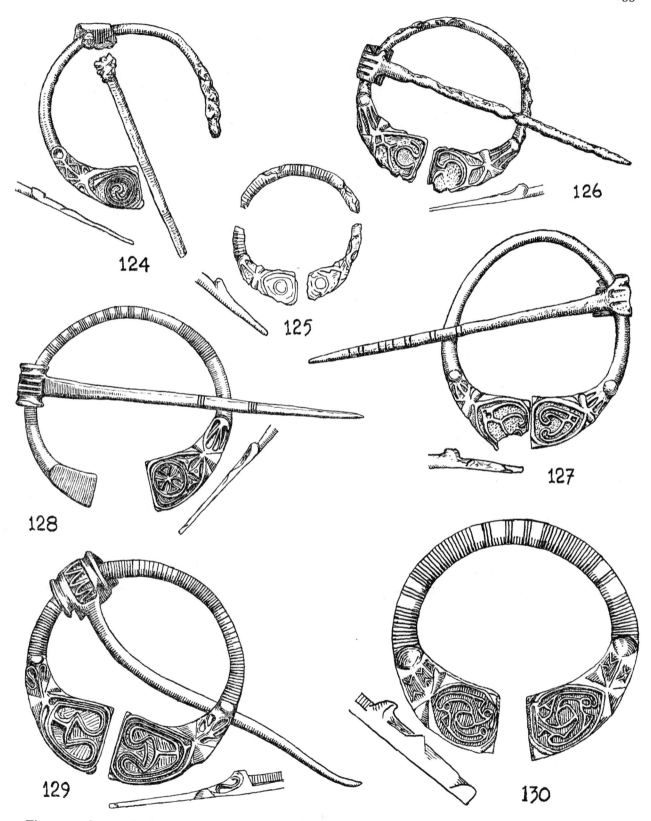

Fig. 47. Group C₅ brooches: 124, 125, Clogher, Co. Tyrone; 126, Killucan, Co. Westmeath; 127, Ireland; 128, Ireland; 129, Navan Rath, Co. Armagh; 130, Bog of Clogher, Co. Tyrone. (1/1)

pin, but one terminal missing. These very thin terminals had been sweated on: this one came adrift because of a dry joint. The remaining terminal is squared, with very small marked-off ears at the corners. Terminal head decorated with a 'Maltese' cross enclosed within a circle; alongside are three spherical triangles with dots at their centres — all on a background of enamel. Angular eyes. Snouts enamelled, snout tips slightly raised and rounded. Well-moulded barrel-form pin-head, with three deep channels at centre. Two narrow bands of transverse lines on pin.
D. = 5.7 cm. Pin L. = 9.5 cm.
ASH, 1886-5819

129 NAVAN RATH, CO. ARMAGH
Well-made brooch, with four bands of spaced ribbing on hoop, and complete with pin. Very thin squared and splayed terminals, with very small marked-off ears at corners. Heads decorated with scroll pattern on background of enamel. Large angular eyes, snouts enamelled, one having a scroll pattern. Snout tips raised and flattened on top. Large barrel-form pin-head, with zigzag in centre panel, enamelled.
D. = 5.9 cm. Pin L. = 10.3 cm.
BM, 68, 7-9, 19

130 BOG OF CLOGHER, CO. TYRONE
Clumsy cast brooch, hollow terminals, hoop decorated with four unequal bands of ribbing. Terminals splayed, thick, and squared, with marked-off ears at corners. Complex design made up of three linked triskeles interlocked at a common point at the centre, on an enamel background, is on both terminal heads. Eyes angular. Snouts with medial ridges, decorated with Vs and enamelled. Snout tips upturned and pointed. Pin missing.
D. = 6.4 cm.
UM

GROUP D

131 CLOGHER, CO. TYRONE (brooch factory)
Raw terminal casting, imperfect, with large 'rags'. Head, ears and snout tip clearly indicated.
UM

132 IRELAND
Very well made and finished brooch, with four equal bands of ribbing on hoop, and complete with pin, point missing. Round heads, each decorated with five squares of millefiori in enamel background, rounded ears. Multiple lozenge pattern on snouts, snout tips decorated with a chip of millefiori in enamel background. Sides of terminals also decorated with multiple lozenge pattern. Reverse sides decorated with sixfoil motif enclosed within two concentric circles, with hollow dots in between the two circles, together with a scratched S pattern. Pin-head based on barrel form, but with extended centre seed-like moulding.
D. = 5.8 cm.
NMI

133 IRELAND
Brooch, with hoop decorated with three bands of ribbing alternating with two bands of criss-cross pattern. Modern pin. Round heads decorated with five pieces of round millefiori (each) on

enamel background. Snout plain, snout tip enamelled.
D. = 4.7 cm.
NMI

134 GRANSHA, CO. DOWN
Badly-preserved brooch, having two bands of criss-cross pattern on hoop. Round heads, decorated
with (each) a single square of millefiori on enamel background, and having large ears sunk for
enamel. Snouts plain, snout tips sunk for enamel. Pin broken, pin-head based on barrel form,
with extended centre seed-like moulding.
D. = 4.2 cm.
UM

135 IRELAND
Brooch, with indented ribbing possibly covering entire hoop, complete with pin. Round heads,
with small ears, heads decorated with studs of pink coral at their centres, from which radiate
indented lines to give a sort of 'sun' pattern. Snouts indented with transverse lines, snout tips
flattened on top. Pin-head based on barrel form, with centre seed-like moulding, and two extended
'horns' of metal.
D. = 4.8 cm. Pin L. = 9.8 cm.
UM

136 IRELAND
Brooch, with plain hoop, pin probably a later addition. Round heads sunk for enamel, with
small round ears. Snouts and sides of terminals decorated with indented lines, on the snouts in
herringbone fashion, vertically on sides of terminals. Snout tip sunk for enamel.
D. = 5.3 cm.
NMAS

137 IRELAND
Brooch, with traces of ribbing and of herringbone pattern on hoop, which is badly weathered,
and complete with pin. Round heads, with projecting rounded ears. One head decorated with
four unequal squares of millefiori on enamel background, the other possibly the same, but enamel
has fallen out. Snouts decorated with panels of lentoid petals, snout tips raised and slightly
pointed. Pin-head based on barrel form, with centre seed-like moulding. Centre also extended
and having a round 'cap'.
D. = 5.6 cm. Pin L. = 7.1 cm.
UM

138 IRELAND
Heavy and ugly brooch, with plain hoop. Large round heads, sunk for enamel, and having large
'Mickey Mouse' ears hollowed for enamel. Plain snouts, but snout tips sunk for enamel. Debased
pin-head form, elongated and having a top extension sunk on the end for enamel. Seed-like centre
moulding, with dot of enamel below it. Short pin.
D. = 6.7 cm. Pin L. = 8.6 cm.
UM

139 ENGLISH (or EAGLISH?), CO. ARMAGH
Well-finished brooch, plain hoop. Plain round heads, with small projecting rounded ears, snouts

10

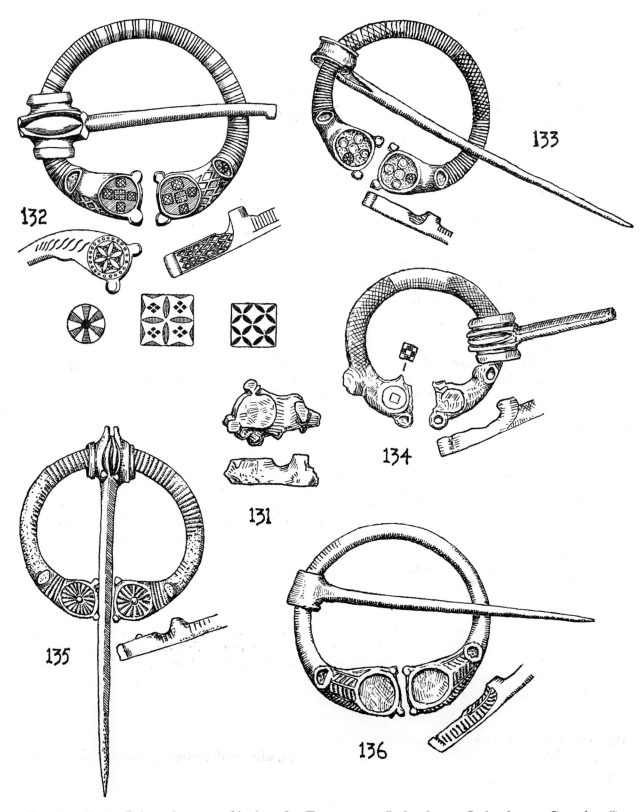

Fig. 48. Group D brooches: 131, Clogher, Co. Tyrone; 132, Ireland; 133, Ireland; 134, Gransha, Co. Down; 135, Ireland; 136, Ireland. (1/1)

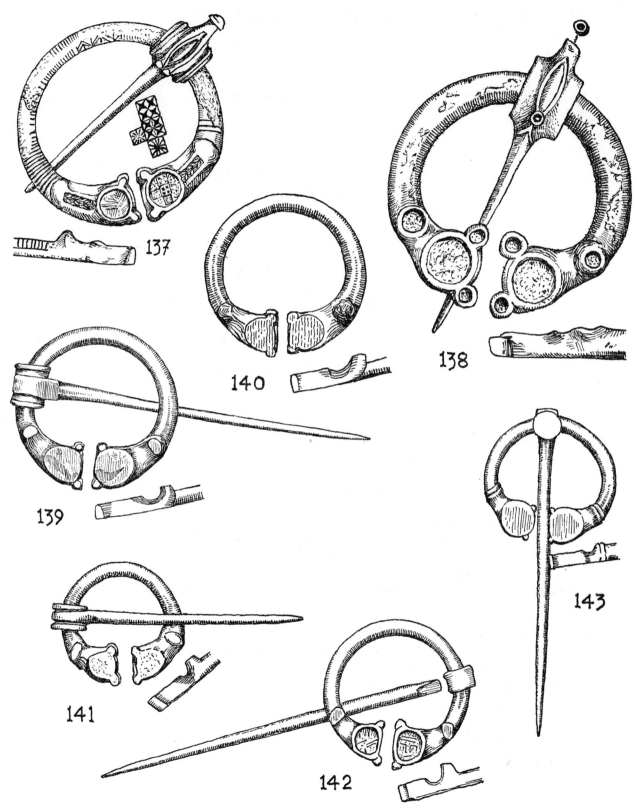

Fig. 49. Group D brooches: 137, Ireland; 138, Ireland; 139, English (or Eaglish?), Co. Armagh; 140, Ireland; 141, Ireland; 142, 143, Armagh. (1/1)

plain, snout tips flattened on top. Well-moulded pin-head, barrel shaped.
D. = 4.3 cm. Pin L. = 9.8 cm.
NMI, 1906:7D

140 IRELAND
Brooch, plain, and identical with No. 139 but less well finished and preserved. Pin missing.
D. = 4.3 cm.
UM

141 IRELAND
Small, plain brooch, complete with pin. Rounded heads and ears, the latter projecting. Snout tips flattened on top. Pin-head of compressed barrel form.
D. = 3.3 cm. Pin L. = 6.9 cm.
NMAS

142 ARMAGH
Plain brooch, complete with broken pin, pin-head of simple form. Rounded heads, sunk for enamel, snout tips flattened on top. Projecting ears.
D. = 3.9 cm. Pin L. (approx.) = 10.5 cm.
ROM

143 ARMAGH
Plain brooch, complete with pin. Rounded heads, very small projecting ears, snout tips having deep channelled transverse line encircling them. Simple pin-head with disc at front.
D. = 3.6 cm. Pin L. = 8.7 cm.
ROM

PINS

GROUP D

144 INISHKEA NORTH, CO. MAYO
Pin, with moulded head, and having a penannular plain ring with zoomorphic terminals sunk for enamel, small ring-like ears and raised snout tips.
D. = 3.1 cm. Pin L. = 9.8 cm.
NMI

145 IRELAND
Pin, moulded head, and having a plain penannular ring with zoomorphic terminals, heads sunk for enamel, large ring-like ears, snout tips hollowed for enamel.
D. = 3.3 cm. Pin L. = 12.0 cm.
UM, no number

146 LOUGH-A-TRIM, CO. WESTMEATH
Pin, same as above, but slightly larger terminals.
D. = 3.7 cm. Pin L. = 10.8 cm.
UM, 535:37

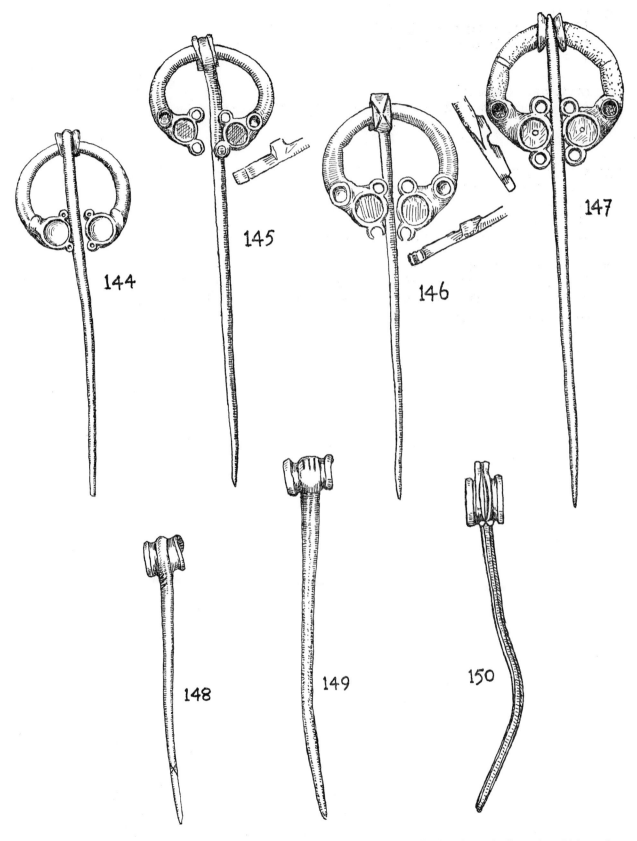

Fig. 50. Group D pins: 144, Inishkea North, Co. Mayo; 145, Ireland; 146, Lough-a-Trim, Co. Westmeath; 147, Ireland. Brooch pins: 148, Silchester, Hants; 149, Garranes, Co. Cork; 150, Clogher, Co. Tyrone. (1/1)

147 IRELAND
Pin, same as Nos 145 and 146, but larger terminals.
D. = 3.6 cm. Pin L. = 13.2 cm.
UM

148 SILCHESTER, HAMPSHIRE
Nicely-moulded barrel-form pin, decorated with saltire near the point.
L. = 7.7 cm.
Reference: *M.A.* iii (1959), 86, pl. III, B1

149 GARRANES, CO. CORK
Large heavy pin, plain, with barrel-shaped head.
L. = 9.8 cm.
NMI
Reference: *P.R.I.A.* xlvii (1942), 95, fig. 4, 330

150 CLOGHER, CO. TYRONE (brooch factory)
Lead pin, used as pattern in pin-making and casting. Pin hexagonal in section, pin-head based on barrel form, with seed-like moulding at centre, centre moulding extended.
L. = 9.5 cm.
UM

ADDENDA

SEVERAL additional brooches, details of which arrived too late for inclusion in the main text, are mentioned below.

To Mr. R. B. K. Stevenson I am indebted for details of Nos. 151–153, together with drawings of Nos. 152 and 153.

To Dr. James Graham-Campbell I am indebted for details of Nos. 155 and 156, to which his attention was drawn by Steve Briggs, who supplied Xerox copies of drawings.

It has been found impossible to obtain an illustration of No. 161 from the Friesch Museum, at Leeuwarden.

INITIAL FORM

151 PRESTON TOWER, EAST LOTHIAN
Zoomorphic penannular brooch, with small terminals, hoop plain. Pin missing.
D. = 6.3 cm.
NMAS, DO 17

152 SHURRERARY, CAITHNESS
Poorly preserved zoomorphic penannular brooch, hoop plain, pin missing. Slightly splayed terminals much corroded, but ends squared, ears marked off at corners. Heads probably rounded, and eyes and snouts also rounded.
D. = 6.6 cm.
NMAS
Reference: *P.S.A.S.* lxxxi (1499), 193

153 NORTH BERWICK, EAST LOTHIAN
Somewhat decayed zoomorphic penannular brooch, hoop plain and complete with pin. Cast rectangular terminals, with oval heads having ears marked off at corners. Eyes angular, snouts splayed and squared off. Barrel-form pin-head, part of it missing.
D. = 8.2 cm. Pin L. = 8.2 cm.
NMAS, FA 111

GROUP C

Second Series, C_2

154 MEALSGATE, CUMBERLAND
Irish zoomorphic penannular brooch, cast hollow terminals. Said to resemble No. 79. Plain pin.
Tullie House Museum, Carlisle.
Reference: *Arch. J.* cxx (1963), 98 ff.

156 TULLYHOGE, CO. TYRONE
Drawing of zoomorphic penannular brooch, by A. E. P. Collins from notebook kept by Rev. Dr. Porter, and dated 18th October 1874. Pin not original. This brooch comes nearest in style to No. 88, from Armagh.
Location: not recorded.

159 IRELAND
Zoomorphic penannular brooch, hoop ornamented with five bands of ribbing, pin a later addition. Terminals squared and sunk for enamel, no ears, rounded eyes, pronounced medial ridges on snouts, which are decorated with lentoid petals. Snout tips rounded and raised.
D. = 5.0 cm.
NMI, 1959:629
Reference: *J.R.S.A.I.* xci (1961), 99, fig. 29

161 IRELAND
Zoomorphic penannular brooch, with four bands of ribbing on hoop, complete with pin. Squared terminals, with ears marked off at corners. Heads decorated with chips of millefiori on enamel background. Eyes rounded, snouts enamelled, bulbous snout tips. Barrel-shaped pin-head, with centre panel of lentoid petals.
Museum of Archaeology and Ethnology, Cambridge
Reference: *J.R.S.A.I.* lxvi (1936), pl. XXIV, 5

Third Series, C₃

160 IRELAND
Zoomorphic penannular brooch, hoop plain, pin missing. Terminal heads decorated with patterns, at the centres of which are simplified palmettes, on an enamel background. No ears. Eyes angular. Pronounced medial ridges on snouts, which are decorated with lentoid petals. Snout tips rounded and raised.
D. = 5.7 cm.
NMI, 1959:630
Reference: *J.R.S.A.I.* xci (1961), 99, fig. 30

Fifth Series, C₅

155 BALLYMULDERY-MORE, PARISH OF ARTREA, CO. DERRY
Zoomorphic penannular brooch, hoop decorated with ribbing, complete with pin. Splayed terminals, with complex pattern on enamel background on heads; the remaining features are not represented.
Presumed lost.
Reference: Co. Derry O.S. Memoirs, Royal Irish Academy.
Extract: 16 September 1836, Thos. Fagan writes — 'Ed. Larkin while destroying a fort in Ballymuldery-More discovered a circular vault 2 feet deep & diam., and covered by 5 flat stones laid a top of another, and each about 3 feet long and broad, and 16 inches thick each. The vault contained a quantity of pitch black earth. He also found a large quantity of timber ashes and cinders, also a quantity of bright pins with brooch attached to a ring.'
There is little doubt but that this brooch is a product of the Clogher brooch factory.

UNCERTAIN

157 IRELAND
Zoomorphic penannular brooch, complete with pin. Hoop with three ovals dividing ribbing into bands. Terminals decorated with chips of millefiori on enamel background. Barrel form of pin-head.
Alnwick Castle Museum
Reference: *Arch. J.* cxx (1963), 98 ff.

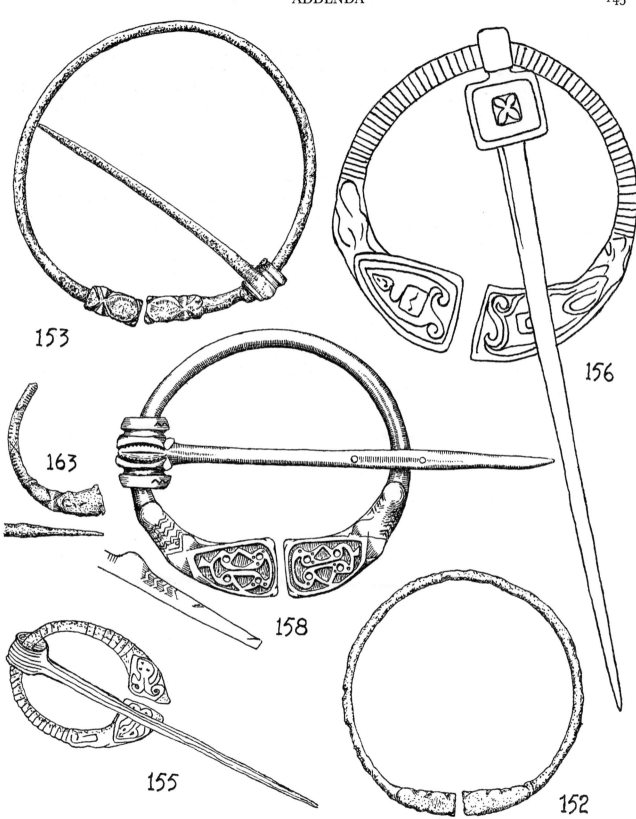

Fig. 51. Miscellaneous brooches: Initial Form: 152, Shurrerary, Caithness; 153, North Berwick, East Lothian. Group C$_2$ brooches: 156, Tullyhoge, Co. Tyrone. Group C$_5$ brooches: 155, Ballymuldery-More, Co. Derry. Uncertain: 158, Ireland; 163, Corbettstown, Kilpatrick, Killucan, Co. Westmeath. (1/1)

158 IRELAND
 Zoomorphic penannular brooch, plain hoop. Splayed terminals with ears marked off at corners.
 Complex patterns, presumably based on the simplified palmette, decorate both heads, against a
 background of enamel. Angular eyes, snouts decorated with zigzags, snout tips rounded and
 raised. Barrel-form pin-head, with seed-like moulding at centre, and a 'butterfly bow' below.
 D. = 7.6 cm. Pin L. = 12.0 cm.
 NMI

162 LOUGH GILL, CO. SLIGO
 Zoomorphic penannular brooch, slight ribbing on hoop, and complete with pin. Terminals
 ornamented with quatrefoils at the centres. Snouts and sides of terminals decorated with lentoid
 petals. Reverse sides of terminals decorated with capital N pattern. Barrel-shaped pin-head, with
 seed-like moulding at centre and 'panels, the two outer of which are ornamented with two series
 of lines dividing the panels into small squares'.
 D. = 7.0 cm. Pin L. = 11.8 cm.
 Stolen.
 Reference: *N.M.A.J.* ii (1940–1), 86, 2

163 CORBETTSTOWN, KILPATRICK, KILLUCAN, CO. WESTMEATH
 One half of a zoomorphic penannular brooch, pin missing. A saltire and traces of ribbing appear
 on the hoop. Terminal splayed, with one slightly projecting ear remaining. Head probably
 enamelled. Eyes angular, snout rounded. Because the terminal has been hammered, in order to
 splay it, and the snout tip is not yet raised or upturned, this brooch is most likely to be early,
 say third-century.

CATALOGUE OF PSEUDO-ZOOMORPHIC PENANNULAR BROOCHES

1 LYDNEY, GLOUCESTERSHIRE
Brooch, with unequally spaced ribbing on hoop, pin missing. Bent-back terminals, oval heads and splayed snouts formed by filing U-shaped hollows in from the sides. No eyes, ears well defined.
D. = 4.0 cm.
Reference: R. E. M. and T. V. Wheeler, *Excavations at Lydney Park, Glos.* (Soc. Antiq. Research Report No. 9, 1932), fig. 14

2 BIRDOSWALD, CUMBRIA
Brooch, with continuous ribbing on hoop, and complete with pin. Bent-back terminals, heads lozenge shaped, snout tips splayed. No eyes, ears well defined. Plain pin-head, with small outer and inner mouldings.
D. = 3.2 cm. Pin L. = 3.7 cm.
Tullie House Museum, Carlisle
Reference: *Trans. Cumb. & West. Ant. & Arch. Soc.*, n.s., xxxi (1931), 132

3 KNOWTH, CO. MEATH
Brooch in poor condition, with remains of coarse ribbing on hoop, pin missing. Simulated bent-back terminals, features barely discernible, but perhaps similar to No. 1.
D. = 3.2 cm.
In possession of Dr. George Eogan

4 WOODEATON, OXON.
Small brooch, two zones of ribbing on hoop, complete with pin. Bent-back, badly formed heads and roughly indicated features. Pin-head resembles barrel form.
D. = 2.6 cm. Pin L. = 3.2 cm.
ASH
Reference: *J. Roman Studies*, vii (1917), pl. VI*e*

5 WITCOMBE, GLOUCESTERSHIRE
Brooch, with a combination of ribbing and mouldings in false relief on hoop, complete with pin having a plain head. Terminals with indefinite features, but barely zoomorphic, medial lines on heads.
D. = 3.4 cm. Pin L. = 3.8 cm.
Reference: *Trans. Bristol & Glos. Arch. Soc.* lxxiii (1954), 314, fig. 14, 1

6 ICKLINGHAM, SUFFOLK
Brooch, with three widely spaced bands of ribbing on hoop, complete with pin. Only one terminal still retaining debased zoomorphic features of shortened head, eyes indicated by dots, and bulbous snout. Medial line on head. Attempted moulding of pin-head, otherwise plain.
D. = 3.2 cm. Pin L. = 3.7 cm.
Reference: H. N. Savory, 'Some sub-Romono-British brooches from south Wales', in D. B. Harden (ed.), *Dark Age Britain* 1956, pl. V*c*

7 YORK
Brooch, plain hoop, remains of moulded pin-head. Terminals having no heads, but V-shaped ears, dots for eyes, and broad rounded snout.
D. = 2.6 cm.
York Museum

8 OKSTROW BROCH, BIRSAY, ORKNEY
Brooch, one half of hoop with ribbing, complete with pin. Terminals copied from evolving form, with marked-off ears, no eyes, snout rounded. Primitive moulding of pin-head.
D. = 4.1 cm. Pin L. = 4.3 cm.
NMAS
Reference: *P.S.A.S.* xi, fig. on p. 85

9 CAERSWS, MONTGOMERY
Poorly-preserved brooch with coarse ribbing on hoop, no pin. Terminals simulate zoomorphic form, but badly carried out.
D. = 2.3 cm.
NMW
Reference: *Y Cymmrodor*, xxxiii (1923), 138, fig. 60

10 SOUTH SHIELDS, CO. DURHAM
Well-finished brooch, continuous coarse ribbing on hoop, complete with pin having well-moulded barrel-form pin-head. Terminals a very fair copy of the zoomorphic form, with marked-off ears at corners, oval heads, slightly projecting eyes, rounded snout and slightly upturned snout tip.
D. = 2.6 cm. Pin L. = 3.5 cm.
South Shields Public Library
Reference: *Arch. Ael.*[4] xi (1934), 198, fig. 2

11 SOUTH SHIELDS, CO. DURHAM
Brooch, scraps of ribbing on hoop, complete with pin having a badly moulded head. Splayed terminals, with irregular and badly marked-off features imitating the zoomorphic form, all achieved by undercutting.
D. = 3.4 cm. Pin L. = 3.9 cm.
South Shields Public Library
Reference: *Arch. Ael.*[4] xi (1934), 198, fig. 2

12 WHITFORD BURROWS, GLAMORGAN
Brooch, with continuous very coarse ribbing on hoop, pin missing. Narrow elongated terminals, fairly well simulating the zoomorphic form, and complete with ears, heads, eyes, and snouts.
D. = 3.3 cm.
NMW
Reference: H. N. Savory, 'Some Sub-Romano-British brooches from south Wales', in D. B. Harden (ed.), *Dark Age Britain* (1956), pl. V*d*

13 DOWKERBOTTOM CAVE, DERBYSHIRE
Well-finished brooch, slight ribbing on hoop near terminals, otherwise plain. Rectangular heads with ears and eyes marked off at the corners, no snouts. Plain pin-head.
D. = 3.3 cm. Pin L. = 4.0 cm.
BM, 57, 11-13, 8

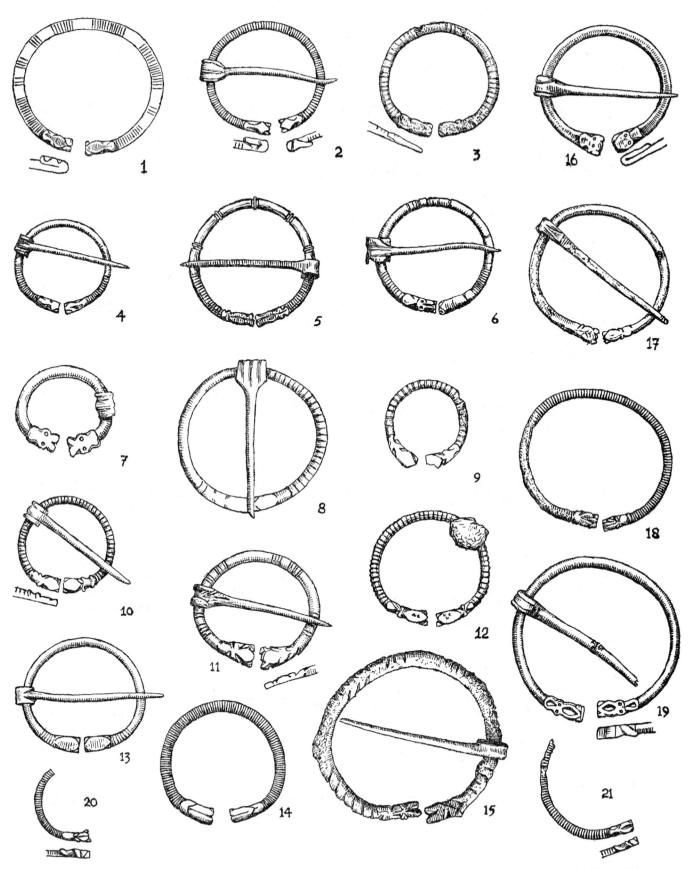

Fig. 52. 'Small', or pseudo-zoomorphic penannular brooches: 1, Lydney, Glos.; 2, Birdoswald, Cumbria; 3, Knowth, Co. Meath; 4, Woodeaton, Oxon.; 5, Witcombe, Glos.; 6, Icklingham, Suffolk; 7, York; 8, Okstrow Broch, Birsay, Orkney; 9, Caersws, Montgomery.; 10, 11, South Shields, Co. Durham; 12, Whitford Burrows, Glam.; 13, Dowkerbottom Cave, Derbys.; 14, Catterick Bridge, Yorks.; 15, Portchester Castle, Hants; 16, *Cilurnum* (Chesters), Northumberland; 17, 18, *Segontium* (Caernarvon), Gwynedd; 19, Barnton, Edinburgh; 20, N. Uist; 21, Tara, Co. Meath. (1/1)

14 CATTERICK BRIDGE, YORKSHIRE
Brooch, with continuous ribbing on hoop, pin missing. Simple bent-back terminals, with medial lines on heads, ears indicated on inside only, no eyes, short snout.
D. = 3.4 cm.
Yorkshire Museum
Reference: *Yorks. Arch. J.* xxxix (1958), 243, fig. 5, 11

15 PORTCHESTER CASTLE, HAMPSHIRE
Crudely-finished brooch, some worming on hoop, terminals V ended, various file marks for features. Plain pin-head.
Reference: B. Cunliffe, *Excavations at Portchester Castle, I; Roman* (Soc. Antiq. Research Report, No. 32, 1975), fig. 109, 8

16 *CILURNUM* (CHESTERS) NORTHUMBERLAND
Brooch, with plain hoop, and with bent-back terminals, one having ears indicated, both having dots for eyes and short snouts. Pin-head simulates the barrel form.
D. = 3.5 cm. Pin L. = 3.4 cm.
Chesters Museum, 1141:1393

17 *SEGONTIUM* (CAERNARVON), GWYNEDD
Brooch, plain hoop, and having one terminal fashioned in correct zoomorphic form, but the other is haphazardly made. Plain pin-head with V-like marking.
D. = 3.7 cm. Pin L. = 4.4 cm.
NMW

18 *SEGONTIUM* (CAERNARVON), GWYNEDD
Brooch, somewhat decayed, but formerly having continuous ribbing on hoop, pin missing. Heads of terminals with medial lines, but otherwise haphazard representation of zoomorphic features.
D. = 4.0 cm.
NMW

19 BARNTON, EDINBURGH
Well-made brooch, plain hoop, and having a broken pin. Terminals, cast, and having a deep elongated hollow in centres of heads. One terminal squared off with double moulding, the other with marked-off ears. Eyes indicated by dots, snouts hollowed. Plain pin-head, with two channels to give the impression of moulding.
D. = 4.5 cm.
NMAS

20 NORTH UIST
One half of brooch, with continuous ribbing on hoop, no pin. Terminals nicely simulate the zoomorphic form, slightly projecting ears, medial line on head, eyes and slightly upturned snout tip.
NMAS
Reference: *P.S.A.S.* cv (1972–4), 288

21 TARA, CO. MEATH
Nearly one half brooch, with continuous ribbing on hoop. Nicely finished terminals, with medial line on head, marked off ears and eyes, slightly upturned snout tips.
NMI, no number

INDEX